OBEY THE GIANT

LIFE IN THE IMAGE WORLD

RICK POYNOR

Birkhäuser
Basel · Boston · Berlin

352684

First published in 2001 by
August Media Ltd, London

Second Edition 2007
Birkhäuser Verlag AG
Basel · Boston · Berlin
P.O. Box 133
CH-4010 Basel, Switzerland
Part of Springer
Science+Business Media

© 2001 Rick Poynor
The moral right of the author
has been asserted
Design © 2001 August/Birkhäuser

Library of Congress Control
Number: 2007932887

Bibliographic information
published by the German National
Library
The German National Library lists
this publication in the Deutsche
Nationalbibliografie; detailed
bibliographic data are available on
the Internet at http://dnb.d-nb.de.

Art Direction: Stephen Coates
Design: Anne Odling-Smee
Project editor: Alex Stetter
Editorial assistant: Ruth Ward
Publishing director: Nick Barley

Picture research: Heather Vickers
Copy editor: Lise Connellan

Printed on acid-free paper
produced of chlorine-free pulp
TCF ∞
Typography: Quadraat Light,
Checkout

Printed in Germany
ISBN 978-3-7643-8500-2

9 8 7 6 5 4 3 2 1

www.birkhauser.ch

For Tim P.

Contents

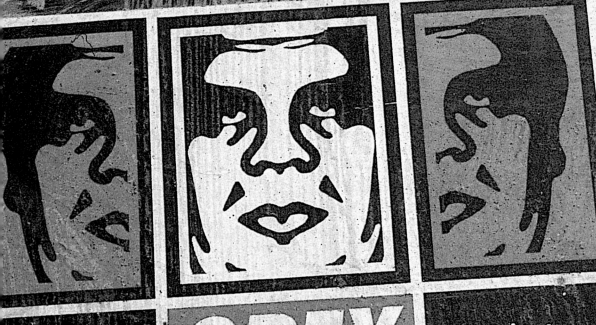

giant OBEY giant

HELLO my na

NDRE

THE

Introduction

Any ambiguity in this book's title is completely intentional. It can be taken ironically – 'obey' the giant – or it can be taken straight. You might be inclined to accept the imperative as an accurate picture of reality: the 'giant' requires us to surrender to its every command and whim. Or you might scoff at the very idea. No one is coercing us to do anything and we are manifestly free, as no people before us, to do whatever we like. American artist/designer Shepard Fairey's long-running 'Obey Giant' poster campaign – from which the phrase is taken – captures the spectrum of possibilities. To some viewers, coming across the giant's leaden visage in the street, like an ordinary piece of fly-poster advertising, the message seems threatening. To others, this mysterious, ubiquitous, endlessly reiterated graphic instruction is a seductively absurd image-game. It's possible, too, to feel that other people are doing the 'obeying' – without even realising it – while we go our own way.

That there is, however, a 'giant' out there few could seriously deny. Even the most determined and Panglossian free-market optimist must be assailed at times by the suspicion that mighty forces, many of them corporate, are making decisions over which we, as individuals, seem to have little if any control. Our triumphant age of plenty is riddled with darker feelings of doubt, cynicism, distrust, boredom and a strange kind of emptiness. As one newspaper headline summarised it: 'We have reached utopia – and it sucks'.[1] On British television, as an experiment, a wealthy family of four try to live for three weeks without their hundreds of designer possessions, carted off by the programme-makers. It doesn't go well. 'I just feel totally insignificant and worthless,' confesses the de-branded husband, who is later found to be securing a surreptitious product high by wearing his gold Rolex to business meetings.[2] Any novelist who made up this story to satirise consumerism gone haywire would be accused of exaggeration. Meanwhile, the disaffection and sense of powerlessness apparently felt by many people is a source of mounting public concern. Demonstrations in Seattle, Prague, London, Gothenburg and Genoa confront governments and media with worrying signs of disturbance in the depths of the social body. If there is still a tendency to stigmatise

all acts of protest as the work of an irresponsible carnival of anarchists, falling voter turnouts in national elections are beginning to oblige even the most complacent politicians to face the fact that growing numbers of citizens feel their democratic votes count for nothing.

The change of mood is now so widespread that it is easy to forget how recent it is. In the years after the collapse of communism, there was no public appetite to hear about the problems of consumer capitalism and dissenting viewpoints were not part of the mainstream media discussion. One could read a journal like *The Baffler* – published in Chicago – and nod sagely at the acumen of its analysis of business-world double-think, wishing for a time when such ideas would once again be part of the everyday news agenda, but in the mid-1990s that moment had yet to arrive. It didn't occur until December 1999 when images of goons in Darth Vader body armour, protecting corporate property in the streets of Seattle, were seen around the world. Naomi Klein's *No Logo* is only the most visible and media-friendly example of a flourishing new genre of scorching anti-corporate tract that stretches from Charles Derber's *Corporation Nation* (1998) by way of *Baffler* editor Thomas Frank's *One Market Under God* (2000) to Noreena Hertz's *The Silent Takeover* (2001). Interestingly, the group that seemed to grasp some of these ideas quickest – stylish, educated young people – was one that had, not long ago, provoked deep sighs of disappointment from ageing baby-boomers dismayed by the kids' seemingly total surrender to the branded life. 'The point is that there are no ways for you to express yourself that the brands don't own or control or won't own or control in an instant,' writes Nick Compton in the British style magazine i-D. 'That there is no space or event or experience that cannot be bought and made part of the brand message.'[3] Another youth-culture bible, *Dazed & Confused*, devotes a whole issue to the subject of rebellion: is it possible anymore? For the magazine's twenty-eight-year-old editor, Rachel Newsome, there is no such thing as an underground because corporate culture has infiltrated youth culture and utterly co-opted it.[4] Her generation has got what it wanted – in the sense of material opportunity – but young people still seek something to believe in, even as they come to terms with the realisation that corporate 'cool hunters' are lurking in the shadows, taking detailed field notes about their every move.

For a discipline that lives by clocking the latest trends, design was not especially quick to catch on. For many of those busily engaged in fabricating the image world, there was probably too much at stake. In the last fifteen years, the design business, too, has burgeoned into some kind of giant. In the 1960s, a successful metropolitan design firm might consist of three or four designers, an assistant or two, a tin of Cow gum and a few drawing boards cross-hatched with cut marks. In 2000, the UK-owned WPP

Group became the world's largest marketing communications giant, as well as the biggest owner of design groups, when it acquired US advertising group Young & Rubicam. Its ever-expanding list of subsidiaries now includes Landor Associates, The Partners, Coley Porter Bell, Enterprise IG, Addison, BDG McColl, and The Brand Union. Any one of these component companies might employ 50 or 100 designers, as well as other personnel. Other growth-hungry conglomerates – some originating inside design; some entering the field from the business consultancy and marketing services sectors – are also gobbling up design firms to strengthen their ability to win and implement huge national and global design projects. In Britain, according to a government audit in 2001, the creative sector is now a significant business worth more than £100 billion a year. Design generates £26.7 billion of this revenue, second only to software and computers (£36.4 billion) and some way ahead of publishing, television and radio, and music.[5] And this accelerating dependence on design's magical services is a global phenomenon. A recent *Time* magazine cover story enthusiastically proclaims 'The rebirth of design' – 'Function is out. Form is in. From radios to toothbrushes, America is bowled over by style.'[6]

For most of the 1990s, creating an ad campaign for a brand such as Nike – let alone designing the actual footwear – was one of the most desirable jobs to which a thrusting young creative could aspire. Now, suddenly, protesters were throwing rocks at Nike megastores and serious cognitive dissonance was almost bound to result. The response among some design, advertising and marketing people is to try to regroup. A book called *Beautiful Corporations* (2000) readily agrees on its cover that 'Corporations rule the world' and this message is reinforced in its pages by the claim that governments are fundamentally impotent and a spent force. They have 'now probably withered to such an extent that they cannot help' with impending ecological catastrophe.[7] But that is okay, it seems, because 'beautiful' corporations will gallop to the rescue. According to the business world's more far-sighted theorists, in a successful market economy shopping is a new kind of election: every item bought and carried off home is another vote cast. (Good news for the designer label-addicted TV family: they are clearly outstanding democrats.) In this kind of gung-ho design text aimed at the business reader, great premium is put on the necessity for style. Genuine style, we are told, is idiosyncratic; stylish individuals go their own way; style has to come from within. In the same way, if it is not to seem phoney, style must emanate from deep down in the very 'soul' of the corporation. Preachers of the design gospel never acknowledge the essential contradiction in this language. A soul is not something you can acquire along the way by trying harder: it's a determining essence that is present from conception. Design

might well be able to help the fortunate bearer of a decent soul to express its inner light more effectively (though even this sounds manipulative) but no amount of expensive design penance can imbue a corporate entity with a 'soul' that was not there in the first place. If a corporation really needs to be told that customers admire and reward values such as quality, consistency, integrity and honesty, it is already a lost cause. Any attempt to confect the appearance or 'style' of these virtues must necessarily be bogus and the idea of design consultants going around trying to smarten up the corporate soul in this way – in order to 'insinuate your company into the customer's mind' – is enough to confirm a disenchanted consumer's worst fears.[8]

The trendier end of the branded universe has responded with a battery of hip-sounding rethinks and wily new strategems: funky business, viral marketing, stealth advertising, ambient advertising, guerrilla advertising. One new British ad agency underlines the anti-corporate message by actually styling itself Anti-Corp. At the Anti-Corp website, potential clients are advised that the team has assembled a panel of 'early adopters' and opinion-formers, who can supply instant e-mail feedback on their views and attitudes about ideas and brands. If the 'underground' is now officially dead, the news appears not to have reached Anti-Corp. 'We're going to use [the panel] like an early warning system,' says co-founder Dave Hieatt, a former Saatchi & Saatchi copywriter, 'because we've learned that the more "underground" an idea is in the youth market, the more likely it is to work.'[9] In another guise, Hieatt and his partner Mark Simmons operate the skateboard clothing line Howies, voted ninth 'coolest' brand in Britain in 1999 by *Fashion Weekly*. Howies does a T-shirt emblazoned with the legend 'Big Brand Defector' and a little registration mark in a circle – just the thing for readers of *No Logo* and *The Silent Takeover*, which make similar ironic use of registration and copyright symbols on their covers.

Design and advertising people who dedicate their efforts to this line of work are caught in a double bind from which there is no obvious way out. The difference between big brand communication and 'defector' brand communication is one of scale rather than essence. The mechanisms of 'insinuation' are largely the same. In some recent public statements, the angst is almost palpable: 'Everyone's trying to pass off their product as experience these days. I even passed The Kebab Experience last week. People in marketing need to learn responsibility, or it's all just spin,' warns Ralph Ardill, marketing and strategic director at Imagination, a huge British consultancy, with 160 designers on the payroll.[10] Another design consultant bemoans the fact that: 'Quirky or niche local offers, regardless of their ability to endure, are rapidly becoming things of the past.'[11] And what exactly is driving these unfortunate 'niche offers' towards

extinction with such regrettable haste? It's the gigantic, all-consuming global design and marketing initiatives on which so much creative energy is now lavished.

The unfocused sense of awakening detectable in such laments is starting to find expression at a larger institutional level. In May 2001, D&AD, the British organisation representing advertising and design, organised a one-day event, 'SuperHumanism', intended to act as 'an international forum for change in the design and communication industries'. In the conference announcement, Richard Seymour – product designer, TV personality, past president of D&AD and leader of the initiative – noted that philosophy was no longer part of our view of design and spoke of the urgent need to 'put people first'. 'There's a growing sense of alienation that has touched every aspect of our lives,' he explained in Blueprint. 'This sense of fear must be reversed to engender trust and empowerment and this can only be achieved through a thorough investigation of how the structures of brands, communications and service-to-user relationships are able to develop in a world beyond digital convergence.'[12]

Two of the forum's three core aims – to master 'out of control' technology and to meet people's real physical and emotional needs – seemed reasonable enough, however complex these goals might be to realise in practice. But the forum's third ambition – 'to restore the population's faith in brands and business' – threw the entire initiative into question. For those who earn their living (or make their fortunes) by providing services to brands and business, the public's loss of faith in their alchemical powers is bound to cause anxiety and no doubt appears a pressing concern. Nevertheless, the aim of a genuine 'super-humanist' committed to putting people first (rather than putting brands or business first) must surely be to start by addressing the underlying social, political and educational causes of that loss of faith. A restoration of faith in brands might – or might not – be the eventual result of this process but, if clear, impartial thinking about these issues is the intention, brand rescue certainly cannot be the project's stated purpose. In other words, you don't 'reverse the sense of alienation' in order to change reality; you work to change reality in order to reverse the sense of alienation. Not for the first time, it seemed that design people visualise these problems in terms of image rather than substance, even though this superficial way of thinking is a root cause of public suspicion. By tracing design's etymological origins, the Czech philosopher Vilém Flusser arrived at a startling definition of the designer as 'a cunning plotter laying his traps'.[13] Design, he proposed with persuasive elegance, has an inherently deceptive dimension. Starting a reappraisal of design practice from this point, rather than with the need to get us all back 'on message' for the business community's benefit, could produce profoundly radical conclusions. Yet critical perspectives that would require a

more fundamental interrogation of design and its relationship with marketing and advertising were not aired at 'SuperHumanism's forum of industry insiders, despite the proposal in its mission statement to unite philosophy and design.

While it might seem from the foregoing remarks that *Obey the Giant*'s agenda is entirely polemical and opposed to much visual production, this is far from the whole story. As an ordinary viewer, my attraction to the image world was first prompted by forms of commercial communication that seemed to go far beyond the routine and made a gripping, genuinely life-enhancing contribution to everyday visual culture. I still see plenty of evidence of design-thinkers, form-makers and image-crafters who are striving, sometimes against the odds, to develop strategies both to engage with, and resist, contemporary conditions. Some of them are discussed in this book. In design education, issues of personal engagement, authorship and responsibility are often debated and there is much talk about the need for 'critical making' and the 'reflective practitioner'. Yet even now, in a design-conscious age, there is little real interchange between the relatively open and speculative domain of higher education and the more tightly focused, income-watching 'creative' professions. If the would-be reformers of the design establishment really want to promote meaningful change, then they should open their minds, cast their nets wider in the search for fresh thinking and reconsider an obsession with size that is squeezing the spirit out of design. It's hard to talk sensibly with giants – their massive heads tend to get lost in the clouds.

My own path as an observer has been to move from a position outside design, in towards the centre, and then by degrees to pull back to a position further out. There is simply no way to occupy a place near the heart of an 'industry' and maintain a truly critical stance. After a while, you cease to recognise how many of its assumptions and values you now take for granted. Where I stand at the moment, I view design as part of the landscape, not as the main event. Its growth as a business or revenue-generator is not my concern. I am interested in its effects. My motive for writing about visual culture begins and ends with a desire to understand my own experiences: my life – our lives – in the image world. The key difference of emphasis between *Obey the Giant* and other books with a broadly 'anti-corporate' theme is that visual culture itself – rather than iniquitous labour practices, or environmental disaster, or the relationship between business and democracy – is its focus. These essays are written, with a kind of repelled fascination, from the perspective of a street-level participant, an image-consumer, a tuned-in viewer. Above all, what I hope comes across is a sense of the visual sphere as an inexhaustible supplier of provocation, stimulation, enlightenment and many different shades of pleasure. Irritation and even anger with the products of the image world are inevitable.

Ambivalence and not always being certain are part of the fun. It's possible to be deeply immersed in this culture, seduced, excited and energised by aspects of it, yet, simultaneously, to feel alienated from it in fundamental ways. By this I mean that all day long you are exposed to visual messages – delivered as edicts, targets and norms – which may affront every value you cherish, yet, short of total withdrawal, you must find your own way of coping with the incessant demands of this 'mental environment'.

Any conclusions I draw about the larger picture are heavily shaped by these everyday personal encounters with posters, billboards, photographs, books, magazines, websites, record covers, tourist attractions, exhibitions and shops. It is because I think that visual culture matters, that it makes a difference, that there are too many occasions when it is confiscated, controlled, doctored, diluted and sold back to us with its meanings changed for completely different purposes, that I want to take issue. I hope that at least some of these observations and reflections will strike your eye the same way.

1. Advertisements for utopia

The boredom of plenty

What is it about Martin Parr that makes him not only one of the most successful, influential and ubiquitous British photographers, but also one of the most controversial and reviled? In 1995, after looking, with mounting agitation, around a Parr exhibition in Paris, Henri Cartier-Bresson – a key inspiration for Parr in his teens – informed the latest Magnum recruit that, 'You are from a completely different planet to me.' The French master photographer later explained that he had taken great exception to the 'nihilistic attitude symptomatic of society today' that he found in Parr's pictures. Parr, who seems to keep a level head in the face of these onslaughts, sent Cartier-Bresson a note agreeing that they saw the world in very different ways, but asking, 'Why shoot the messenger?'[1]

Parr's output is a classic illustration of Oscar Wilde's dictum that diversity of opinion about a work of art is a sure sign that it is new, complex and vital. Magnum's campaigning brand of photojournalism has struggled, in recent years, to find regular outlets. Publishers think it is a turn-off. There is a feeling that the same grim, black-and-white picture stories have been told too many times to provoke much compassion any more. Battling to keep afloat, the Magnum collective has no choice but to open itself up to alternative ways of seeing. 'The traditional, concerned photographer photo-essay is a dying thing,' says Parr. 'Perhaps that's all the more reason why one doesn't want to be part of a dying trend. One wants to be part of a living trend, even though one may not approve of this trend.' Parr's deceptively artless 'snapshot' aesthetic, his hyper-real, saturated colours, his intrusive, voyeuristic stance, have galvanised public attention and divided opinion. Some, such as fashion designer Agnès B., praise his pictures for the 'admiration' they show their subjects.[2] For photography critic Colin Jacobson, on the other hand, he is a 'gratuitously cruel social critic who has made large amounts of money by sneering at the foibles and pretensions of other people'.[3]

Certainly, Parr's excursions rarely make for comfortable viewing. In collections such as The Last Resort (1986), The Cost of Living (1989) and Small World (1995), he offers a consistently unsparing take on the modern malaise. Where a photographer like Cartier-Bresson instinctively sought the good in people, producing dignified, celebratory images of everyday life, Parr rubs the viewer's nose in squalor, tackiness, affectation and monotony. In Cartier-Bresson's France, published in 1970, there is a full-page, black-and-white picture of an attractive young couple in a furniture store, discussing some seating. They are stylish, informed consumers, photographed from slightly below in a way that confers dignity and presence, captured at the decisive moment when their pointing arms form a compositional echo with the concave seat. When Parr tackled a similar subject at Ikea, in The Cost of Living, the effect was anything but ennobling. A woman

holds a catalogue in front of her face, possibly to shield it from the camera; it displays the legend: '£9'. Her partner, gazing down at something unseen, points vaguely in the direction of the photographer – why isn't clear. Another man, clad in a tasteless, illustrated T-shirt, slumps in a chair, head back, nose in the air. Both men wear shorts, which jar incongruously with the setting. At first sight, the image is as random as a snapshot. The pictorial shapes are ugly, the mood torpid. The picture speaks not of the heroism of daily life, but of its banality: the boredom of plenty.

In Britain, social class remains the touchiest of subjects and Parr has been accused of judging others by his own middle-class standards of behaviour and taste. When we begin our interview, at his five-storey Georgian house in Bristol, he brings up class straight away. 'I'm so middle class, it's unbelievable,' he says. 'My father was a civil servant. I was brought up in middle-class Surrey. That's it – it's a perfect middle-class pedigree.' Now in his late forties, Parr has the face of a school teacher or – yes – a civil servant: thin-lipped but affable, not cold or unfeeling but dispassionate. Detached. His mild, unrevealing expression can be studied in his little book *Autoportrait*, which collects pictures of him taken by photographers in photo studios in places like Beijing and Benidorm, Dhaka and Rimini.

Autoportrait is not the first time Parr has turned the camera on himself, but it confirms the degree to which he sees himself as implicated in his own work. The crucial difference between Parr and many of his Magnum colleagues is that, while they journey to remote societies to bear witness to starvation, strife, disease and death – subjects for which a stricken, humanist eye is probably the only sensitive response – Parr prefers to level his lens at us. He photographs middle-class consumers because he, too, is a middle-class consumer; he documents tourism because he, like us, sits obediently on planes, stays in bland hotels that could be anywhere, and visits one tourist attraction after another with the restless, escape-seeking hordes. 'You can look through your colour supplement at the weekend,' he says, 'and see black-and-white pictures of famine and you know, quite safely, that although it's going on and you should feel bad about it, it's not directly to do with your life. I'm interested in reflecting the lives, ideas and concerns of the people looking at the photograph – normally the middle-class reader or viewer.'

Parr's pictures function so incisively as social criticism precisely because his own complicity is a given. In the Gambia, travelling in the back of a Jeep, he photographs five boys running along the dusty track after the vehicle, in a futile effort to catch up. A white girl gazes back at them, amused by the spectacle, while another tourist raises his camera to snap the scene unfolding within the metal frame of the Jeep's back window. This is

held by an African – possibly a tour guide – as though he were making the picturesque view available to the westerners, which in a sense he is. We can afford to pay for this kind of pleasure, the photograph suggests, and it might even benefit the local economy, but the voyeurism and objectification leave a nasty taste, and many other tourism pictures by Parr return to this theme.

It's hard not to conclude from Parr's ludicrous, logo-bedecked sightseers, his acquisitive sale-goers and wine guzzlers, his hatchet-faced garden party guests and endless shots of other image-hunters wielding cameras with lenses the size of bazookas that he takes a dim, if not thoroughly damning, view of his own kind. No, says Parr, the pictures are 'partly therapeutic': exploring these subjects is a way of assuaging his middle-class guilt for living so well. 'In the end, I do like people,' he says. 'I'm a very sociable, garrulous, gregarious person. I'm certainly not a misanthrope. But, of course, inevitably there is a cynical element in my work about some of the people and the situations they get themselves into. But I'm not necessarily blaming them so much as blaming all of us. We're all guilty. We're all part of the problem.' His aim as a photographer, he explains, is to express and articulate the problems of our wealth.

This mission doesn't prevent Parr from taking a relaxed view of the way in which his own wealth is earned. Like many working in the arts today, he sees no necessary division or line between artistic and editorial projects, and commercial and advertising commissions. His provocative images have adorned ads for Fiat finance, Pepe jeans, and Barclays bank, and he has undertaken fashion work for Amica magazine in Milan, Citizen K in Paris, and the New York Times. 'Clearly, if the line becomes vaguer, I'm a beneficiary because I get very well paid when I do advertising work,' he says. 'It's the only reason I do it because I'm not interested in promoting anyone else's agenda. So, yes, in a sense I'm prostituting my talents by taking on work for huge multinationals, or even for smaller companies.' Parr has received fierce criticism for allowing pictures made for other purposes to be re-used in commercial settings. He accepts the reproof and is more careful now. Where he differs from some contemporary apologists of commerce-as-art is in his assessment of the work's ultimate value. Images expressing a client's needs are bound to be compromised, in his view, and none of his fashion shots will be shown in his 2002 retrospective at the Barbican Gallery, London.

Until the mid-1990s, most of Parr's pictures were taken using a 6 × 7cm camera and daylight flash. The wide-angle format was suited to complex groups and social interactions, sometimes involving many individuals, but he had a knack for getting in close to his subjects, often achieving a leeringly intrusive intimacy. In the 1970s, he worked in black and white – the pictures are both quirky and lyrical – but switched to

colour in the early 1980s under the joint influence of art photography (*William Eggleston's Guide*) and popular culture (postcards by the British photographer John Hinde). Parr's recent work elaborates both tendencies. Today, he looks less like a photojournalist than an artist, and this might explain why early supporters in the first camp disapprove of his later pictures. It is the technique that has changed, though, not his core concerns. By using a Nikon 35mm camera, with macro lens, Parr can bore down into his subjects. The lighting and colour, achieved with ring flash and slow film, endow these startling close-ups with radioactive intensity.

Common Sense, published in 1999, is the high point. At first the book looks bright, upbeat, cheerful, but the longer one lingers over this 'catalogue of flotsam and jetsam of the wealthy world', as Parr calls it, the darker it seems: hands, rings, watches, bracelets, cigarettes, sticking plaster, dirty fingernails, chipped nail polish, hair, sausages, frankfurters, sun-broiled bodies, cake decorations stuck in a quagmire of icing, pink sugary confections with faces like pigs, a wasp gorging itself on a mound of jelly, shrink-wrapped plastic toys, plates of cold meat, and blow-up dolls. Saccharine, synthetic, garish, glutinous, purulent, obscene – Parr's sensory impressions, 'common' or not, indict a realm of toxic artificiality and convey the disgust of gratified desire. The more brutally he dismembers and amplifies his experiences – *Common Sense* opens with a shot of 'volume' and 'tempo' controls – the more extreme and subjective his pictures become.

'Photography is an interpretation,' says Parr, 'so if you want to have a clear message, although you want to retain its ambiguity, you've got to shout it across. This was a case of shouting.' The book has no text, not even a cover blurb, and Parr, as with all his projects, sequenced the full-bleed, landscape images himself. One critic noted the 'incipient despair' in work such as this,[4] but his follow-up, *Think of England* (2000), is lighter in mood – though, oddly, even more ambiguous – and Parr himself, probably rightly, rates it a lesser book.

Parr is disarmingly honest in interview. He has been accused of becoming part of the malaise he set out to document and he uses strikingly similar language to describe his commercial work. 'By doing it,' he admits, 'I become part of the disease, too.' Later, he announces: 'Most of my photography is probably behind me, rather than in front of me.' Perhaps he senses, though he doesn't say it, that he has exhausted trademark subjects such as the seaside and the country village. In recent years, the boredom implicit in so many of his images has become an explicit and recurrent theme. In the catalogue *Bored Couples*, for a show in Paris in 1993, Parr included a picture of himself looking glum at a café table. His book *Boring Postcards*, based on transcendently

unexciting postcards from his own collection, sold well and he has produced two more volumes – one American, one German. Another project, in spring 2000, took him on an eccentric pilgrimage to Boring, Oregon (pop. 3,000) where, in 468 deliberately dull pictures taken with a compact camera, he itemised everything he found: an entire town as metaphor for a state of mind.

Boredom's fascination for Parr lies in the familiar paradox. 'We're fighting boredom by trying to employ these things [to entertain us],' he says, 'but inevitably we do get bored. However interesting our lives become, however much information and media we have available, people are always going to become bored.' Ennui is the existential corollary of excess – or perhaps it's the other way round. The psychotherapist Adam Phillips, writing about boredom, discusses the case of an eight-year-old boy who was hugely greedy yet somehow always bored. Phillips concludes: 'For this desolate child greed was a form of self-cure for a malign boredom that continually placed him on the threshold of an emptiness, a lack, that he couldn't bear.'[5]

The disquieting aspect of Parr's pictures, the quality that incenses old-school humanists, and depresses those who still believe that photography might be used as an active agent for change, is that he so viscerally pinpoints this mood of unbearable emptiness – this lack. Are the wealthy western consumers he shows – in admiration, or anger, or both – living in the best of all possible worlds? Given the human capacity for disenchantment, for freely choosing not to do the right thing, would it make that much difference if we were? The viewer must decide. Parr's work is simultaneously opportunistic, trading on a vibrant populist aesthetic, and subversive, challenging the norms and values of cosy, colour-supplement representation. He readily agrees that his pictures are voyeuristic, but argues that this is the nature of photography, whether his colleagues admit it or not. 'My conscience is relatively clear,' he tells me. 'But not totally clear.'

Inside the blue whale

Before I went to Bluewater, if someone had asked me what I thought about the idea of it, my answer would have spoken volumes to an impartial observer – a sociologist, say, or the kind of market researcher that Bluewater might commission – about my background, expectations and prejudices. I hesitate to add 'class' to the list only because in Britain the received wisdom, in the last ten or fifteen years, especially among the political classes, is that we are becoming a 'classless' society. True to type, without having seen Bluewater, I would have condemned the ultimate – and quite possibly the last – British shopping mall as a cynical, ecologically unsound cathedral of commerce; a vampire development sucking the life out of ailing high streets in nearby towns; a non-place as characterless and sterile as the contemporary airports it so much resembles.

Shopping malls, as the British social critic Paul Barker has observed, bring out the English vice of snobbery on both left and right. 'The attacks on the shamelessly populist designs of the shopping malls follow in the footsteps of the earlier onslaughts on 1920s surburban semis or 1930s super-cinemas, on 1950s TV aerials or 1980s satellite dishes. The motto often seems to be: Find out what those people are doing, and tell them to stop it.'[1] Ironically, though, what the middle classes find objectionable today, as a manifestation of vulgar working-class culture, they have a tendency to treat as 'heritage' a generation later. 'I await, with confidence,' concludes Barker, 'the first conservation-listed shopping mall.'[2]

The criticisms of Bluewater, after its opening in March 1999, followed this all too predictable path. *Blueprint* magazine's editor, for one, could not hide his disdain: 'Many millions of people will visit Bluewater this year. They will laugh and shop and eat and say they like it. They will be greeted as "guests" in the "welcome halls" and "groom" themselves in the loos and eat in the "break out areas". It would be patronising to tell them to stop it.'[3] But patronise Bluewater's millions he does (not that many will have subscriptions to *Blueprint*). 'What kind of people are so scared of rain or cold, so lazy that they can't walk up hills, so frightened of alleyways or a darkening sky?' he demands to

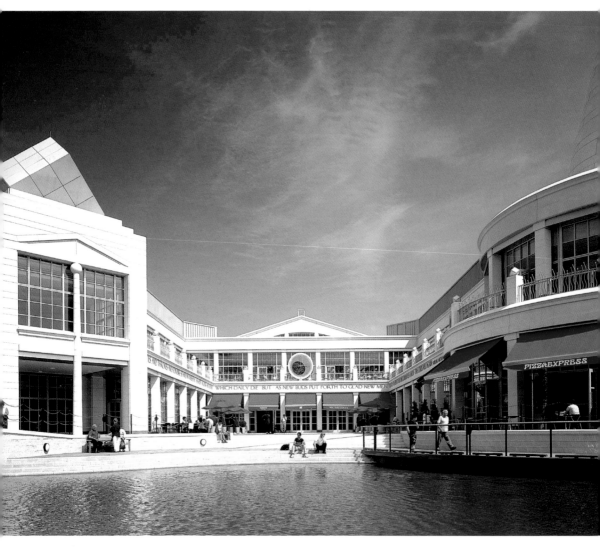

West Village,
Bluewater shopping
mall, Kent, 1999

know. 'Catering for them only reinforces their paranoia and threatens to destroy the rituals of real town centre shopping.'[4] Another of *Blueprint*'s writers, finding a shop interior she can bring herself to recommend among the hundreds of retail units, scoffs at the shoppers' unseemly behaviour. 'You almost feel that the whole shop could be slid out of its hole and driven away if the company ever changed its mind about Bluewater. Which given that the clientele have taken to standing and clapping every time the drawbridge is opened or closed, might not be a bad idea.'[5]

The tone of these dismissals made me more intrigued by Bluewater than I might otherwise have been. I found myself wanting to test my own preconceptions with a visit. These writers sound determined not to be impressed, as a matter of principle, and the intellectual position behind their criticisms – other than snobbery – is unclear. What are these cherishable rituals of town centre shopping? What's so wrong with clapping if you enjoy a special effect? The writer takes Bluewater's shop designs to task for not being adventurous enough, but seems to regard the fashion shop she does admire as being almost too good for its non-metropolitan clientele, who fail to respond to its design values with the right degree of sophistication and restraint.

Bluewater is eighteen miles east of central London, a mile or so from the River Thames, in Greenhithe in the county of Kent. Among Bluewater visitors, I belong to an underclass. The mall, a destination conceived for drivers, like all such developments, has 13,000 parking spaces, but I don't drive a car (or want one). I take the 45-minute train journey from London to a tiny station where the railway signs now say 'Greenhithe for Bluewater'. It's Friday morning and a regular shuttle bus transports me and a few other carless shoppers – mainly young women – to the nearby mall.

The despoiler of high streets lies, half-hidden, in a reclaimed quarry surrounded by chalk cliffs. From the outside, Bluewater is a jumble of grey forms, sprawling low and flat in the landscape, largely undistinguished except for the angled ventilation cones on its roof, shaped like Kent's oast houses, which give it the look of an aerial tracking station. I wander along the side, cross the boardwalk over a lake (one of seven), and enter the Wintergarden, a glass and steel canopy inspired, we are told, by the Palm House at Kew, and said to be the largest greenhouse built in Britain in the twentieth century. Pathways meander between the trees and restaurant seating areas. It's like being in the atrium of a tropical hotel.

The two-storey building's plan is triangular. Each side is a distinct zone with its own theme, design style, atmosphere and type of store. The Wintergarden leads to the Rose Gallery (typical high street shops) and, depending on which way you turn, this eventually takes you to the Guildhall (glitzy fashion labels, designer homewares), or

the longer, gently curved Thames Walk (toys, sports, games, street fashion). These sectors also have their own recreational spaces and eating areas, which spring from the sides of the triangle. A shop-lined passage, modelled on London's Burlington Arcade, connects the Guildhall to the Village, and the Thames Walk is served by the livelier, club-like Water Circus. At each corner of the triangle there is a domed entrance, also themed, to one of Bluewater's three 'anchor' stores – John Lewis, Marks & Spencer and House of Fraser – the dependable retailers of middle-class Britain.

Early research by Lend Lease, the Australian owners of Bluewater, showed that nine million people live within an hour's drive of the site, and they are among Britain's wealthiest consumers, with an annual expenditure 32 per cent higher than the national average. Four out of five fall into the A, B, or C socio-economic groups used by marketers. Over 72 per cent of these homes are owner-occupied and have access to a car.[6] Further research, in the form of a questionnaire, led to the division of this catchment into seven 'clusters', accounting for almost five million people. These categories were given names to reflect their lifestyle characteristics. Highest in spending power, and therefore of greatest interest to Bluewater's developers, were the 'County Classics' (wealthy, usually married, wide interests, concerned with home, entertaining, family and quality); the 'Club Executives' (successful, married, quality-conscious, like to be in control, prepared to pay extra for convenience); and the 'Young Fashionables' (single, early twenties, image-conscious, brand-oriented, active).

All three groups preferred to do 'serious' shopping in central London. To convince them to choose Bluewater, it would have to match the experience, quality and range of retailing in London's smartest shopping areas. The mall visionaries pursued this goal with a vengeance, attracting 72 stores from Covent Garden and 58 from King's Road, many of them agreeing to venture out of London for the first time. Camper, the Spanish shoe company, had just a handful of stores in some of the capital's snootiest addresses (Brompton Road, Knightsbridge and Bond Street). Others prepared to dip their toes into Bluewater included Calvin Klein, Diesel, French Connection, and Muji, the 'no brand' minimalist home store. Three hundred and twenty shops now occupy 1.6 million square feet of retailing space.

Bluewater promised these status-conscious outfits that they would rub shoulders with similar establishments. It painted a seductive picture of a 'retail experience' that went far beyond the usual perceptions of even the most successful British malls. Special attention would be paid to 'sensory factors' such as surfaces, materials and air quality. Creating a sense of welcome was vital. The need for safety, expressed by many potential customers during research, would be a matter of overriding concern realised in every

design detail. The toilets, often hidden away down long, threatening corridors, would be situated in the welcome halls, where customers would enter directly from the adjacent car parks, and these halls would have the aspect of hotel lobbies, with a concierge on hand to help guests, and coffee bars, where people could pause to get their bearings.

The architect charged with developing these concepts is an American, Eric Kuhne.[7] Even critics who abhor Bluewater gush with enthusiasm at his 'charm', 'erudition', 'educated manner', and skills as a speaker. Kuhne visualises the project in the grandest of terms. 'We've really designed a city rather than a retail destination,' he says.[8]

This is fighting talk to those who take the view that the last word to use to describe a place like Bluewater is 'civic'. But if one of things we value in real outdoor city spaces is the possibility for people to meet, converse, interact, pass the time, and enjoy a shared public life, then Bluewater offers pleasures and satisfactions that the mall's more hostile commentators have been reluctant to concede. For a commercial space, it's prodigiously supplied with non-paying seats not connected to cafés, many of them comfortable leather armchairs. Soon after I arrive, I pass three women in their sixties, one wearing a knee bandage, talking about a friend's swollen ankles. It's unlikely they belong to Bluewater's favoured socio-economic clusters and they don't seem to have bought much. This is not a place you pass through, however, on the way to somewhere else, so they probably came on the bus just to be here with their friends and relax. I'm struck by how few people carry shopping, though the day is still young. Bluewater has forty or more places to eat, from upmarket French cuisine to sushi on a conveyor belt, but, at lunch time, I notice a young woman settle down in a leather chair, place her lunch box on a side table, and unwrap a home-made sandwich.

Of course, all this attention to sensory factors and quality of experience is not motivated by altruism. Bluewater is a machine for making money and these are the lubricants that increase its efficiency. The parkland outside is there to help visitors 'recharge their batteries', explains the celebratory Bluewater book, *Vision to Reality* (a sign in itself of the mall's ambition). The unstated hope is clearly that, rather than flopping into the car and driving home, the recharged shopper will return to the aisles with a spring in his or her stride and credit cards at the ready. The book half-expects our disapproval and makes a brief attempt to brush it off: 'To say, as some inevitably would, that there was something underhand about this would be tantamount to writing off every piece of design-for-profit that had ever been built or produced. The environments were intended to seduce, and in that way, Bluewater was no different from a designer dress or a piece of exclusive furniture.'[9] This is a painfully thin defence of consumerism,

but it has a point. If the aim is to sell good design, and this is acceptable in luxury design shops in London, aimed at the trendy, loft-dwelling classes, why is it unacceptable ('sinister' according to *Blueprint*) for such things to be made available to a much wider public outside London, in the suburbs?

Class may not be a word that British politicians like to use these days – it suggests inequality and unresolved struggle – but it remains a significant factor in British society. Ordinary people clearly think so. A Mori survey in 1991 showed that nearly four in five believe that the country 'has too many barriers based on social class'. A Gallup poll in 1995 indicated that 85 per cent subscribe to the existence of an underclass. Britain's classless society is a myth, argues a widely acclaimed indictment of our social structure by political journalists Andrew Adonis and Stephen Pollard.[10] We might not like to admit it, but we are all experts at reading the signals and giveaways of class. 'Accents, houses, cars, schools, sports, food, fashion, drink, smoking, supermarkets, soap operas, holiday destinations, even training shoes: virtually everything in life is graded with subtle or unsubtle class tags attached,' they write.[11] But these signals are becoming increasingly scrambled. You can buy cappuccinos as well as baked beans on toast in a motorway service station. Social mobility abounds and almost everyone is better off today, even if the gap between the top and the bottom of the income scale grows apace. As the authors explain, 'most of the "working class" – meaning manual workers – leads what even a generation ago would have been considered a middle-class consumer lifestyle.'[12]

Bluewater shows just how far this process has come. It offers an experience that many of its visitors would not, or could not easily have had before it arrived in their midst. It recognises the consumer behaviour of different social classes within its many zones, but this multiplicity, the sense of things to discover, encourages people to wander and explore, and they do. Drinking coffee in the Mise en Place café in the Village – its dark wood cabinet windows clearly conceived with the middle-class 'County Classics' in mind – I watch a couple arrive with their daughter, no older than four. The man has cropped hair, tattooed biceps, a beer belly, combat trousers and boots. His keys hang from a belt loop. They have come to take the little girl to a film. She is bored, restless and has to be encouraged into an armchair. 'You want to go the pictures?' the man says gently. 'Well, sit down.' He pushes the chair towards the table. He is not entirely at ease and you can tell this isn't the kind of place he would usually frequent. 'There are rules and regulations,' he tells the little girl.

Yet Bluewater aspires to be something greater than a social melting pot in which all visitors are notionally equal in the sight of the pound. In Kuhne's imagination, it is

a 'city' and this is not only a matter of size and services, although a poster really does boast that Bluewater is 'Twice the size of Bath city centre' – that is, equal to one of our most beautiful, historic cities, and even *bigger*. In its attempt to relate itself to its environs, in its *faux* monuments and its elaborate literary programme, Bluewater strives to endow itself with nothing less than the trappings of civic meaning, as though these ordinarily gradual accretions to a city's fabric, the statues and inscriptions, could be willed into existence and achieve gravitas overnight.

Do visitors pay any attention to these decorations and texts? I saw no evidence that they do. The only person pausing to study the sculptures or read the epigrams was me. In the upper mall of the Thames Walk, verses in four-foot-high capitals about Old Father Thames rolling along to the mighty sea form a frieze that runs the length of the mall. It's impossible to read at a glance and few will walk the entire length for this purpose. In the Rose Gallery, lines waxing lyrical on creamy, dreamy roses, fresh as morning's birth are plonked on an I-beam under a monotonous trellis of artificial roses – easily the most impoverished of Bluewater's displays. At every turn archways and entablatures are adorned with words by Rudyard Kipling, Robert Graves, Laurie Lee, and other Kent writers. The Roman lettering is obviously intended to be monumental, but it is invariably overpowered by the loud typography and jangling colours of the shopfronts, an unwitting reminder of the triumph, everywhere, of commercial communication as the dominant form of public address. The hollowness of the literary sentiments, in this context, is underlined by the shoddiness of the appliqué lettering, which awkwardly straddles the cracks between the stone blocks.

In the Guildhall, Britain's 106 guilds – loriners, shipwrights, clerks and tallow chandlers – are represented by sculptures in niches. Again, the quality of craft and manufacture of these lumpish figures is poor. They look like relief carvings, but there are empty spaces behind them so you can see they are just flimsy mouldings. Far from dignifying visual art as a source of higher meaning, these devices reduce it to the level of visual Muzak, shallow and irrelevant. Any of the mall's stores will offer finer examples of design and workmanship.

This attempt to dress up the commercial machinery of Bluewater in a layer of culture and 'class' is patrician and patronising. It tries to pretend the mall is something other than it is, and then, having taken the cultural path, it loses its nerve, rather than commissioning real artists to create unexpected and challenging experiences. Culture is treated as a Linus blanket, to coddle the visitor, and the arts are demoted to empty decor. I doubt consumers are taken in by these cultural pretensions, though. They almost certainly don't care. While the art might contribute vaguely to the ambience, the primary

features of the interior design – the use of timber, limestone and leather, the ornamental balustrades, the lamps like harbour buoys, the 'sails' hanging in the Thames Walk – carry more weight.

I came to Bluewater expecting to despise it. What I discovered is that while you can hate the idea of Bluewater, it's harder to hate the experience itself. In truth, it was easy to spend time there. Five hours passed quickly. It was kind to the senses, unexpectedly relaxing and I could have stayed longer. I didn't feel oppressed. If I lived closer to it, I would probably go again. Maybe this is its cleverness: it lulls and anaesthetises.

As Bluewater's critics inadvertently revealed, once the routine arguments about the economic and environmental damage caused by such a development have been stated, a convincing case against the place is hard to make – a case that would be persuasive to someone clutching bags of shopping after an enjoyable afternoon at the mall. What would you say? How would you convince the shopper he or she is wrong? For the cultural critic Bryan Appleyard, struggling with this dilemma, Bluewater encapsulates a moment of transition to what he calls a 'new order'. Appleyard rehearses the arguments of the traditionally-educated person – someone like himself – with a conception of human progress, values and ethics derived from Greco-Christian-Renaissance-Enlightenment culture. 'I could easily imagine the newspaper columns I could write deriding this place,' he notes. 'Its architecture, although fine and lovely, is depraved. The staff are robots. It pollutes. It glorifies the empty pleasures of consumption. Its superfluity is trivial . . . Its artificiality suppresses seriousness and depth.'[13] And yet, he concludes, he could not write such a column because his response is much less simple than that.

Right now, as I discovered, the arguments for and against Bluewater are *both* true. But when we complete the transition to the new order of abundance it represents, suggests Appleyard, the case against it will cease to make sense. As he notes, our values were formed by historical conditions of scarcity. The new conditions of plenty make those values not just redundant, but also incomprehensible to most. For many visitors, Bluewater is as luxurious as it gets, spectacular local evidence that prosperity is growing and twenty-first-century living is good. So, once again, as the shopper loads his bounty into the car – what exactly is our objection? Appleyard puts it this way: 'If 2,500 years of intellectual and physical struggle were not meant to achieve this, what were they meant to achieve?'[14]

But again, this is too simple. The struggle isn't over. Bluewater, despite its police station, multiplex cinema and bus garage, is not a town. It's a controlled, private space. The lower-class Ds and Es – to use the marketing lingo – can turn up if they like, but

with much less cash in their pockets and few aspirations to upward mobility, they are not part of the plan, and they had better not step out of line. No drunks and crazy people here, thank you. No beggars. No street musicians. No gangs. No protesters. No disorderliness of any kind. No wonder we fall for Bluewater. It offers a secure, tidy, Pleasantville vision of utopia – but only for some. To let yourself be lulled by it is to collude with the politicians' rhetoric of classlessness, to forget the ideal of social justice, to pretend that the old class tensions between the haves and the have-nots no longer exist in Britain, and, having blanked this underclass out of the scene, to abandon them to the town centres we no longer care to visit.

It may be that no more malls will be built in Britain. Many of the public say they prefer them, but government policy has changed and planning permission is being withheld.[15] Perhaps the country will set about regenerating its high streets at last. Many are degraded spaces. Blighted by long-term neglect, ravaged by the car, they offer little to compete with the safe, weather-free, indoor cornucopia of a place like Bluewater. But there is minimal evidence to suggest that we have the political determination, the public vision, or the public money to reinvent the civic, and appropriate retail design's understanding of sensory experience for the non-commercial public realm. Our vehicles have helped to corrode our townscape; so doing further damage, we drive somewhere else, where the cars are at least kept at the door. If declining town centres are to reawaken, it will be by embracing the new order and becoming surrogate malls.

Prozac for the ear

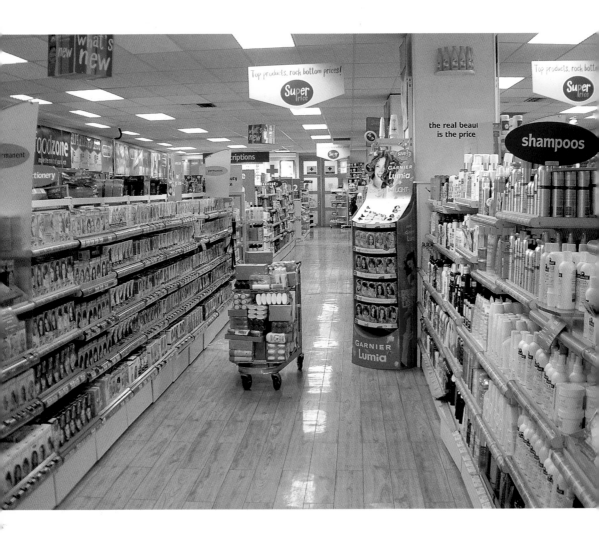

Muzak has always had an image problem. For its critics, it takes something vital, passionate, infinite in its variety – music – and masticates it until the mildest grit-free sonic paste remains: Muzak! The problem is immediately obvious in the term 'background music'. This is music that is there, but not there; music by numbers; music to soften the edges, smooth away the differences and fill the air with bland uniformity. Muzak became a generic term, like vaseline or kleenex, but while this was a measure of the functional success of the idea, it wasn't a compliment. Muzak came to mean music that was surplus to requirement, music you could happily live without.

Then something changed. There are still those who rail against the idea of 'canned' music in public places and demand the right to shop or eat or work without a soundtrack. But they are fighting a losing battle. In the 1980s, the Muzak corporation's long-held distinction between instrumental background music and vocal 'foreground music' – supposedly a no-no – collapsed. In the right circumstances, almost any kind of music could be played as background accompaniment to other activities, and this is what most of us were already doing at home, in our cars, or jogging in the park wearing a Walkman.

Superdrug, central
London, 2001.
Photography:
Anne Odling-Smee

Little by little the idea of background music even started to become hip. In 1978, revisiting composer Erik Satie's idea of 'furniture music', Brian Eno released *Music for Airports*, a new kind of ambient music (as Eno dubbed it) intended to be as 'ignorable as it is interesting'. In the years since then, every genre of easy-listening has been rediscovered, from the suave melodies of the cocktail lounge to the electro-doodling of space-age bachelor pad music. Joseph Lanza's book *Elevator Music*, published in 1994, has no time for the dystopian warnings of social critics like Aldous Huxley who, in *Brave New World*, pictured a soulless future society in which 'The air was continuously alive with gay synthetic melodies'.[1] For Lanza, this is all to the good. 'Elevator music,' he writes, '(besides just being good music) is essentially a distillation of the happiness that modern technology has promised. A world without elevator music would be much grimmer than its detractors . . . could ever realise.'[2]

Which is encouraging news for the new-look Muzak. 'Business music' replaced background music as its calling card some time ago, and these days there is a lifestyle-friendly sounding 'audio architecture' division at its Seattle headquarters. In a determined bid to look contemporary, a new 'm' logo in a circle, created by San Francisco design firm Pentagram, was introduced in 1998. For an American institution that is nearly seventy years old, Muzak was slow to spread the gospel overseas, but that was finally rectified in 1996 by establishing a corporate base in Hilversum, in the Netherlands, responsible for programming six music channels beamed out to 5,000

European sites by a satellite 26,000 miles above North Africa (the US has 60 channels reaching a quarter of a million businesses).

In the 1940s, Muzak presented its service as a quasi-scientific productivity tool designed to lubricate the capitalist economy. Using its 'stimulus progression' programme, it was claimed, stress would be reduced, concentration enhanced, morale improved, and, as a result, output would increase; lower costs meant higher profits. In Europe, in the 1990s, Muzak's focus is less on the site of production (music in the workplace never took hold to the degree that it did in the US) than on the point of consumption – shops, bars, restaurants and fitness centres – but the motivating effect is much the same. 'We can provide a level of comfort,' explains Michael Clark, managing director of Muzak UK, based in Chesterfield. 'We can provide a relaxing, identifiable, easy-to-slip-into environment. People might want to apply that in a retail situation where there's stress.'

Muzak UK's promotional literature promises subscribers 'Music – with YOU in control'. The 'you' mentioned here isn't the people who will actually hear the music – customers and staff – it's the owners of the business. Once the Muzak antenna and solid-state receiver have been connected to an amplifier or mixer, the client can play Muzak round the clock; no one on site has any control over it at all. A bar might begin the day with the Easy Listening channel from 9 to 11am, liven things up with some Classic Pop from the Bee Gees, Simon and Garfunkel, and R.E.M. over lunch, unwind with Soul Time from 2 to 6pm, before quickening the pace again with the Pop Dance channel from 6 to 11pm. More sedate establishments might opt for Classical & Solo, or the Environmental channel – no-vocal covers of pop classics that come closest to the original Muzak concept (demand is apparently limited).

Six programmers based in Hilversum scour the music magazines, study the charts, then strip down and analyse tracks in the most functional terms. A computer database is used to flag qualities such as beats per minute, style, chart position, emotional content, political content, and the age group to which a track will appeal. The database then determines the channel (or channels) for which it is best suited. Each channel has a playlist of as many as 3,000 tracks at any one time and play frequencies are carefully determined. Tracks are selected and sequenced to have a precisely calculated effect on the listener's mood.

It sounds manipulative, and it is. 'A lot,' agrees Michael Clark. 'What is retailing, other than manipulative? We don't package things by accident, do we? We are a retail organisation. We are here to manipulate people. We're here to help McDonald's sell burgers, to help Next sell dresses.'

In Superdrug, a large pharmacy on London's bustling Oxford Street, Muzak is pumped in through circular speakers in the ceiling tiles. It's part of the retail chain's standard 'plant', along with lighting, air conditioning and fire detectors. By the sound of it, we're currently listening to Pop Dance. At intervals the monophonic music channel cuts out and specially made in-store advertising cuts in, seamlessly programmed into the mix. Advertisers such as Gillette, L'Oréal, Maybelline and Diet Coke are queuing up to buy spots on Muzak UK's two advertising channels. Up to eight ads an hour are broadcast.

As Clark explains it, Muzak works by slicing horizontally across market sectors. A fashion store has more in common with a bar than it has with a supermarket. A young woman goes to buy a top that she plans to wear on Friday night, so the store evokes the right associations and atmosphere by using the kind of music she would hear in a club. Retail and leisure have merged. Clark describes another client, a chain of fitness centres: 'It's not a gym anymore. It's a disco with exercise bikes. This place is sumptuous. It's got disco lighting and big-screen TVs. It's got our music throbbing away. Everyone's wearing designer clothes. It's retailing a leisure lifestyle.'

Advertising has long made use of the history of pop music to sell its products. As the cultural critic Jon Savage remarked in 1988, 'pop's assimilation into the colonising thrust of the multinational media industry marks the end of consumption as a democratic project . . . most pop music today is either explicitly or implicitly selling something.'[13] We have grown accustomed to hearing a song we have enjoyed as a source of private meaning in the narrative of our lives return – sometimes rewritten – as the soundtrack to a TV commercial that means nothing to us and permanently damages our image of the song by grafting it to something banal. Any record was always in part a commodity; with this second purely commercial use, in advertising or Muzak, it is treated *only* as a commodity.

Muzak undoubtedly works. It's a kind of Prozac for the ear. It trades on our associations, reflexes, emotions and memories, and the sales shoot up. Soothed by its ubiquitous 'sensurround' comforts, directed by its irresistible beat, we are slowly forgetting that one of the factors that gave music its extraordinary pleasure and meaning, for the consumer of recorded sound, was deciding for yourself what to hear.

The medium of emergent desire

And yet ganseys almost passed into oblivion: the English industrial revolution swept away practically every inland hand knitting tradition, but the network of traditional fishing patterns was spared this fate because of the poverty and isolated location of most fishing villages. The English ganseys travelled far overseas with their wearers, so that fishermen's jerseys were also introduced to the Dutch.

The comfortable English fishermen's gansey replaced the wide hand-woven linen workman's smock with its freedom of movement, and Dutch fishermen's ganseys were clearly inspired by the English. Unfortunately this Dutch version of the fisherman's gansey had a brief heyday and was almost entirely extinct after WW2. It's interesting to note that the history of each fisherman's jersey pattern is different, inter-connected as it is with the history of the village's contacts, direct or indirect, with Irish, English or Scottish fishermen at sea.

As far as we now know, the first real contact was an emergency: around 1500 when Dutch whalers traded food for the ganseys worn by Shetland fishermen. The Dutch however wore the still famous beige shetland woollen jerseys as underwear and it was not until 1860, after many years of friendly contact with Shetland fishermen, that jerseys started being worn as outerwear along the Dutch coast.

The fishermen from the village of Pernis were the first Dutch fishermen who came into contact with English fishermen after around 1700, and this is reflected in the Pernis jersey, clearly based on the smock-like English gansey with its easily-recognisable gathered bib, and complex patterns. The patterns, which demanded skilled knitters, stayed alive in Pernis, unlike in other Dutch fishing villages, where the original patterns were simplified.

Because a fisherman's jersey was highly individual, it had enormous emotional value. Dutch fishermen's wives relate how they knitted different patterns into the front and back, so that their menfolk could read the patterns like Braille and would not mistake the front and back in the dark. The patterns were often full of old symbols and often included a *motif* (also known to the Incas) called 'God's eye', designed to protect the wearer from evil. The jerseys also served as a passport in the event of seamen going missing or drowning; a fishermen could still be identified by his jersey months after his death, and his remains could be taken back to the right port. A moving story from an old fisherman's wife in Urk, formerly on the Zuider Zee, illustrates how the women consciously gave their men's jerseys a hidden identity by knitting an extra symbol or initials into the pattern. A fisher woman would leave her door open day and night for months after a fisherman went missing; if he returned he must not find the door closed. When the sunken boat was found, the jerseys were taken back to Urk, where the women could identify their loved ones according to their jerseys. Once a woman knew all hope was gone, she would close her door and bury - not the remains of her dead son or husband - but the hand-knitted jersey in her back garden.

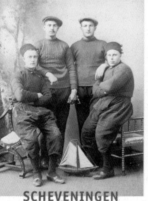

SCHEVENINGEN
URK

PERNIS

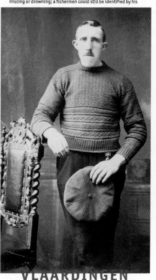

VLAARDINGEN

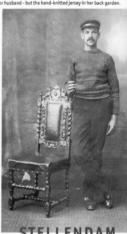

STELLENDAM

Lidewij Edelkoort and Anthon Beeke's colour-forecasting magazine, published twice a year in Paris since its launch in October 1992, is a venture of outsized proportions and equally lavish ambition. Aimed at anyone who uses colour in design, architecture, fashion, horticulture, leisure, or cosmetics, _View on Colour_ carries no advertising among its 160 pages and makes up for its casual approach to commerce with a cover price of £40 that is nothing if not optimistic. 'For me,' explains Edelkoort, 'it is the adventure of my life. It's where I can be really free.' Her partner confirms the personal nature of the project. 'I do it for myself,' says Beeke. 'I'm the first client of the magazine.'

View on Colour, like Benetton's _Colors,_ is a magazine that puts its imagery first. 'The text is the illustration,' says Edelkoort, 'and the illustration is the text.' And while the colour is as lustrous as you would expect, the imagery Edelkoort and Beeke create to carry it holds attention by its constant capacity to break with convention and surprise. In a stunning opening sequence in the third issue, a stained blouse, plucked teddy bear, rusty sardine-can lid, artist's paint-splashed jeans, and smoke-blackened primate skull adumbrate the issue's theme of 'decay'. In another story, a brief text on multicultural enhancements to 'skin tone' products, from crayons to lingerie, introduces pages of underwear shot in warm freckly close-ups that couldn't be further in style and mood from icy retouched supermodel perfection. Elsewhere, models kitted out in camel-coloured Jil Sander jackets and trousers by Helmut Lang don Joe Camel-like heads, tails and cloven feet to lampoon the fashion system.

Edelkoort is a trend-forecaster of international renown. She has been described by mystified observers as a psychic and prophet, but modestly settles for the label of 'medium' or 'receptor'. When she gazes into the future and reports her oracular insights into what consumers everywhere will be looking at, thinking about and longing to buy two years or more from today, all kinds of manufacturers – from cars to cosmetics – sit up and take note. Edelkoort studied fashion at the academy of art in Arnhem, but even then she was more interested in consultancy than in a career in design. 'When I was a designer,' she once explained, 'I always tended to be a little too far ahead of the market.' She moved to Paris at the age of twenty-five and for ten years created award-winning audiovisual installations for the textile fair Première Vision.

These days, Edelkoort's companies, Trend Union and Studio Edelkoort, are based in a converted factory in Paris's 14th arrondissement. Trend Union's forecasters, an alliance of ten professionals with their own studios, monitor consumer habits and research seasonal 'trend books' pieced together from photographs, newspaper clippings, swatches of fabric, yarns, threads, plastics and metals. Six different books, in editions of 200 or more, are sold bi-annually through an agent, to the likes of Mercedes-

Benz and L'Oréal. If Trend Union generalises for the market as a whole, then Studio Edelkoort's eight-strong Paris team personalises the process by analysing product lines, profiling target audiences, and crafting audiovisual research presentations for Philips, Nissan, Estée Lauder, Dupont, and other clients. The week I met Edelkoort she was in London talking to Marks & Spencer about all areas of its retail activity. At her hotel in ritzy Knightsbridge, Edelkoort – clad in a long black jacket, hair swept back from her face – holds court in her room, a fax machine close at hand, room service constantly on tap.

The forecasting business is notoriously intuitive. Forecasters work too far in advance of the market to offer the client any hard and fast data beyond their own track records. If that sounds like a licence to 'prophesy' whatever they please with no fear of contradiction, Edelkoort and her colleagues are at pains to insist that their intuitions do not represent personal preferences or whims. 'There's no way I can influence [what will happen] because it is not about my own taste. It's not a creative process. You're like a sponge, an antenna. I'm picking up the early signals from the *Zeitgeist*. I could never pick up something which is not latent already.'

Edelkoort acts, in her own words, as a sort of 'super-consumer'. Her technique for exposing what Trend Union – in a mission statement worthy of the Bureau for Surrealist Research – calls the 'precognitive universe of emergent desire' is to monitor and analyse the hot spots of unexpected fascination, the colours, textures and shapes to which her own eye repeatedly returns and 'clings'. Aided by what seem to be exceptional powers of recall, Edelkoort applies her skills of pattern recognition to the complex web of impressions gleaned from an exhausting round of shopping, dining, travelling, reading and viewing.

'On a beach in South Africa, I found some shells and pebbles which had been polished into new shapes by the water,' she relates. 'I collected enough to put in my trend book and the word "polished" hit me as a new appearance for material.' Edelkoort's growing conviction that the near future would see a collective fashion defection from 'high shine' to polished surfaces was later reinforced in a meeting when a colleague displayed partly polished papers discovered on a research trip to India and another produced similiarly burnished fabrics found in Japan.

Colour was always part of Edelkoort's forecasting business, and as she proceeded she found she had a particular feeling for it. 'From the end of the 1980s, we recognised that colour had become a major selling force. You could make a wonderful product, but if you had the wrong colour – forget it. Colour was such a powerful language to the consumer, yet we had no tool to discuss it.'

Edelkoort and Beeke's initial plan was to produce a more philosophical journal, but they rejected this as requiring a greater degree of historical and scientific expertise than they could easily muster. *View on Colour* as finally published with a 'silent' third partner, David Shah, using their own money, keeps a much closer eye on the marketplace and takes on some of the function of a low-cost trend book. Their main audience is textile and clothing designers, car designers, and colour and style consultants in Germany, France, Japan, Italy and North America. But the unusual arrangement whereby a Cologne-based distributor buys most of their 11,500 print-run means the publishers themselves have no precise statistics about sales or readership.

Professional needs are addressed by *View on Colour*'s opening 'file', which sets out what its editors consider to be the key influences of the moment, and visual trend information is backed up by numbered Pantone references. Where the magazine differs significantly from a trend book is in the greater freedom of interpretation it allows. In a trend book, Edelkoort must describe everything she believes to be happening, including developments she may not personally favour. In the magazine, she can single out the lifestyles and tendencies she finds most attractive, though she still cannot fly in the face of a broader trend. 'I don't pretend to know exactly why a wave of colour suddenly comes over people, and then fades,' she admits. Through her interviews with designers such as Tadeo Ando, Issey Miyake and Romeo Gigli, she hopes to begin to find out.

Each issue has a theme: ecology, energy, decay, the body, the soil, tactility, monochromes, knitting. Edelkoort, in her capacity as forecaster, determines these directions and many of the accompanying visual concepts, while her fellow publisher and co-art director, Anthon Beeke, takes charge of *View on Colour*'s typography and graphic form. But even to an observer as close as the magazine's editor-in-chief, Lisa White, the 'symbiotic' partnership of two such strong creative forces is not so easy to disentangle. 'Li's very precise,' notes White. 'Anthon will pretend that he's not listening. But he is.' Beeke wryly confirms the contrast of styles: 'Li is always so serious. Everything she says is very serious, never doubting: "This is the direction!"' After the early content meetings in Paris and Amsterdam, pictures are commissioned by both Edelkoort and Beeke, and initial production, including the making of props and sets, begins at Edelkoort's studio, where they can call on her team's creative and technical skills. Design and layout is undertaken at Beeke's studio in Amsterdam.

For Beeke – best known for theatre posters that treat the body with a frankness that would be unthinkable outside ultra-liberal Amsterdam – *View on Colour* is a 'passion'. 'You don't do it to make a lot of money. You do it to have fun,' says the designer. 'What I like about this magazine is that we work in the future. It's a very abstract subject. There's

not much portfolio stuff. A lot of photographers like to work on the magazine because they know they will be as free as possible. Most of the time they work only for expenses, otherwise it would be impossible to do it.' After seven issues, he conceded that it might be time to take finances more firmly in hand and develop a business plan.

Beeke regards *View on Colour* as a chance to make his own statement about graphic design in a period when the 'rococo of form' spun so effortlessly by the computer – and the promise that anyone can spin it – has made the discipline highly fashionable. He expresses a positively unfashionable commitment to the idea of graphic design as a tool of social criticism – 'If it's possible, I will give my own vision' – and emphasises design's responsibility to speak clearly to its audiences: not to preach, or serve some spurious idea of 'universality', but to offer ordinary people a way into democratic discussion. 'You have to say something,' he says, 'and in design it's very easy to print a few colours or forms, and it looks beautiful, but it doesn't say anything. It's like if you speak with your mouth full of chewing gum. Nothing comes out. Maybe a few people have to be "boring" again for something new to happen in graphic design. Putting a text straight on the page is avant-garde now.'

In *View on Colour*, says Beeke, echoing Edelkoort, 'image is language and language is illustration'. To underline this reversal, his treatment of the sans-serif type in the early issues is simple and, as he puts it, 'generic'. In an essay on the 'colours of healing', it's not the letterforms, but the motorcade of toy cars fashioned from papier mâché and old Fujichrome boxes, the widescreen dance of jellyfish gliding through deep water in diaphanous skirts, and the page-filling daguerreotype of two reclining Rubenesque nudes that compel your attention. In later issues, though, the typography loosens up and is sometimes allowed to become its own illustration, as, for instance, in a discussion of colour's meaning in the mystical Islam of the Iranian Sufis, where the type dissolves into a series of tiny windows through which the lights of spiritual revelation appear to flicker and flash.

If there is a criticism to be made of *View on Colour*, it lies in a clash of functions – not so much in the reversal of text and image as in the inconsistency of tone in the writing itself. Reflecting its commercial origins, the magazine tries, a little uneasily, to have it both ways. It challenges professional expectations with a feature demanding to know 'Was Jesus black?' before switching into you'll-do-this fashion speak in shorter texts intended to promote next season's 'look'.

In a wider sense, Edelkoort herself is aware of the problem. Fashion, she tells me, is in a bad way. People are more complex than marketing wanted them to be. Her own stylistic preferences, she reports, have changed little over the years. 'The consumer is

going on strike,' she writes in one *View on Colour* editorial. 'It is as if he is saying, "Enough is enough. Cut out all the nonsense. I cannot cope with it anymore."' Describing herself as 'an angry young woman, even at 45', Edelkoort foresees a time when many will reject consumerism. 'This is one of the lifestyles we predict,' she says. 'Total minimalism, where you will make a sport out of doing the least.' Yet for all this, the magazine ran a celebratory picture-story on techno fashion's 'fresh, hard, graphic' street-level rejection of prêt-à-porter, which despite a 'Beware to counterfeiters' warning, will almost certainly be read in this trend-spotting context as an invitation for outsiders to muscle in on the 'completely new market' the kids have obligingly created for themselves.

In the future, notes Edelkoort, echoing the findings of other social studies, young people expect to work much less than her generation. But isn't there an irony here? We work to afford the products and services that forecasters such as Edelkoort inform their clients we will want. I am about to ask her where that leaves the forecaster, but, seeing the question coming – well, she would – Edelkoort cuts in. 'I'm actually paid now to say, "Stop doing things, do less and do it better, streamline your offer and give depth in variation within one product." The revolution in my job is that I'm not only doing new things. On the contrary, I'm hanging on to the things that work and trying to put production on a solid base, where we would spend much less money and have much more fun. I'm very aware of the problem of over-production. So I'm trying to fight it my own way.'

In every dream home

1. AN EYE FOR FINE THINGS Min Hogg's explanation of why the world needs *The World of Interiors* has the well-honed, confident, almost artless simplicity that comes from editing a magazine that remains, after two decades, the *ne plus ultra* of shelter publications. 'I think nice surroundings are incredibly important,' she says, 'whatever your interpretation of nice is. Nasty surroundings lead to nasty things, so you might as well have as nice as possible – and that's nothing to do with money, nothing.'

Min Hogg's interpretation of 'nice' in practice, in the fabulously unusual interiors she discovers, and in the assessments she and her writers make with a dauntingly urbane air of knowing exactly what is right, is rather more complex. 'Shades of Vermeer still hover over Dutch interiors,' notes a story about two New Yorkers who moved to Zutphen in the Netherlands, 'and in view of this David and Frank decided to shelve their preference for Scottish baronial and Jeffersonian, "Monticello" classicism in favour of a simple Nordic ambience.'

Elsewhere, a highly regarded but no longer living interior decorator receives a mild posthumous reproof. 'There remained some essentials of successful interiors which he never mastered,' his reviewer laments, 'such as how to arrange books, which he used frivolously as props. He had an awkward way with flowers, mixing chrysanthemums with old roses, and had a Dame Edna-ish penchant for gladioli; worst of all he ravaged hedgerows for rare wild flowers.'

Is the *faux pas* here the ravaging of fragile hedgerows or the trying-too-hard vulgarity of rare wild flowers? In what way is a simple Nordic ambience such an apt response to Vermeer's lingering hold on the Dutch interior? Where so many magazines talk down to readers, *The World of Interiors* assumes you will know the answers already or make the effort, by sticking with it, to find out. One might ask, of course, whether the finer intricacies of interior protocol are worth all the trouble. Do they ultimately matter; and, more to the point, for whom do they matter? Min Hogg's 'nice surroundings' sound so unassuming and modest compared to the bravura confections she showcases that you

*Wallpaper**, no. 1, 1996. Art direction: Herbert Winkler. Fashion stylist: Anne-Marie Curtis. Prop stylist: Michael Reynolds. Photography: Stewart Shining

wall paper*

*The stuff that surrounds you

sept | oct 1996

launch issue

urban

Modernists

£3.00 UK

ISSN 1364-4475

interiors * entertaining * travel

wonder whether her intention isn't, at least in part, to pre-empt complaint: who but a sourpuss could argue with 'nice'?

For Hogg herself, *WoI* has been an education. 'I wish I were more informed and cultivated,' she says. She had never edited anything before, though she was well established as a journalist, but she brought to the new magazine her hobby: a passion for houses, design, painting and the arts. 'I had an enormous mental backlog: this person, that house, this place . . . enormous. I've still got my first lists and I could go on and on and on.' Hogg's taste is voraciously eclectic. Some like only art nouveau or minimalism or classicism; Hogg likes them all. Every day, sitting at her desk in Vogue House, her eyes are bombarded by new sensations and from this avalanche of aesthetic possibilities she aims to select the best of their kind: a Dutch squat decorated with ornamental birds' nests, a dark Parisian apartment stalked by stuffed animals, a New York house recast as a shrine to American Gothic, an English schoolboy's neoclassical garden shed ('I couldn't resist him! And he was every bit as nice as I said he was!').

How does Hogg decide between one Italian castle and the next? 'Seat of the pants, really,' she confesses. 'I couldn't describe it, I couldn't . . . every now and then there's one that's got something else.' She won't – or genuinely can't – go any deeper into the 'something else' than this. 'I'm very instinctive . . . about anything. Show me twelve chairs and I know without the expert knowledge which is the best one: I just *know*. And how one osmoses that knowledge, don't ask me; certainly not from studying or school or professors, though I've had some good mentors in my life, like-minded people, before I had the job.'

Hogg's vast network of decorators, antique dealers and house owners ensures a limitless supply of leads. One contact generates another. 'They always have a friend with a bus shelter or a château, or a cleaner with a collection of old tins.' Readers send in descriptions of houses in Kuala Lumpur seen while parking the car. Hogg doesn't visit these recommendations: she gets someone else to take the test shots on which her decision will be based. If she doesn't wish to proceed (and prepare for disappointment, she probably won't) hearing the news from the original contact softens the blow. But what makes people want to expose their private, much-loved, painstakingly crafted living spaces to critical inspection and the public gaze? 'They quite like the idea of a record,' says Hogg. 'I don't think it's for glory, for most of them, I really don't. People quite like to have the underlining of "Someone else likes what I've done." It isn't as though you're exposing your worst secrets; you're exposing your nicer side.' Owners are never paid, she insists, for having their houses featured.

WoI's style of visual presentation, maintained with exceptional dedication, can be

summed up in a word: clarity. Hogg uses the finest architectural photographers –
Fritz von der Schulenburg, Richard Bryant – and briefs them well. Rooms may be tidied,
cornflake packets removed, clean sheets put on the beds, a chair turned to face the
camera, but she is adamant that the interiors are shot substantially as found and that
nothing is brought to the shoot. Great trouble is taken with the way pictures are laid out:
even a poor set of images can be transformed on the page. 'I do the layouts with the art
director,' says Hogg. 'We do them small and then they're fiddled on the machines
afterwards. Then I look at them again and say, "Hey, hey! I said cut off that window
ledge." I have a very noticing eye. We might change a bit of a layout if it's not working.'

Some of WoI's readers must be living in the style of the magazine's subjects, but that
can hardly be true of all 60,000 to 70,000. These interiors are, by rigorous selection,
extraordinary works of visual and spatial imagination. You could read WoI aspirationally.
You could use its 'Inspiration' page to try to re-create some of the effects within your
own walls, but the ultimate fascination of these visual documents – the reason some
readers collect every issue – lies in a brilliance and originality few can hope to attain
(and certainly not by copying someone else's ideas). These charmed and magical
dwellings are food for fantasy and reverie: they represent the universal need for 'shelter'
refined into art. They are also, as Min Hogg intends, 'a pleasure in themselves'. 'I get
letters from duchesses and charladies and little old-aged pensioners in New Zealand
and Indian students. A lot of nice letters come closely typed from vicars in the middle
of Wales who obviously neither live like that nor aspire to, but they love looking at it for
itself, and they write in such minute detail that I know they've read every word.'

2. THE LOOK AND HOW TO GET IT In *Wallpaper**, the crowded shelter market's most
bullish recent arrival, aspiration is the name of the game. If Min Hogg's *World of Interiors*
is the slightly hushed paper equivalent of a museum or gallery, then the asterisked
monthly – subtitle: 'The stuff that surrounds you' – is a thrusting, ambitious, what-to-
buy-next manual for upscale young metropolitans who take good living for granted and
have earnings to burn. '*Wallpaper** is about instant, knee-jerk gratification,' concedes
founder and editorial director Tyler Brûlé. 'Everything we do gives you the look right
away. You see it on the page: we styled it, you can get it.'

Brûlé had no plans to start a magazine until a thriving freelance career writing for
the international style press was brought to a life-threatening halt, on assignment in
Afghanistan, by bullet wounds in both arms. Convalescing in London in spring 1994,
in a Chelsea townhouse found by his mother, the twenty-five-year-old Canadian took up
cookery as therapy, began to ponder the pleasures of interiors, entertaining and travel,

and conceived the idea for Wallpaper*. In addition to various loans, he went on to sink some $75,000 of his own money into the venture. With its first issue in September 1996, the magazine emerged fully formed and by the fifth Brûlé had sold his precociously accomplished and insatiably cash-hungry baby to Time Inc., making it the company's first title originated in Europe.

Wallpaper*'s readers, as Brûlé conceives them, are a much narrower group than WoI's, in their late twenties to early forties. 'They aren't going down the road of wanting the big house in Berkshire,' he says. 'They don't want all those traditional bourgeois trappings. They are interested in having a great apartment in London, good door handles, good light-fittings, great floors.' In practice, Brûlé believes, Wallpaper*'s international readership falls into three groups: habitual female shelter-book readers; a fringe of out-of-towners living on Long Island and in leafy Chicago suburbs who dream of city living but, according to the editorial director, 'don't want their buttons pushed too much'; and the core readers, people like Brûlé himself, the 'really sophisticated urban reader where anything goes'. On the rare occasions that the magazine's hit squad of editors, photographers, models and stylists deigns to touch down in suburbia they experience an attack of the vapours, affecting amazement at the discovery of anything resembling civilised life.

In Wallpaper*'s pages, everything is wish-fulfilment and make-believe. Brûlé's budget-straining method is to find a desirable location in London or Stockholm or Lake Garda in northern Italy, paint it, fill it with furniture and accessories, drape the place with agency models to give it the lived-in look (lived in by models, that is) and bring on the cameras. Every item from a model's Patrick Cox flip flops to his Jasper Morrison side tables is captioned and priced. The style Brûlé's team favours is encapsulated in the first-issue coverline: 'Urban modernists' – stripped back, functional, elegantly understated, off-the-peg luxury. George Nelson, Italian architect Gio Ponti, and the evergreen Eameses, Charles and Ray, are the patron saints. Wallpaper*'s hankering after a 1960s-style, Hefnerish, bachelor-pad existence is reflected in its taste for retro illustrations and in its use of computer graphics to design fantasy 'dream pads' for flexible living and the post-car city centre.

What sets Wallpaper* apart from competitors such as Elle Decoration or Metropolitan Home, and puts it in a different universe from WoI, is the singlemindedness of its consumerist vision and the prohibitive compass of its aesthetic frame. As a guide to the domestic interior, the magazine breaks little new ground; instead it condenses and itemises a narrow band of urban contemporary taste for easy consumption in a way that will rapidly lead to its becoming a cliché. Its most striking innovation, the use of models

to 'wear' the interiors, is the most significant. The models become role models, blocking free, imaginative entry into the pictures, showing us what we as occupants of these interiors should look like and how we should behave and dress. The effect is uncomfortably close to an advertising or marketing person's conception of 'lifestyle' as something to be purchased as an accessory rather than invented for oneself. It further erodes the fast-closing gap between editorial and advertorial and turns the personal matter of devising an agreeable, individualised, self-expressive interior (with or without professional help) into an exercise in buying-in, and playing a part.

Brûlé is at least upfront about the consumer longings that propel his own product. 'Long before I had any meaningful concept of materialism, I knew that Beirut stood for all [the] things that I now know are important in life – money, sun and shopping,' he writes in a *Wallpaper** travel report on the troubled city's better days as the Paris of the Middle East. 'Most of us have some kind of taste for luxury goods,' he tells me when I ask him how tongue-in-cheek this was. 'I've kind of found myself, by default or whatever, a bit of a product-addict.'

Min Hogg, no fan of the magazine – 'I rather despise it' – writes off *Wallpaper** as 'cultureless'. 'You don't feel they've done it because they know an awful lot already so they've chosen to do this,' she says. 'That's the impression it gives me: not interested in learning anything.' *Wallpaper**'s overwhelming publishing confidence, and the chutzpah of its editor, gave it an exceptional start and others quickly copied its style. Whether Brûlé's brainwave has the culture and depth to develop only time will tell. 'What will it look like in three years' time?' muses its founder. 'I'm not sure because I'll be heading up the whole new *Wallpaper** division of Time and I'll be on a new magazine by then so that'll be the challenge for the next editor who comes in.' Tyler Brûlé is riding an express elevator to his own private penthouse.

Alternative by design?

I am leafing through a magazine and the ad that stops me is arresting even by the hyperkinetic standards of contemporary ads. At first glance it's just a jigsaw of black-and-white fragments. There is a photograph of a deserted street or city square cut at angles, with a shadowy figure breaking out of one side into the white of the page – he finds two or three compositional echoes in patches of blackness around the edge. There are scrawled numbers (they could be measurements), a hand-drawn arrow, an illegible rubber stamp, and the main type is fuzzy, suggesting with the other details that this could be a fax. Running up the side there is a third layer, a word-processed message with phrases crossed out.

The main copy, I now see, is posing a dilemma: the man hiding at the back of the photo is looking out for an enemy sniper. I am standing where the shadowy figure is standing and the man is counting on me to send soldiers to help him. And so is the sniper: it's a trap. It is also, I now realise from the logo tucked away in the corner, an officer recruitment campaign – 1990s style – for the British army.

It is possible, though unlikely, that the creative team which put this ad together had never seen a copy of Ray Gun, but even if they hadn't there would be no better word for the ad than Ray Gun-esque. It uses design devices that were not unique to the magazine, but which Ray Gun, more perhaps than any other source, turned into a fashionable graphic signature of the 1990s. The ad's typography is not particularly weird or unusually distressed (nor by that time was much of Ray Gun's) but the engagingly raw, excitingly immediate, loose-fitting assembly of its components would not look out of place in the pages of Ray Gun itself.

So here in a snapshot, as bluntly as I can spotlight it, is the central conundrum about this in many ways remarkable magazine. In the space of just four years from its launch in November 1992, a design language heralded inside and outside the design world for being 'radical', 'subversive', 'revolutionary', 'innovative' and in every sense ground-breaking had been so thoroughly assimilated by the mass media that it could seem an

appropriate mode of address for an organisation as unsubversive, unrevolutionary and completely establishment in outlook as the army.

How did we get here?

For a magazine which generated such apocalyptic claims about the future of communication in our time – even running the tagline 'end of print' on its cover for a while – *Ray Gun* has been subject to little analysis, as either media presence or design construct. Design journalism and the mainstream coverage in newspapers, magazines and television that fuelled art director David Carson's inexorable ascent tended to treat *Ray Gun* as though it exploded fully-formed from nowhere equipped with a set of design precepts that no other designer, in his or her wildest dreams, had ever imagined. If *Ray Gun*'s design was granted a prehistory at all in such celebratory accounts, it extended only as far back as the six issues of *Beach Culture*, Carson's previous vehicle as art director. Carson's first book, *The End of Print*, attempted to reinforce this view of the designer as a creative genius who had, according to its original cover blurb, 'single-handedly changed the course of graphic design'. While the magazine's look was always the work of many hands – type designers, graphic designers, photographers and illustrators were given a great deal of freedom – the book makes no attempt to explore or explain these collaborations. When it comes to the prehistory, it is largely silent.

The disavowal of history is appropriate to a product as postmodern as *Ray Gun* – and I shall return to this – but it does nothing to explain how Carson was able, in the commercial arena, to build on earlier developments. This is arguably less a matter of specific influences (though these could be traced) than of the creative possibilities these precursors opened up. This isn't the place for a detailed examination of the graphic design of the 1980s, but a handful of examples will make the point. The intense subjectivity and private symbolism of fellow Californian April Greiman's work anticipates Carson's emotionally-charged atmospherics by a decade and she, too, was criticised by some for producing 'art' in the guise of design. At *The Face*, Neville Brody deconstructed the conventions of magazine sign-posting and page-layout several years before Carson began his own dismantlings at *Beach Culture*. Just as seminal was the decisive engagement with literary theory pursued, throughout the 1980s, by graduates of Cranbrook Academy of Art. *Ray Gun* is a commercial heir of their commitment to deconstruction, the vernacular and 'anti-mastery' – the deliberate flouting of professional notions of correct design – and a number of Cranbrook designers went on to contribute to it.

As a cultural phenomenon, though, *Ray Gun* has an even more significant immediate precursor in the shape of MTV. Seen from this vantage point, *Ray Gun*'s radicalism may

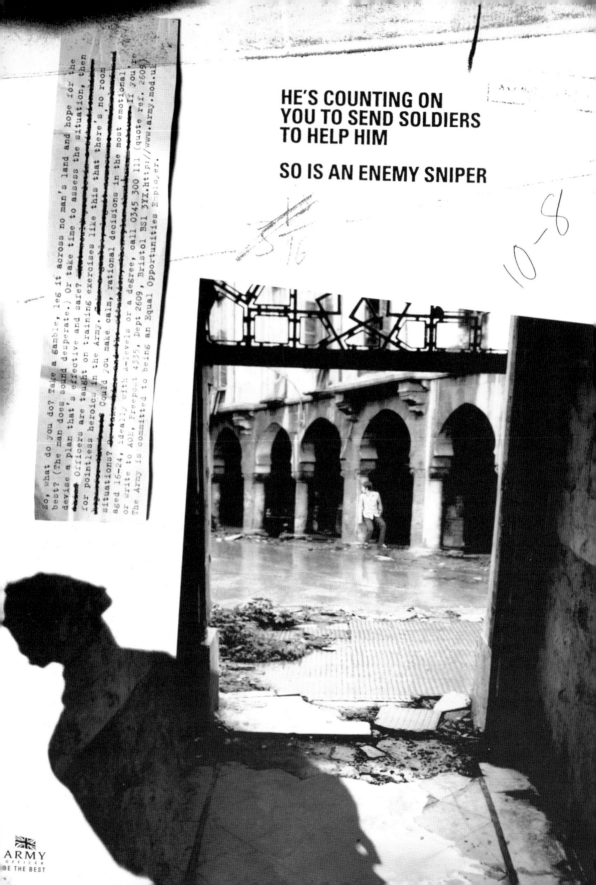

HE'S COUNTING ON
YOU TO SEND SOLDIERS
TO HELP HIM

SO IS AN ENEMY SNIPER

So, what do you do? Take a gamble, leg it across no man's land and hope for the best? (The man does sound desperate.) Or take time to assess the situation, then devise a plan that's effective and safe?

Officers are taught on training exercises like this that there's no room for pointless heroics in the Army. Only cool, rational decisions in the most emotional situations? Could you make calm, rational decisions in the most emotional situations? If you're aged 16-24, ideally with A-levels or a degree, call 0345 300 111 (quote ref. 2609) or write to AO, Freepost 4335, Dept 2609, Bristol BS1 3YX. http://www.army.mod.uk

The Army is committed to being an Equal Opportunities Employer.

ARMY
OFFICER
BE THE BEST

not appear so radical after all. Or rather, what is radical about the design is not so much its intrinsic content as the transposition of televisual devices to the static medium of print, as print struggles frantically to catch up with and compete with the computer and the TV screen. The justifications offered by Carson and others for *Ray Gun*'s design were, as a result, repeatedly framed in terms of the screen's – and specifically MTV's – viewer satisfactions and agenda. *Ray Gun* readers, ran the mantra, belonged to the 'MTV generation', they had grown up with it as kids and teenagers, their brains had been in some way 'rewired' by the experience, they were able to process much higher levels of 'information' than earlier generations could handle and they wouldn't accept, let alone deign to read, anything that didn't offer something approaching televisual levels of intensity and excitement.

There are close parallels between the ways that *Ray Gun* and MTV engaged their audiences. In a much-cited observation, David Byrne suggests that Carson's work on *Ray Gun* and other projects communicates 'on a level beyond words . . . that bypasses the logical, rational centres of the brain and goes straight to the part that understands without thinking'.[1] Twelve years earlier, MTV executive Bob Pittman, speaking to *Rolling Stone*, had used strikingly similar language to explain the station's way of grabbing its viewers: 'Our core audience is the television babies who grew up on TV and rock & roll. The strongest appeal you can make is emotionally. If you can get their emotions going, [make them] forget their logic, you've got 'em.'[2]

MTV's aim, from its earliest promotions, was to give everything a larger than life quality, or what its programming manager called a 'weird edge'. But the channel's debut, in 1981, proved to be a false start. MTV's on-air image didn't look right – it was too stiff, too formal, too close in style and tone to conventional television. After a total rethink, bright, 'phoney' lights were abandoned for 'shitty' lighting, tele-prompters were banished, and veejays were told to adlib around the scripts. If they made mistakes that was fine because mistakes would look real. 'It took a little while,' *Rolling Stone*'s Steven Levy noted, 'but MTV finally got what it wanted – a well-designed studio that looked like something casually thrown together, scripted patter that sounded like it was made up on the spot, an ironclad format that proceeded like a random chain of events . . .'[3]

Ray Gun got it right from the start. It was a highly designed object – 'Alternative by design', as a first-issue mission statement put it – while appearing completely informal and almost dangerously spontaneous, as though a suitcase of Dadaist poems, scribbles and family photographs had been upended across the pages and stuck down where they fell. You didn't need a degree in design (though many *Ray Gun* readers did have, or were getting, degrees in design) to enjoy the brutal relish with which its typography broke

every so-called rule in the book. Typos. Negative leading. Hand-scrawled headlines. Weird new mangled fonts. Colliding columns of text. Letters drifting so far apart that you had to piece them together yourself to make words, while others clumped in tight strings or massed in threatening black clouds that obliterated verbal meaning and linear sense. And holding this graphomaniac chaos together: a synthesising collage sensibility that fairly screamed the word 'ART'. In 1992, *Ray Gun* looked like nothing else on the newsstands, including rivals such as *Spin* and *Rolling Stone*. For its readers, it offered compelling signs of authenticity, appearing to promise a publication that was non-corporate, irreverent, self-expressive and free.

Ray Gun's problem as a publication for its first three years was that a design so blinding made it hard to see where its editorial vision lay, or even whether it had one beyond letting the designer do his own thing. In that sense, editorial director Neil Feineman's clarion call, 'Raw by choice. Immediate by necessity. Alternative by design', was more prescient than he could have known at the time. If *Ray Gun* had something genuinely new, something *alternative* to say about the 'alternative' musicians it featured alongside more mainstream stars, it came to seem that this lay less in the editorial conception or writing than in the functioning of the design itself. On a production level, working from his own studio rather than the publisher's offices, Carson had an exceptional degree of control. It was the designer's decision, for instance, not the editors' or publisher's, to put the words 'end of print' on the cover. Often *Ray Gun* founder and publisher Marvin Scott Jarrett wouldn't even see proofs before the pre-press stage. Most of the media attention *Ray Gun* received in its first two years came from the design press and this focused, inevitably enough, on the designer's 'interpretations' of the content. Their appropriateness was taken for granted, rather than demonstrated by analysis, because these observers were not, in truth, particularly interested in *Ray Gun*'s editorial content, or how it might relate to the history of thinking, writing and publishing on popular music. For these design-world onlookers, the design *was* the content. Whether they were academic theorists of graphic design as a form of authorship, or just straightforward sensation-seeking design fans, *Ray Gun* was a timely, highly public demonstration – a vindication even – of what experimental graphic design could accomplish, given the chance.

Yet there are small signs, in *Ray Gun*'s first editorial, of another agenda struggling to break free: 'We still believe that music and the people who make it can change the world. Have to, in fact. Because if we don't, no one else will.' This is a revival of a form of rhetoric that hasn't been voiced with total conviction since the 1960s and was last heard, with any stridency, during the heyday of punk. For many music critics and fans,

this view of rock as a radical binding force and agent of social and political transformation had been blown apart by the tribal fracturing of the audience in the postmodern 1980s and, not least, by the coming of MTV. It was not an ideology that *Ray Gun* was able to sustain with any conviction (Feineman left after four issues) and it was ironically rejected, towards the end of his own time there, by the magazine's designer: 'Graphic design will save the world right after rock and roll does.'[4]

Here again, there is a parallel with the evolution and critical perception of MTV. 'Unlike the activist Sixties rock coalition,' noted a sceptical *Rolling Stone*, 'the MTV coalition is essentially passive. Their function is to sit still, watch the commercials and buy the products, not change the world.'[5] Critical accounts of the channel's programming in the 1980s tended to assess it in the gloomiest terms. According to these commentators, MTV's postmodernism, its mesmerising play of surfaces, its denial of everything except the perpetual present, its '"schizophrenic" abandonment of rational, liberal-humanist discourse which creates a nihilistic, amoral universe of representation',[6] would so enrapture viewers that the real world of real problems would cease to register with its audience at all. More recently, though, cultural critic Andrew Goodwin has challenged this reading of MTV's supposedly ahistorical, apolitical, asocial aesthetic by suggesting that there are in reality two MTVs. Pointing to the channel's response to cause-rock events such as Live Aid and Amnesty International's Conspiracy of Hope tour, he discovers the persistence within its output of a 'classic Romantic rock ideology' that combines 'traditional notions of rebellion . . . with a new sense of social responsibility and philanthropic concern'.[7]

Ray Gun's seductive play of surfaces is nothing if not thoroughly postmodern, but the sense that the magazine was searching for some deeper commitment strengthened in the mid-1990s. An editorial in issue 33, written by managing editor Dean Kuipers, doesn't go quite as far as Goodwin (Kuipers points out, in fact, how rock has 'moved away from mass social movements') but there are clear signs that the editors are trying to rethink *Ray Gun*'s editorial policy and subtly re-position the title. Even before David Carson's departure after 30 issues, *Ray Gun* had begun to embrace in its design a quieter, more reflective mood which Jarrett liked to describe as a 'new simplicity'. Layouts were cleaner, dysfunctional typefaces thinner on the ground. This streamlining (with outbursts of the old head-banging) continued over the next ten issues following the appointment – with issue 33 – of British art director Robert Hales. 'We have a new commitment to content and readability in the design,' Kuipers notes. The effect of cooling the design temperature was to increase the magazine's appearance of authority and consequently to put new emphasis on the writing itself: now it had no choice but to deliver.

Kuipers identifies the prevailing *Ray Gun* message as 'constructive anarchy', with a passing nod to the Russian anarchist Peter Kropotkin's idea of 'mutual aid'. 'Rock 'n' roll continues to offer the possibility of personal transformation,' he suggests, 'precisely because it is not organised and not led. In fact, you might get more out of rock now, more that pertains to you personally, than ever before.'

Whether the magazine could somehow resolve the tension between what its form seemed to express and what it would perhaps like to believe in was, at best, highly questionable. In magazine publishing terms, *Ray Gun* was a quintessential Avant-Pop product. Avant-Pop, writes American literary critic Larry McCaffery, 'combines Pop Art's focus on consumer goods and mass media with the avant-garde's spirit of subversion and emphasis on radical formal innovation'.[8] It is the product, he explains, of the 'coevolution' of the artistic avant-garde and mass culture – rock music, TV, films, and advertising – so that by the early 1980s, with the arrival of MTV, they were mutually supportive, exchanging 'information, stylistic tendencies, narrative archetypes, and character representations'. Many of the formal strategies of Avant-Pop, as defined by McCaffery, were present in *Ray Gun* from the start: sampling; collage principles; digressive, improvisational structures; surface textures; the seductive, information-saturated feel of advertising; the pace, surrealism and visceral impact of punk and MTV; a painterly emphasis on the emotional and aesthetic intensity of the creative act. McCaffery is surely right when he suggests that the marriage of the avant-garde and mass media is entirely logical because hyper-consumer capitalism's unquenchable demand for 'the new' is exactly the same need that has always driven the avant-garde.

Was *Ray Gun*'s readership ready for a return to meanings you might have to think about (if that is what Dean Kuipers was hinting at) or did it prefer the immersive, seductive, kinetic sensationalism of Avant-Pop graphics? *Ray Gun* may have succeeded briefly in being 'alternative by design', but the design was never used by the magazine as an instrument of opposition or critique and at the close of the twentieth century, with the death of the artistic avant-garde, in the context of mass-market hyper-consumption, in a newsstand title packed with lifestyle advertising aimed at a wealthy audience, it perhaps never could have been. By the time these radical visual ideas reached *Ray Gun*, they had come a very long way, and the speed with which they jumped the page gutter to become advertising shows just how close they were by then to the end of their journey. In an age of hyper-consumption, *Ray Gun*'s design dilemma was the same one that faces any artist trying to locate a position of resistance in a culture that can accommodate and commodify anything you throw at it.

I can see the sniper. Now how do we avoid the trap?

Branded Journalism

The idea that a sales catalogue could create a stir would once have seemed a laughable proposition. Catalogues were useful as a service for those who preferred or needed the convenience of buying from home, but as *news stories*? Forget it. To command attention and become a publishing event, the catalogue had to mutate into a new form, still at root a sales tool, but with the extras needed to turn a product list into a cultural phenomenon. Enter the 'magalog', part catalogue, part magazine, a boundary-blurring hybrid that fuses functions – advertising and journalism – traditionally regarded as fundamentally different publishing activities.

Abercrombie & Fitch, the hugely hip American purveyor of outdoor clothing for the college crowd, launched *A& F Quarterly* in 1997. The first issue featured a piece entitled 'Drinking 101', offering concoctions such as 'Sex on the beach' that infuriated advocacy groups like Mothers Against Drunk Driving. Right on target: controversy, publicity, sales. The 'Naughty or Nice' Christmas 1999 issue, which had, in truth, rather mild sexual content, was entirely true to form. The Chicago city council passed a resolution 'imploring the public and parents especially' to boycott A&F until it cleaned up its advertising; politicians in Michigan, Missouri and Arkansas added their outraged voices to the protests. The $5.95 magalog was already shrink-wrapped; now, to prevent the publication getting into the hands of 'impressionable' minors, buyers at A&F stores needed to show a photo I.D. It was another brand-building coup for A&F. The furore only added to its cachet with the eighteen- to twenty-two-year-old college set, not to mention high school teens.

Looking at it today, the 300-page issue (which sold out) radiates confidence. The pages flip effortlessly and the matt paper feels lovely to the fingertips; it's a lot nicer to handle than many a newsstand glossy. First thing you see is a double-page shot of clouds. Cut to a couple of tepees and a lone horse. Now we are inside a tent decorated with Bob Marley and Einstein posters, Indian rugs, an old portable TV, a bow and arrows, an acoustic guitar, a Christmas tree (well, it's the season), and a Harvard

banner: an unlikely collection of signifiers, but it works. In the next spread are the kids, two guys and a girl, cool techno-nomads reclining on a rug. One has a mobile phone; the others are looking at a laptop. There are no labels in evidence yet – just artfully dishevelled A&F models.

The outdoor location pictures, shot by regular *A&F Quarterly* photographer, Bruce Weber, run through the entire magalog – in muted earth colours, old-time sepia and newsy black and white. The men have taut, washboard stomachs; the women, long, untamed hair. These flawless specimens of American youth ride, climb, play ball, kiss, cuddle, roll on the grass, or just stand there looking young and soulful for page after page. In this wholesome idyll, their perfect bodies aspire to a state of Edenic oneness with the natural world. They wear A&F's sweaters, paratrooper trousers and mountain

fleeces casually – half on, half off. Sometimes they wear nothing at all. A naked girl leans back on a horse, her hair tumbling down its hindquarters. Some of the clothes are fraying and torn: their hard-living owners have loved them to death.

Catalogue pages with the prices are interleaved with Weber's pictures, as are the interviews and stories, all of them written and edited to fit exactly one page. The typographic style is tasteful but unembellished – a functional sans-serif with generous line-spacing and small, centred headlines, picked out in green. The stories are alternately 'Nice' (a ten-year-old genius) or 'Naughty' (ubiquitous porn star Jenna Jameson). Sophomoric humour is only to be expected when many of the uncredited authors are, like the readers, college students. *A&F Quarterly*'s fantasy photoworld of achingly desirable youth is brought down to earth by articles about everyday popular culture: film stars, relationship bust-ups, computer games and 'hot pick' CDs. Not far below the alluringly shot surface, it's a stylised variation on the content of any newsstand consumer title aimed at the same group.

In reality, the divide between editorial and advertising has rarely been absolute, especially in the fashion and shelter titles. 'Some years ago . . . the magazine art director Henry Wolf took a copy of *Vogue* and attached a coloured thread to every ad that related to some editorial mention within the issue,' says Milton Glaser, editorial designer and co-founder of *New York* magazine. 'When he was done the results looked like a small Persian rug.'[1] In 1997, Glaser withdrew his nomination for the Chrysler design awards following the revelation that the company had instituted a policy of asking magazines to submit articles for screening before deciding whether to run its ads. Writing in *The Nation*, he saw this meddling as 'an insidious attack on the principles of a free press'. A statement at the time from the American Society of Magazine Editors warned that the requirement to submit tables of contents, text or photos to advertisers for prior review could 'at the very least create the appearance of censorship and ultimately could undermine editorial independence'.[2]

In recent years, the principle of editorial independence has been under repeated attack. In 1999, at the *Los Angeles Times*, in a move that was heavily criticised by journalists, former chairman Mark Willes – whose previous line of business had been breakfast cereal – brought together the editorial and advertising sides of the business in a dubious way. In one notorious incident, the paper ran a special issue of its magazine about the Staples Center, a new sports arena in LA, having agreed to split the profits ($600,000) with the building's owner. The deal, brokered by then-publisher Kathryn M. Downing, had been struck without the knowledge of most of the paper's top editors. A furore ensued in the newsroom, prompting an in-house report later published in

A&F Quarterly, no. 1, 1997. Design: Shahid & Company. Photography: Bruce Weber

the *Times*. In it, staff writer David Shaw revealed how business considerations impinged on journalism and how the advertising staff had demanded favourable coverage for certain advertisers. 'A wall is impregnable,' reported Shaw. 'A line can be breached much more easily.'[3]

Principled journalists may try their best to patch up the cracks in the wall, but the balance of power has decisively shifted and advertisers know it. 'In this age of hyper-capitalism and thus also hyper-marketing,' says Kurt Andersen, chairman of inside.com, the web digest of media news, 'all the old lines between editorial content and advertising – like those lines between high art and pop culture, and between news and entertainment – are blurring and breaking down.' At the same time, Andersen notes, even reputable publications devise sections with the primary purpose of attracting advertising dollars. 'As the most prestigious organs create new sections that are significantly, if not overridingly, advertising-driven – whether those sections are nominally editorial (the *New York Times*' 'Circuits') or nominally advertising (the *New Yorker*'s travel sections) – the signal goes out to the whole advertising, marketing and magazine world that, further down the media food chain, fuller crossbreeds of ads and editorial are permissible.'

The crossbreeding in all media is accelerated by the Internet, where, as Andersen points out, there are no pre-existing protocols to determine how 'editorial' and 'advertising' roles are assigned. If a company with merchandise to sell wants to offer commissioned content to make its website 'stickier' for visitors, it can. Brands now see themselves as alternative providers of content. They can shape the environment in which their brand message is delivered, ennabling them to further reinforce the brand. The magalog, *No Logo* author Naomi Klein tells me, represents 'a growing impatience in the corporate world with the traditional role of the advertiser as the commercial interrupter, intruding on "real" culture. Now the brand wants to be the cultural infrastructure, not an add-on, or an interruption. Magalogs are an important part of that: rather than associating with a lifestyle, represented by *Rolling Stone* or the *New Yorker*, magalogs allow the brand to be the lifestyle, their products the essential accessories.'

Sony Style, launched by the electronics giant in 1999, is one of the most fully realised and convincing examples of the genre to date. At first sight, with jazzy design, cover lines, and come-hither cover stars like Jennifer Lopez and Milla Jovovich, it looks like a typical newsstand title. At no point in his replies to my questions does Ken Dice, Sony's director of corporate marketing communications, refer to it as a 'magalog'. It's a 'magazine' throughout, produced for Sony by Time Inc.'s custom publishing division, with designer Terry Koppel as creative director. 'Our goal,' explains Dice, 'was to evolve

our old catalogue into a new publication that would help readers understand the myriad applications of today's technologies. Catalogues depict products. Manuals demonstrate the basic operations. But nothing out there today brings to life the possibilities of today's products and tomorrow's technologies. *Sony Style* attempts to fill that void.'

Sony's obliging void-filler is divided into four parts: short profiles, showing creative uses of technology; new products and longer stories, often with a Sony theme; a 'Manual for digital living' – tips on using Sony products; and a catalogue selection. Time Inc.'s editors provide direction, make contact with Sony personnel for specific input, and develop stories as they see fit, always bearing in mind the marketing goals. 'We are trying very hard,' says Dice, 'to present the convergence of technology, entertainment and design not through the eyes of Sony, but rather through the eyes of end-users.' Koppel's lively page designs are crucial to the impression that this is indeed a publication about Sony rather than a communication from on high. Although it remains, in essence, a corporate message, its journalistic look and language are intended to smooth its acceptance as a magazine like any other – one that just happens to focus on the Japanese giant. It even has a few ads for other companies: Ford, Toyota, Oldsmobile, the Gap.

As Klein suggests, the purpose of a magalog like *Sony Style* is to establish the brand not merely as an adjunct to one's personal lifestyle – one input among many – but as the lifestyle itself. Magalogs deliver a concentrated hit of brand essence that could never be achieved by placing ads among the many competing signals projected by a traditional magazine. 'Unlike most magazines,' says Dice, 'where content – editorial and design – is developed with a specific demographic or psychographic in mind, *Sony Style* was developed with the intent of re-aggregating people around the concept of new digital lifestyles.' In plain English, they don't go looking for you on someone else's turf – they provide the turf. In the controlled environment of a magalog, says Klein, 'brand lifestyle' can be displayed 'with as much texture and nuance as possible, in its utopian habitat – outside the studio and in our lives.' There would be little point in reading each new issue (print run: approximately 400,000 copies) without this degree of commitment to the brand.

'While magalogs aren't yet direct competitors to traditional magazines,' notes *American Demographics*, 'their mere existence attests to the changing and fragmented media landscape.' Magazine publishing has probed every last niche and magalogs seem set to do the same. Teenage girls, checking out the latest fashions, have MXG and its website; art collectors can keep track of forthcoming auctions with Christie's *Living with Art*; lovers of sparse Scandinavian interiors can explore Ikea's *Wallpaper**-ish *Space*. Urban moderns with refined tastes and bigger wallets might prefer *Room*, started by former

House & Garden style editor Amy Crain. And those requiring practical advice on business cards, e-mail etiquette or tailoring a résumé can consult Kinko's *Impress*.

From a business point of view, magalogs represent an entirely logical development of the brand. Like the interactive megastore, the magalog turns brand meaning into a tangible experience, one beyond the buying and owning of the product itself. Advertising's impact is fleeting. You view a print ad or a TV commercial and quickly move on. The magalog sucks you into the brand's universe, keeps you there for longer, entertains and diverts you, forges a complex network of personal associations and connections, and gives you reasons to keep coming back. A&F is not just a nice line of clothing – it's a natural way of living for shiny, beautiful people. Sony is not only a provider of stylish camcorders and DVDs – it's a way of thinking, playing and growing through technology. Kinko's is not simply your local copyshop – it's a super-enhancer of all forms of communication.

From a journalist's point of view, though, the rise of the magalog is cause for concern. Their existence on equal terms, especially on the newsstand, makes it that much harder to defend the idea of 'the wall'. Brands have effectively bulldozed the boundary line and built on top of it, often by calling on the services of publishers, editors, writers and designers who, for at least some of the time, also offer their talents to publications where lip service is still paid to the need for the wall. They may draw a distinction in their own minds between the two kinds of publishing, but to many readers, and to advertisers once held at bay by an unyielding barrier, such hair-splitting counts for little. A magalog's primary task is to represent a brand's commercial interests, to win converts and move the goods, and this is no substitute for the ideal of sceptical, questioning, impartial journalism, however hard it might be to achieve. The fact that so many magalog buyers seem untroubled by such considerations reveals the degree to which corporations, advertisers and publishers have succeeded in merging and confusing channels of communication that are best kept firmly apart.

Will readers see through the magalog? 'The hopeful view,' suggests Andersen, 'is that only magazines that have a distinct and valuable point of view and/or provide distinctly valuable information and analysis will survive.' With new magalogs arriving by the truckload, though, the outlook is muddled at best. 'The consequence,' says Klein, 'is that the very concept of editorial is eroded and journalism is transformed just as advertising has been transformed. Whether it's *Sony Style*, *Spin* or *Wallpaper**, producing a magazine has become the same as producing any other product. Advertising looks more like editorial, editorial looks like advertising, and pretty soon these distinctions begin to look to everyone like petty semantics.'

Sentenced to buy

My eight-year-old daughter was unsettled. She had just seen a Benetton billboard at the end of our street with the words 'SENTENCED TO DEATH' stamped in big, black letters across a picture of an African-American man. 'What does it mean?' she asked. I hastened to assure her that we no longer have the death penalty in Britain (it was abolished for murder in 1965, and finally abolished for all crimes in 1998), and that most civilised countries now regard such a thing as completely unacceptable. Then I began to try to explain why the American justice system decrees that Jerome Mallett, the man on the billboard, must die.

Does anyone still doubt the huge power of street advertising? You could easily overlook Benetton's broadsheet newspaper ads showing the same images. You could surf the web forever and never stumble across the Benetton website, carrying the full 'We, on death row' campaign. Even this is more likely than accidentally seeing the catalogue. I broke the habit of a lifetime and visited my local branch of Benetton to see if they had piles of this publication for the Saturday shopper. No, not a single copy. In the colourful, fluffy, cuddly surroundings of the shop, the idea that the same outfit should be mounting such a campaign (and all the previous campaigns) was frankly incredible.

Two and a half years in the making, 'We, on death row' is a disturbing document and, it must be admitted, an impressive piece of work. The US has executed approximately 600 people in the last twenty-five years. Journalist Ken Shulman travelled the country and interviewed twenty-five men and one woman condemned to die. Benetton creative director Oliviero Toscani took their pictures. The authors do not excuse their crimes, but they want us to see their faces and understand who they are. The condemned are remorseful, self-pitying, blank, haunted by failure, consumed by fear, accepting of the almost inevitable, and sometimes even wise. Jerome Mallett once dreamed of doing illustrations for advertising; he has been waiting for his lethal injection since 1986. Shulman argues that these state-sanctioned gassings, poisonings

and electrocutions, which few American politicians dare to question for fear of losing votes, cheapen citizens and contaminate all who are involved.

My daughter, struggling to come to terms with the idea of legalised killing, found a moment to wonder what any of this has got to do with clothes. Always the same question: if we ever stop asking it, we will be in deep trouble because at that point the dividing line between advertising and news, grasped by even the eight-year-old mind, will have dissolved once and for all. Toscani impatiently dismisses such scruples. He argues that the unexpected eruption of this material in a new 'inappropriate' context, with a Benetton logo attached, forces viewers jaded by years of horror on the nightly news to pay attention. And sure enough, here we are talking about Benetton again. He says that most editorial is heavily compromised by the advertising that supports it. The dividing line is already blurred. Blur it some more.

While Benetton's campaigns are still unusual in their support for controversial causes and ideas, they are part of a relentless trend by which advertisers attempt to co-opt cultural space as a way of boosting their brands. Increasingly, superbrands such as Benetton see themselves as being in the business of culture-creation. The result, as this trend develops, will be to make culture itself appear to exist at their behest. Toscani's repeated jibes at the 'stupidity' of most advertising dare other advertisers to follow his lead. If they did so, Benetton would lose the leverage that comes from being one of a kind, and fragile but vital distinctions between commercial interests and independent commentary would suffer irreparable damage as corporations routinely meddled in serious public matters for their own ends. As things turned out, however, Toscani had finally gone too far. The death row campaign provoked public fury in the US, especially from relatives of the inmates' victims, Benetton came under sustained commercial pressure to call a halt, and Toscani left the company, bringing his long campaign of provocation to a close.

It's hard, though, if you read 'We, on death row', to reject Benetton's initiative out of hand. Jerome Mallett hopes his girl friend will see the catalogue. He seems resigned to his fate. But the campaign comes too late for Harvey Lee Green, photographed holding his Bible. He was executed in September 1999 after seven years on death row.

Poster for Benetton,
2000. Art direction
and photography:
Oliviero Toscani

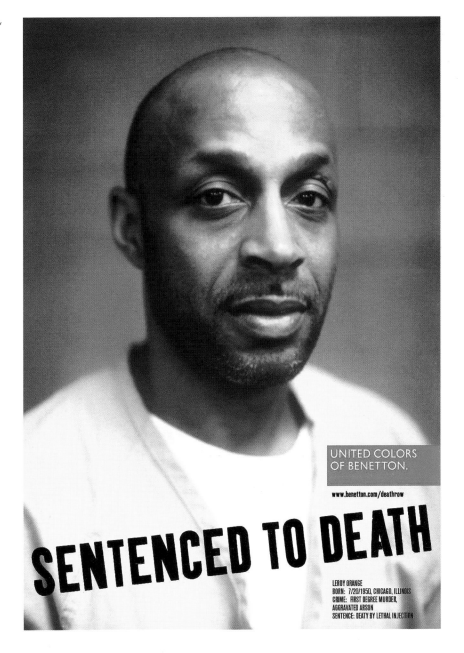

Here is me!

Poster for AIGA
Detroit/Cranbrook
Academy of Art, 1999.
Art direction: Stefan
Sagmeister. Design:
Martin Woodtli.
Photography: Tom
Schierlitz

I have in front of me a picture of Stefan Sagmeister's testicles. Yes, I'm sorry, you read that correctly the first time: Mr Sagmeister's manhood, his *cojones*, his pride and joy. The New York designer's unabashed self-portrait, published in a recent anthology of new design, is probably the boldest gesture to date from a man with an unnerving talent for overstepping the mark.

Presented in tandem with a scabby close-up of the words 'WHERE IS HERE', carved into the flesh of the designer's own back, this may well be the defining diptych of graphic design at the century's end. Few images better encapsulate the profession's, indeed the culture's, obsession with the self. By offering himself as sacrificial subject, Sagmeister is doubtless making an 'ironic' comment on our collective self-obsession (in its testosterone-fuelled version) but he is also, more straightforwardly, delivering a graphic demonstration of his own creative potency. Here is a designer with the balls to show his balls and inflict wounds on his own flesh. Where is here? There's no mistaking the answer: 'HERE IS M E!'

Twenty years ago, in a wonderful essay that bears revisiting, Tom Wolfe dubbed the 1970s the 'Me Decade'.¹ If the 'decade' part now looks superfluous it is only because, as Wolfe himself fully expected, our love affair with the personal pronoun has run and run. This is the age of the rampant ego, of the boundless narcissistic 'I', and as with any deep-rooted social trend, advertising throws up some of the most revealing texts: from the brattish demands for total gratification in Pepsi's mid-1990s 'I wanna' ads – 'I wanna seven day weekend, I wanna ticker tape parade, I wanna be clear for take off', etc. – to the stylish personal intransigence of Christy Turlington's pay-off line in a commercial for Calvin Klein's Contradiction. 'I do what I want,' says the twinkling supermodel. 'I can't do anything else.' And what could be more reasonable than that?

As you might expect, the new religion of the self has profound consequences for design. In the 1990s, progressive members of the profession made an articulate case for the development of graphic design as a form of authorship. Their demands implied that

design could be more than fancy window dressing: that it could, and should, become an acknowledged part of the content of the communication. Graphic designers too might have something to 'say', some point of view to express, something necessary to add to the other viewpoints (the client's, the writer's) contained in the message. Worthy as these ideas remain, it has to be said that acts of design authorship with this level of sophistication and complexity are rare. Few designers seem to have grasped quite how demanding, in terms of new skills and understanding, the pursuit of design authorship would be.

What younger designers much more readily absorbed, to the point where it is now pervasive, is the conviction that designers have some vaguely apprehended yet automatic right to self-expression through the process of design. I often encounter students who have entered the discipline for this reason. For many young designers, the idea of a career as a professional communicator, attempting to reach all kinds of audience through design, seems to hold diminishing appeal.

The depressing paradox is that the desire for self-expression goes hand in hand with a deep reluctance to take up a position, to say anything definite about anything, and a paralysing belief (of course, this itself is a position of sorts) that visual communication doesn't make a jot of difference anyway. These attitudes find apparent endorsement in one of the brief texts in *Whereishere* (the book with Sagmeister's sac): 'As the creative operatives (designers, writers, architects, directors and so forth) are increasingly doubtful of any meaningful direction to their work (beyond its power to involve and entertain themselves in a sense of performance), so they forgo being responsible for trying to effect change in their audience. Instead, they are simply struggling to assert their own existence.'[2] In other words, the old-fashioned egotism required to believe you have something to say that an audience might want to hear is superseded by the narcissism of thinking you deserve an audience simply because you are you.

The rationales offered for this way of thinking are equally self-centred and self-serving. The uncertainties and relativism of postmodern theories of culture have been wildly extrapolated by some commentators to justify giving up any attempt to communicate anything specific to a given audience. 'Obvious meaning is obsolete,' the Dutch writer Max Bruinsma pronounced in the pages of *Eye*, 'one cannot say anymore whether something is true or false. So why bother with fixing meanings?'[3] The nature of truth has always been a matter of intense and legitimate disputation in philosophy, but this is so sweeping in its rejection of everyday experience (precisely the realm of most design) as to be absurd. Statements such as 'my brother's new Lexus is blue' or 'the designer has cut his back with a knife' are as verifiable as they ever were. If we see

something with our own eyes, or can find reliable witnesses to say that it occurred, most of us would agree to regard it as 'true'. The denial of objective reality means that for Bruinsma, and for others sharing this view, graphic design is now largely about the 'subjective interpretation of signs'. In digital media, in particular, he discovers a 'meandering associative process in which everyone recognises what they want'. Here again, the individual's personal view of the world, with all its idiosyncratic limitations, is held up as the measure of all things.

Such an advanced degree of social fragmentation presents the practice of communication design with some genuine dilemmas. At graphic design's 'cutting edge' – the focus of the observers I have mentioned – we are further than ever from design-thinker Jorge Frascara's proposition that quality in design should be measured by the changes it produces in the audience, and that this close concern with the audience is what qualifies graphic design as a social science.[4]

While cultural critics regularly sound the alarm about the inherent problems of a solipsistic society, most design commentary seems only too happy to turn a blind eye. By choosing not to read, by blanking out their own past almost as soon as it happens (many design students show little interest in design history) designers also conspire in this process. Yet even as it occurs to me to cite another book – Christopher Lasch's *The Culture of Narcissism* – I realise that I shall probably fall into the catch-22 that Lasch lays bare. Despite a lucid, still relevant analysis of our present condition, his book will doubtless just seem 'old' (it was published in 1979), though this is exactly the blindspot that he addresses: our waning sense of historical continuity; our trivialisation of the past by equating it with outmoded attitudes, fashions and styles; our reluctance to learn anything from the experiences of our predecessors, or to sustain an imaginative grasp of posterity. To a narcissistic society, it makes sense only to live in the moment, here, now, for ourselves. Have we lost the balls to turn 'I wanna' into a collective 'We want'?

Don't think, shoot

The projecting shop sign shows a line drawing of a small, primitive-looking camera. Underneath it, in lowercase letters, is the simple instruction: 'don't think'. The shop itself is not much bigger than a cabinet. Its walls and ceiling are wallpapered, top to bottom, with a lurid, chromatic patchwork of snapshots – people, animals, street scenes, aircraft. We are in a 'Lomo embassy' devoted to the cult, philosophy and promotion of the Lomo, possibly the trendiest camera money can buy. This particular outpost happens to be in London, but the Lomo's growing army of converts has established similar bases in New York, Munich, Berlin, Paris, Zurich, Moscow, and Sydney.

For dedicated lomographers, the Lomo – hand-made in Russia – is a new way of seeing. Lomography may look a bit like traditional photography, they admit, but it is actually something completely different, a new kind of communication, a way of getting closer to the heart of things, an attitude to life that will make every day more varied, intense and exciting. Ten 'rules' embody lomography's methods and worldview, among them: take your Lomo everywhere; use it at any time, day or night; move in as close as you can to the objects of your 'lomographic desire'; be fast; don't think; shoot from the hip; don't worry about what you have captured on film – it is considered bad form to look through the viewfinder; and, lastly, pay no heed to the rules.

Part of the Lomo's appeal, as an object to own, lies in its looks. In an age of smooth-shelled, press-button, digital wonders, its clunky contours and abrasive, Cold-War styling appeal to the same ironic sensibility that savours cheaply printed East European packaging – the Lomo's three-colour wrapper looks like it was designed forty years ago. It is also a great story. In 1994, the Leningradskoje Optiko Mechanitscheskoje Objedinzinie factory in St Petersburg had decided to discontinue the Lomo and lay off 150 workers when two Austrian fans of the camera offered to promote the Lomo in return for world-wide distribution rights. The Lomographic Society started by these enthusiasts now claims more than 200,000 members, among them David Byrne, dance musician Moby, Fidel Castro and the Dalai Lama.

The Lomo sales pitch is brilliant. Reading their paeans to the camera, you end up feeling that to be anti-Lomo would be to be against life itself. The prose zooms along in an excited rush: 'Whatever you want, just don't stand still to do it, keep moving, click, you can't plan anything, click, don't think about it, concentrate on the important things, forget the Lomo in your hand and take lomographs, click, until your fingers start bleeding.'' They go on like this for page after page.

How could the pictures live up to this? The inevitable truth is – they don't. Lomo devotees love the super-bright hues produced by the specially-coated lens. They admire

the vignette-like shadowing round the edges. They make a virtue of the unpredictable focus: more often than not lomographs are blurred. They like the strange angles, abrupt foreshortenings and raw, unexpected details that come from trusting in chance and shooting on the run. They believe that snapping pictures the Lomo way, with their enchanted instrument, will 'eradicate all traces of your photographic education and the process of cultural-aesthetic socialisation you have undergone'. Above all, they cherish the sense that the camera is capturing the beating pulse of experience itself.

Yet the entire Lomo phenomenon – enjoyable as it is – rests on some dubious assumptions. Photography's unique power has always resided in its ability to freeze the fleeting moment, to magnify and elevate the smallest of events. Anything acquires importance by having its picture taken and 'lomography' is no different in this respect from plain old photography. The snapshot aesthetic has been with us as long as the lightweight camera. Street photographers like Robert Frank, William Klein and Garry Winogrand were exponents, and Nan Goldin's casual, confessional pictures inspired a whole school of defiantly offhand image-makers operating in the fashion world. Far from being a breakthrough, lomography is completely in sync with current attitudes in both photography and design – from David Carson's *Fotografiks* to *Process* by Tomato, which offers dozens of blurry snapshots of trees, leaves, streets, water and clouds.

'Nothing has come to prove Surrealism more correct than photography,' wrote Salvador Dalí, as long ago as 1929. 'Oh Zeiss, lens so full of uncommon faculties of surprise!'[2] The odd thing about the Lomo, despite the semi-surrealist invocations of delirious, lomographic desire, is that its 'surprises' are only too predictable and tame. Consider the London shop's promotional poster. The featured lomographs are almost formulaic in content and method. Most consist of a single prominent subject and a depthless pictorial space that the eye can absorb at a glance: shadows, clouds, dogs and babies, silhouettes of hands and feet, street signs, a man's behind, planes passing overhead, a woman drinking tea. Not much to make you linger and few, if any, epiphanies to be had. The strongest statement comes from the designer's decision to repeat some of the more graphic pictures and generate unifying rhythms across the poster, giving it a visual complexity missing from the individual images.

The poster refers to one of the key lomographic concepts, to be seen at any Lomo embassy – the 'Lomo Wall'. Surrounded by hundreds of pictures – money no object, click! – the happy lomographer sifts and selects, mixes and matches to piece together a huge mosaic of details, memories, atmospheres and stories, real or imagined. The Lomo Wall embodies the central paradox of lomography. Making one is said to 'train your eye', yet when taking the actual pictures, the eye is denied, as though it cannot be

trusted to do the job. What is gained by randomness at the point of capture, if the plan is to apply visual criteria all along? Why can the eye not be trained by looking through the camera? How is leaving the picture-making process largely to chance going to increase the likelihood of producing meaning in the resulting image? And is it okay to start thinking again when you are designing your 'world of images' for the wall?

Lomography's error – now also commonplace in design – is to confuse the private meaning that lomographers find in the experience of taking and living their pictures with the meanings communicated when the images are shown in public, where they must stand or fall by their intrinsic expressive power. Like other iconoclastic credos, such as the Dogme 95 'vow of chastity' in film-making, lomography wants to strip away convention's dead wood and return to an imagined condition of pre-existing purity. Studiously applied, as they seem to be in the published examples, its prescriptions quickly become stylised, rigid, restrictive and dull. Declining to think, as an article of faith, and trusting personal intuition's every foible and whim, as a kind of all-purpose guidance system, has become one of the more tiresome creative postures of our time. The qualities most likely to produce engrossing photographs that communicate something urgent or necessary to viewers are original vision, a full understanding of the medium, and essential craft skills purposefully applied.

In October 2000, the Lomographic Society staged a 'Lomolympics' final in Tokyo, apparently based on the conviction that some people take better lomographs than others and winners can be decided. It was another masterly product promotion and doubtless sales of the fashionable little Lomo will soar. A new kind of communication, though? Only if you have missed the last 160 years of photography.

An artist's rights

After the impact he has made on the consciousness of ad men, pop stars, newspaper cartoonists, animal rights advocates, not to mention art lovers and haters the length of the land, no one involved in putting together a book about Damien Hirst – least of all the man himself – could have settled for a worthy, critically thorough, nicely laid out but ultimately unmemorable monograph. A Hirst book had to be an event, a media phenomenon, a show-stopping, jaw-dropping, good taste-trashing roller-coaster ride of a book; and the tumescently titled *I Want to Spend the Rest of My Life Everywhere, with Everyone, One to One, Always, Forever, Now* is undeniably that.

Big, brash, riotously colourful and exhaustively designed from first page to last, with gatefold surprises and triple-page throw-outs, the book is a complex feat of paper engineering that taxed the resources of its Hong Kong printer to the limit. See the butterfly flex its wings and rise from the page! Pull this tab and make the tiger shark disappear! Pull that tab and make the tank fill up with ink! Use the sheet of decals to stick the rude bits blacked out under Chinese law back on to Damien and Maia! Stand well back as a pop-up *Judas Iscariot* (1994) springs to attention! And when you've done all that, remember the experience with the bonus posters on your bedroom wall!

I Want to Spend's fun-packed visuality flouts every convention by which the fine art monograph establishes its seriousness. According to the usual way of doing things, design's self-effacing role in the publishing process is to frame the artist's work for inspection and analysis with all due discretion; it certainly isn't supposed to offer competing attractions. The book retains a documentary purpose by including, alongside the oeuvre, a scrapbook-load of press cuttings and letters to the artist, one with razor blade – in this sense it isn't a fully autonomous 'artist's book' – while allowing the pre-existing art works to become graphic elements in a new composite 'Hirst', the book itself.

For his design collaborator, Hirst turned to Jonathan Barnbrook, a London-based typographer, type designer and commercials director with an international reputation

in his own right. It is Hirst's baby (literally, in the case of the infant Connor, given a healthy-looking spread) but it would not have had anything like the same complexion without Barnbrook's input. While their collaboration received little attention in the pop-up fixated popular coverage, this is one of the most notable aspects of the project when considered as a contribution to the medium of the book. Graphic designers have long argued for a closer, more fully authorial degree of engagement with their subject matter; in the 1990s, design itself was theorised as a medium of commentary and authorship. Barnbrook is a central figure in this international movement and with I Want to Spend he has created one of the most spectacular, intensive, not to say problematic demonstrations of these possibilities (in book form) to have come from Britain to date.

The book is revealing, as a result, in ways that neither artist nor designer can have anticipated. In his own projects, Barnbrook's design gestures come perilously close at times to kitsch, but the satirical intention inclines you to give him the benefit of the doubt. Here, by mutual agreement, the designer's triple-coded typefaces and penchant for anti-consumerist imagery have been held in check, but the amphetamine-powered layouts and cod-Pop ambience of the book's candy-coloured palette envelop Hirst's oeuvre in a trivialising clamour that chimes perfectly with the spot paintings and wheel jobs, but does the more powerful work no favours. Pretty soon it all begins to look not just knowing but cynical, and the punkish aphorisms from Hirst – 'I'm a hypocrite and a slut and I'll change my mind tomorrow' – treated like slogans in an ad campaign don't help.

As an editorial strategy, these quotations may have seemed like a good way of making Hirst's art more 'accessible' to the reader, but their close juxtaposition with photographs of the work endows them with the decisive tone of explanatory captions. 'Death is an unacceptable idea,' announces one of the black pages used to show Hirst's installations. 'So the only way to deal with it is to be detached or amused.' This is accompanied, over a sequence of pages, by the three brutal wound photographs (two of them suicides) used in When Logics Die (1991) and it seems, from its position near the start, to be intended as something like a credo: the book, like the art, will gaze unflinchingly at the raw facts of our mortality. Hirst doesn't seem to allow that other emotions, such as compassion, might be possible reactions to the unacceptable idea of death.

What the book ends up exposing, unwittingly, is the shallowness of his vision. The key to this, it seems to me, is the notorious mortuary shot of the young Damien posing beside a severed head, reprinted as a two-thirds-life-size, full-bleed, double-page spread treated in silver duotone. First shown quite small in the pilot issue of Frieze,

in 1991, it's an important image for Hirst, presented larger than most of the art, presumably because it establishes the credentials and continuity of the artist's concerns; here is documentary proof that even as a kid he dared to go to the edge. The image exercises a morbid fascination (the grinning Hirst is incidental to this) but does it tell us anything we didn't know, or needed to know, about death? We weren't there in the room with the body and have no idea what we would have felt. We have only the image. The dead man – the remains of a real life – becomes a ghoulish prop in Hirst's visual biography and now in his book. With his bald head, clamped-shut eyes, flabby jowls and triple-chin, he has been reduced to a graphically enhanced after-life in a media-friendly freak show. Who was he? Who are or were his family? There is no sign in anything that Hirst says about this dubious episode, in silver words floating across the image, that the artist knows or cares. 'I suppose art tries to resurrect the dead,' he offers lamely. By reprinting the picture in this way, at the heart of this self-celebratory extravaganza, he endorses his original youthful act and arrogates to himself, in the name of art, special rights over death.

new entrepreneurial Britain as 'Cool Britannia' in the eyes of the world.

When Kalman and others tried to raise the question of content and commitment in the early 1990s, even some of graphic design's more sophisticated observers took umbrage. Daring new experiments in typography were so absorbing that it was possible to believe that style itself was sufficient as a medium of expression and authorship. There were ironic sneers at 'worthy' causes and insufficiently exciting 'modernist' type formats. In practice, the cool new type styles were swiftly co-opted by corporations happy as always to exploit their 'transgressive' power. Years later, books with titles like *Cool Type* and *Cool Sites* pile up in the stores. For any designer concerned to avoid falling into cool's sticky trap, commitment to principled personal content remains the only way to go.

It's time to accept that cool, as a signifier of meaningful rebellion, is belly-up in the water. It is profoundly manipulative and makes no sense at all as a mass frame of mind. If you still want to be a rebel, go right ahead and kick out the jams, but it will have to be a rebellion *out of cool*. There is no other way. Kalle Lasn of *Adbusters* calls for nothing less, at this point, than the 'uncooling of America' – its icons, signs, fashions and spectacles. 'The only battle still worth fighting and winning,' he writes in *Culture Jam*, 'the only one that can set us free, is The People versus The Corporate Cool Machine.'[6]

You may think he overstates the case – the *only* battle? – but one thing is clear: there is nothing quite as uncool these days as 'cool'.

Blank look

In a NatWest bank commercial a gang of office-workers stages a great escape. One woman takes a spade from an umbrella stand and starts digging through the floor, while another straps herself into an ejector-seat swivel chair, presses a button and catapults herself through the ceiling. A third escapee pulls a release handle and makes his getaway down an inflatable emergency chute that unfurls from the office block window. 'Last year,' says the voice-over, 'NatWest helped 67,000 people break away and set up their own businesses.'

What makes this commercial so striking is its mode of delivery. In style, it's like an animated version of the airline safety instruction cards frequent flyers never bother to read. It uses all the same graphic conventions: panels with rounded corners, chunky red arrows and simplified outline drawings of furniture and figures. It makes throwing in your job and starting a new business seem routine, entirely sensible, a logical choice that is almost risk-free.

There is something odd about the lack of passion in all this. The figures' faces are featureless. The black outlines of their heads and bodies enclose empty white spaces without detail, texture or pattern. They are template people, generic men and women rather than distinct individuals, and even when they have made their escape from the office they still look like dummies.

Even so, the objectivity of the outline style suddenly feels right. You find it in fashion ads in *Dazed & Confused* magazine and gracing the covers of techno CDs. *Arena* uses it for tongue-in-cheek illustrated features on executive flying, the future of work and wife swapping in suburbia (interchangeable swingers go through the motions on the stairs, on the kitchen table and even in the loft). Habitat catalogues have offered cute-looking line drawings of the product range for some time. Very Pop Art. Very Patrick Caulfield, in fact, and in one of those moments of perfect timing that help to confirm and boost an emerging visual taste, Caulfield had a major retrospective in 1999 at the Hayward Gallery – sponsored by Habitat.

Stills from TV
commercial for
NatWest bank, 1999.
Agency: TBWA GGT.
Illustration:
Vehicle@Nexus

As a popular style, the outline look may be just starting to get going. *Open Here*, a book about the art of instructional design, is likely to consolidate the attraction of diagram chic for art directors and designers. Its cover shows a giant outline hand opening a silver can worthy of Warhol or Lichtenstein. Inside, page after page of inexpressive outline people fasten life jackets, set the video, brush their molars and demonstrate the correct way to insert a nasal spray in the nose.

So what's the appeal? At the most basic level it's certainly graphic. A black line on a plain background has immediate impact and its unexpected directness and simplicity make a startling change from the photographic or obviously computer-generated image (though drafting software is ideal for producing this look). Instructional drawing, however, aspires only to describe and delineate. If it has an aesthetic character – and clearly it does – it is one that has arisen from the modest aim of giving only as much visual information as is needed to convey the basic facts. Anything more elaborate would slow down a potentially urgent message.

The meaning of this style undergoes some inevitable changes when it is used in lifestyle magazines and ads. In these fashion-conscious precincts, pictorial minimalism is not a matter of function or necessity – it's a deliberate choice. Here, aesthetic neutrality comes across as self-conscious, deadpan, reluctant to make further comment and determined at all costs not to commit itself. On the face of it, the only thing to be discovered within the outline, other than the blandest washes of colour, is empty space. This pared-down style appears to lack any semblance of an interior life.

Might this blankness be in some way liberating? Consider the case of Miffy the rabbit. Dick Bruna's famous creation has a cross for a mouth, two black dots for eyes

and inhabits a primary-colour world of stark simplicity. Small children have always loved the Miffy books, identifying with the stories and completing them in their own imaginations. That Miffy makes a lasting impression on some young minds is confirmed by a new range of leisurewear for older teenagers that carries the rabbit's image.

In the 1990s, the idea that visual communication tends to be too prescriptive was a constant refrain among younger designers. Many rejected the idea that it was their job to transmit a direct, unambiguous message using a device such as a visual pun. They argued that their own screen-fed generation was able to handle messages of much greater complexity. Using computers, they blitzed their peer group with overloaded patchworks of text and image to filter and process. Let the viewer decide what it all meant.

The outline style is just as resistant to 'closure', but goes about it with much less fuss. The walking man on the cover of Gay Dad's much-hyped *Leisure Noise* album (1999) is even simpler in form than Miffy. Here, the outline – as a distinct line – disappears entirely. The shape is literally no more than a white hole in the blue background, a place where the colour stops. Its head is a featureless blob, as are its fists; only the bent right foot hints at a toe. The image is obviously derived from the pedestrian road sign, but it has become something else again in the process of appropriation. Since the figure is also the band's logo, it is hard not to interpret it as a picture of a 'gay dad', but where is he going? Is this a statement of purpose, a call to get up and join in? Turn the cover and you find two similarly stylised children heading his way. Ah, a warming reminder of old-fashioned family values, with a contemporary spin.

In the end, who can say? Project your own story into the picture's blank space. This is why the outline is exactly the right line for indecisive times. By leaving the details vague and declining to state where it stands, the style purports to allow everyone to join in. That faceless woman in the ejector seat could be you. This striding man could be you. There are no specifics to say otherwise. The outline is an empty vessel that tries to deny the real differences between us that we will, somehow, still have to surmount. What it suggests, more than anything, is not a message of inclusion, but a failure of nerve.

Shopping on planet irony

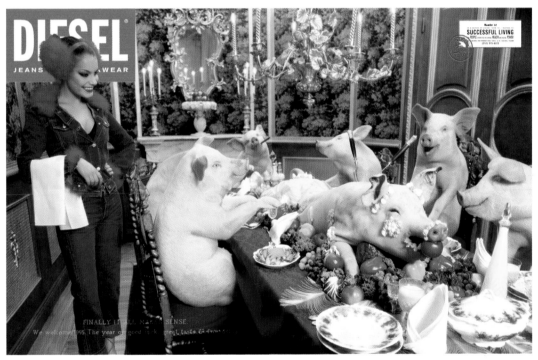

Print ad for Diesel,
no. 32 in a series,
1995. Creative
director: Joakim
Jonason. Photography:
Peter Gerke

The 1990s, as everybody knows, yawn, was the Ironic Decade. The essential groundwork was laid in the 1980s – though irony has been with us since at least Socrates' day – but the closing years of the twentieth century were the moment when irony became not just a useful device, to be applied when some specific occasion demanded it, but a routine, everyday attitude, a mass way of being, a social default. What irony offered users was an all-purpose form of protection. Just spray it on and nothing would pierce your psychological defences; nor would anything socially embarrassing leak out. Doubt everything, take it all with a large pinch of salt – yeah, right. In the 1990s, irony came to pervade just about every level of reality: magazines, movies, television, personal relationships, fashion, advertising and design. People without irony were just plain weird.

The Italian fashion house Diesel was in the advance guard of this popular irony trend. In the late 1980s it was still small and concentrated its efforts mainly on production – denim jeans and workwear in the time-honoured American style, manufactured to the highest local standards. All that was to change in 1991, when Renzo Rosso's company made an ambitious leap towards a more recognisable public image with the launch of its first world-wide advertising campaign. 'We wanted people to think, to question and to react,' Rosso explained later. 'In order to do that, we had to discard all the accepted assumptions about how to create effective advertising.'¹

This is a story, as we shall see, in which ironies abound. The first is that Diesel has never been widely perceived, and has never wanted to be seen, as an obviously Italian company. Its aim, from the first ad, showing a pneumatic blonde with her jean-clad legs laced through a big rubber tyre, was to speak in the lingua franca of Americanised global culture. The company name Diesel was chosen for this reason. The ad's copy, like all those that followed, appeared only in English, even in Italy. This was, it said, the first in a series of ' "How to . . ." guides to successful living for people interested in health and mental power.'

Diesel's early ads, retro-styled in collaboration with the Swedish agency Paradiset, offered a fairly direct – albeit ironic – satire on advertising's claim to offer a better life through consumption. The message was somewhat blunted by the invariable presence of a beautiful girl or a strapping specimen of manhood – or perhaps it was just rendered doubly ironic – but as the 'For Successful Living' series unfolded the ads developed a sharper edge. (Benetton, too, was sparking one controversy after another at this time.) One Diesel ad, featuring a gigantic cigarette, offered advice on 'How to smoke 145 a day'. Tobacco giant Philip Morris allegedly threatened to withdraw its own advertising if it ran again. Another ad, possibly ahead of its time in pinpointing the issue of gun

control, gave lessons in firearm use: 'teaching kids to KILL helps them deal *directly* with reality'.

Over the next few years, hitting its wacky stride, Diesel HQ served up a riotous parade of leathery sun-worshippers; sadistic dentists; generals in nappies; cannibal pigs; a boardroom full of blow-up dolls; a Turkish firing squad ('also available in . . . China, Sudan, Nigeria'); nuns in jeans; and Christ's second coming as a little green alien. As one crazed jest followed the next, it became increasingly difficult to decipher the intended purpose of these campaigns, apart from signalling madly that Diesel was every bit as wised-up and ironic as its young buyers, for whom almost any subject – politics, religion, the family, love, history, the environment – was suitable material for disengaged, postmodern fun.

In 1998, Diesel ran a series of seven ads purporting to be set in North Korea (they were shot near the Chinese border) that are probably its most mystifying and, to some observers, troubling images to date. In one bleak street scene, a man shelters from the elements with his child under a piece of cardboard, while behind him, on a wall poster (an ad within an ad) a bright-faced western couple, kitted out in Diesel, advertise a fictitious travel agency called 'Lucky Tours'. 'ESCAPE NOW!' says the poster. Clearly, some form of commentary on the invasive – and inevitable? – march of globalisation is intended. But the problem, as always with Diesel, or Benetton, or any similar ad, is that advertising is just about the least appropriate medium to carry out a public discussion of its own validity. 'What exactly is the Italian jeansmaker Diesel up to in this campaign?' raged one critic. 'This new kind of shock ad is quite possibly operating on a deeper level than even the advertiser understands. It seeks to commodify some of our most personal feelings about suffering, justice, greed and excess. Once co-opted, those feelings are lost to us.'[2] The irony, if that's what it is, is circular and self-defeating. It reduces everything to farce, clouding issues that require not self-serving image-games and jokes, but the clearest possible thought.

Primed by exposure to messages like these, I arrive at the Diesel Industry base in Molvena, about an hour from Venice, expecting to find industrial quantities of ambiguous 'attitude' among its 350 staff. But at all levels of the company, the purveyors of irony as a way of life could not be friendlier, more open, or less ironic if they tried. Diesel people – average age twenty-six – are positive. They brim with fresh-faced confidence, wear the company's clothes and truly believe in the Diesel cause. 'Everybody who works here should be a potential customer, more or less,' says Wilbert Das, Diesel's head of design. This is a creative environment that offers great freedom and the Dieselites show every sign of having a ball. Perhaps the down-to-earthness comes

from being surrounded by green fields and hill tops, far from the fashion hot spots of New York, London, Paris and Milan.

Das, an easy-going Dutchman, has been with Diesel for twelve years. His style team has outgrown its space in the brick-fronted HQ, and he is currently supervising the move to a new building, where we talk. He has a staff of thirty and despatches his designers in pairs on ten-day research trips to destinations of their own choice, such as Colombia, South Africa, Namibia and Bolivia. They come back loaded with clothes, fabrics, colour samples, tribal jewellery, tourist tat, local magazines – anything that might prove useful. The circular patterns on the knees and crotch of the Priest Pants (autumn/winter 1998) were inspired by some minefield mapping diagrams in an armoured personnel carrier crew manual that one of the designers found in Alaska. In recent years, Japan has been a mother-lode of novel ideas. In 1998, they based a collection on Mongolia. The theme for spring/summer 2001 was Africa – 'Le chic afreak'. It's a 'logical progression', says Das. He has a gut feeling that the timing is right.

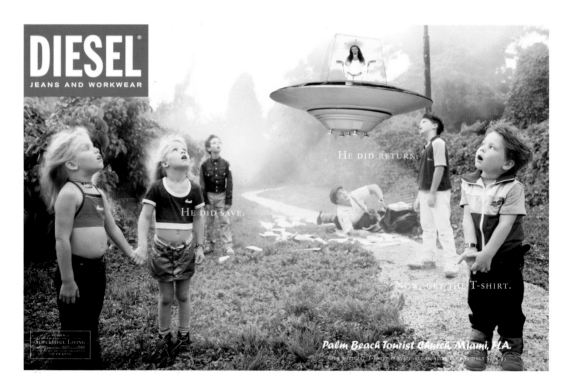

Opposite: Print ad
for Diesel, no. 52 in
a series, 1991-1998.
Creative director:
Joakim Jonason.
Photography:
Henrik Halvarsson
Below: Print ad for
Diesel, no. 86 in
a series, 1991-1998.
Creative director:
Joakim Jonason.
Photography:
Peter Gerke

The design process is as postmodern as the advertising. Images, shapes, patterns and textures that once had specific local meanings are sampled, spliced together in funky new combinations and recirculated in the international marketplace as commodities for knowing young consumers schooled to expect a continuous flow of exciting new sensations. From the start, Rosso wanted Diesel to be a global company and brand, but globalisation has become one of the more contentious and emotive concepts of the new century. The deep unease that many now feel about these trends erupts in protest on the streets of Seattle or Prague. The Diesel view, as expressed by Das, is that globalisation, though in some ways regrettable, is the future.

I ask him about the North Korea campaign. 'It was all about globalisation,' he says, 'brands forcing their own mindset into other people's culture and a lot of times it's completely irrelevant to what's happening in those countries. We just wanted to exaggerate that visually by getting all these people in grey uniforms and then putting lovely, western, sexy ladies telling them how to diet, or how to sell chewing gum. Of course, it's a visual joke, but very much mocking globalisation. And at the same

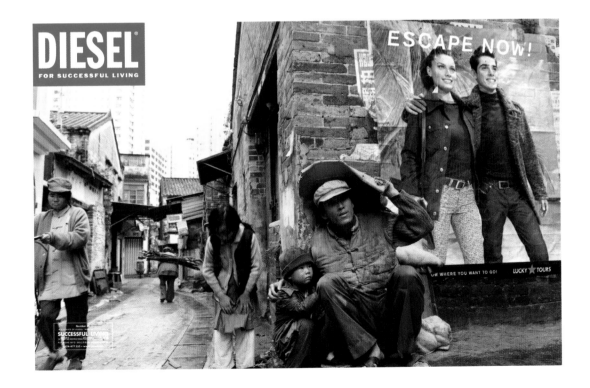

Digital supergirls

The model is lying on an overturned supermarket trolley. Her dresses – she is wearing two, paint-splattered and sprayed – trail among the rubbish on the ground. Behind her, through the trolley's frame, you can see an unsightly carpet of trash. A distant lorry is bringing more waste to the dump. Gulls on the lookout for scraps glide overhead.

Pop, in which this image appears, is a new magazine from the publishers of *The Face*. It's devoted, according to the cover, to 'Super Fashion, Shiny Art' – and that sums up its worldview. *Pop* is a very 'now' kind of product. It's hugely confident, totally convinced of its own glossy rightness, but artily vague about its purpose or point. It probably prefers 'enigmas' – the word comes up twice on its contents page alone.

In *Pop*, editorial and advertising are as tightly entwined, as brazenly intimate, as models at a fashion shoot. It's not easy to prise them apart and that is the way they – and no doubt their advertisers – like it. *Pop* showcases the work of digital lensmen like Mert Alas and Marcus Piggott (who shot the dump), Sølve Sundsbø, and Norbert Schoerner, who is also profiled in the issue. 'Is he a commercial photographer or an artist working in photography?' asks *Pop*.' Schoerner professes not to know; it's something to do with developing his full potential, apparently.

For two or three years now, digital photography has been all the rage in fashion circles grown weary of grungy *verité*. Work by *Pop*'s photographers and others can be seen in the book *The Impossible Image*. In the introduction, *Vogue* art director Robin Derrick enthuses about how new and exciting it all is, but offers no insights into what these 'extraordinary mind-games' might mean. The motivation of male fashion photographers has always been a bit suspect – all those women at your service, all those bodies to scope out. How much creepier to imagine them tweaking their digital playthings, pixel by pixel, into an 'image of impossible perfection' (Derrick).

Actually, we have been here before. Some of Sundsbø's *Pop* images are so sleek, so purged of specific surface detail, so polished until they shine with all the radiance of plastic, that they might have been confected in the early 1970s with an airbrush. Only an

art director who has forgotten, or somehow overlooked, early Dalí could describe the molten forms and trite dislocations of digital fashion imaging as offering 'new languages and conventions' (Derrick, again).[2]

What does feel new in these pictures is the blankness of many of the models, who bear more resemblance to waxy, animatronic dolls than living, breathing beings. Artificiality may be the very essence of fashion photography, but here the lust for epidermal perfection propels the images towards a mass-market embrace of concepts of the 'post-human' first broached in early 1990s art and critical theory. What does it mean, as a viewer and buyer of fashion, to want to identify with a fantasy figure who is inert, pliable, glacial – not really there?

One thing's for sure: the move from optical to digital imaging is fundamentally rewriting the viewer's contract with the image. According to one of their collaborators, Alas and Piggott originally hoped to do the shoot at a dump, but health and safety regulations prevented this. They could have abandoned the plan, but chose instead to take separate pictures of the dump and of the models in a studio and fuse them using the computer. If the models had been shot on location, the pictures would have had a completely different atmosphere and a significant part of the meaning would have come from our understanding that everyone, especially the models, got their hands dirty, risked possible injury, and put up with the discomfort and smells. Constructed digitally, in conditions of sterile detachment, the montages are merely frivolous. The images lack presence and weight. The dump doesn't appear to feature because it signifies something definite, or relates in some critical way to the subject. It is nothing more than a provocative 'look'.

This might imply that such pictures, shot differently, could have had something significant to say about fashion. This is debatable, to say the least. The key question that is sidestepped in *The Impossible Image* – where pictures are plucked from their original contexts and presented as art – and in *Pop*'s interview with Schoerner, is the extent to which it is really possible to speak independently, let alone critically, about the fashion system in publications that exist expressly to promote it. On the evidence of *Pop*, 'super fashion', with a big helping hand from 'slick advertising', could prove to be the undoing of 'shiny art'.

Graphic sex

When historians of the distant future furrow their highly developed brows and take a close look at the 1990s, in an effort to discover what *Homo sapiens* was like back then, they will need to take a long, hard look at pornography. A decade that began with Madonna, the world's most famous singer, generously announcing 'I'll teach you how to fuck' in her foil-wrapped *Sex* book, ended with the Starr Report on the sexual antics of the world's most powerful politician – a document so popular with readers that Congress' website all but caved in under the rush to download its graphic tale of artful new uses for tobacco products and dresses in need of a good drycleaning.

The pornographic sensibility, if not actual porn, has invaded everyday life to a degree that would have once seemed impossible. Porn is trendy. Hollywood makes a box office hit about 1970s blue movie pioneers, starring Burt Reynolds, and the same trashy signifiers of porno-chic – wood veneers, shag-pile carpets – turn up in Calvin Klein ads. Rock and rap videos routinely feature porn stars, while performers like Annabel Chong, subject of the documentary *Sex: The Annabel Chong Story*, become mainstream mini-celebrities. Cultural studies and film classes in porn are taught in American universities and, in 1998, the first World Pornography Conference was held at the Sheraton Hotel in Universal City, Los Angeles. An unseemly alliance of sex industry leaders and pro-porn professors with steamed-up glasses agreed that pornography was pretty much okay.

Then there is the product itself. During 1998, according to Laurence O'Toole's exhaustive study, *Pornocopia*, Americans bought or rented a total of 686 million sex tapes. The same year, an estimated $1 billion was spent online on pornography. On the supply side, anyone can get involved, from monogamous husband and wife teams to retired ex-servicemen who would once have whiled away their twilight years mowing the lawn, but opt instead to create thriving video and Internet businesses based on distributing images of themselves having sex.

Yet design, in this super-heated environment, remains a strangely chaste affair, still hanging on firmly to its inhibitions for the most part. Somewhere out there in the San

'Sexi machin muchos masculin', 2000.
Art direction:
Yacht Associates.
Illustration:
Jasper Goodall

Fernando Valley anonymous studios are pumping out lurid packaging for the likes of VCA and Vivid, but when was the last time any of them were celebrated in the design annuals? In the era of the self-proclaimed design auteur, one might have expected graphic risk-takers to respond to the ubiquity of sexual imagery in contemporary culture by incorporating it in some way, but Madonna's 1992 book – designed by Fabien Baron – remains something of a rarity as a piece of widely available 'high design' about sex.

On rare occasions when designers do loosen their buttons, pull down the blinds and get to grips with sexual imagery, it tends to be, quite literally, the graphic possibilities that turn them on. In a book of 'collaborations, commissions, inspirations and aspirations' by the British design team Yacht Associates, there is a sequence of three pink instruction cards for plastic 'Porno' kits. Since no information is given, it is not clear whether this is a real project for a European client – stranger things have emerged from the porn industry in recent years – or a private joke. The mildest kit features a tattooed muscleman in chains; in the other diagrams, a plastic 'porno lady' lies on her front and pleasures herself and a couple engage in intercourse – or a 'sexi machin porno shag', as the instructions put it. Each stage of the assembly process is described by numbered, exploded diagrams, including a helpful arrow to show exactly how the couple slot together once the two figures are complete.

The deadpan graphic conventions of the plastic model kit are tellingly observed and the images are undeniably amusing and even sexy in a sniggering, laddish kind of way. Whether the project is genuine or not, it exposes the contemporary fixation on minutely descriptive imagery of the sexual act at the expense of private feeling. In another collection from the same German publisher featuring the work of designer/illustrator François Chalet, a similarly decontextualised series of diagrammatic images shows fellatio, anal intercourse, 'breast orgasm' and sado-masochism, among other amusements (they seem to be illustrations from a 'sex lexicon' in a German magazine).[1] The computer-drawn figures have the simplified outlines and exaggerated gestures of digital avatars. Again, they are meant to be funny but, where the deft lines of a good cartoonist can fill the simplest shape with human presence, Chalet's stylised, pictographic sex-people, with empty circles for eyes, are strangely repellent and do nothing to convey the intense, personal pleasures of sexuality, despite their air of athletic sexual expertise.

Is a more grown-up vision of sex possible in graphic design? Perhaps the most interesting designers in this respect – though it is not an aspect of their work that has ever been discussed – are Laurie Haycock Makela and her late husband, Scott. First

came their *Sex Goddess* poster (1989), then, writing in *Emigre* magazine, Laurie described a Cranbrook Academy of Art project titled, with typical candour, 'Response of the vulva'. Scott Makela liked to keep audiences at his lectures on their toes with an image captioned 'Flesh and fluids make the mechanics possible', which showed penetration in startling close-up. The Makelas' lasting commitment to sexual imagery can be seen on the cover of the book *Whereishere* – just stand back a bit and squint.

For the Makelas, this material, used sparingly, was an integral part of their graphic vision – a celebration of life, passion, physicality, intensity, pleasure. If we still automatically think of it as pornographic, it is because the images of sexuality that pervade the media derive principally from porn and, little by little, as we consume them, they are transforming our conception of sex. For an early example of how sexual imagery changes sexual behaviour, think of nineteenth-century photographic pornography. To a modern audience, it simply isn't arousing. The participants are often awkward and ungainly because people had yet to learn how to display themselves erotically for the camera. Nowadays, everyone knows how to strike such a pose. Leaving aside the unsavoury fringes of the 'gonzo' scene, the most alienating aspect of industrialised, mass-market porn is not the acts it depicts, but a vision of human relations, performed by robotic bodies inflated to cartoonish proportions, which is the sexual equivalent of the Don Simpson blockbuster movie or the production-line Big Mac.

What to make, then, of Natacha Merritt's *Digital Diaries*, which evokes immediate comparison with Madonna's hymn to self-love by its use of blue ink on a silver cover? I picked up a shrink-wrapped copy, published by Taschen, in a reputable London bookstore, from a big display next to the latest novels. The twenty-two-year-old American's digital pictures of herself and her friends at play in assorted hotel rooms achieve some arresting compositional effects. Often taken in the thick of the action, by holding the camera at arm's length, they break with the conventional viewpoints and poses of masculine porn, if not with the content (erections and blow jobs). The book's picture editing and design, by Andy Disl, control the mood and sustain interest for 250 pages, which is no mean feat. Few fashion or architecture books deploy negative space with as much precision and flair.

The cover describes Merritt as a '21st-century girl' and in her use of the latest technology to chart her own 'sexual journey' she is certainly that. It's often observed that the video camera has been sexualised as an instrument by its use in the bedroom. 'If you can tape yourself,' says journalist Dean Kuipers, who tried it for *Playboy*, 'then you become one of those people who has somehow gathered all that magnetic, erotic

power that comes from just having their image replicated through electronic means. You've replicated your image electronically. And that's powerful stuff.'[2]

What else would we expect, though, in a culture that regards the video image as a form of self-validation and believes things don't really matter and aren't truly real until they appear on MTV? 'Everything becomes a lot more interesting when I have a camera,' says Merritt. 'Everything. Even everyday things.'[3] In *American Beauty*, the teenage boy's video of the empty plastic bag, buffeted by the wind, is the most unexpected, mysterious and mesmerising image in the film.

Twenty years ago, the idea of a young woman creating such a book would have caused cries of outrage and dismay. Not any longer. Merritt's *Digital Diaries* offer gripping evidence of the ways in which people's eagerness to embrace the camera as a sex partner is transforming behaviour and perception, as old ideas of privacy, modesty and even identity melt into air. As Channel 4's six-part television history of pornography showed in 1999, each new technology – printing, photography, film, video, DVD – is immediately pressed into service to satisfy our no longer secret craving to expose and to see.[4] Merritt, a very modern exhibitionist, is responding on her own terms to a collective obsession. In several images, a single, dark, beautiful, wide-open eye rises to the edge of the picture, watching itself being watched by the camera's aperture. Our complicity as viewers is correctly assumed. The publisher's blurb greets buyers with a cheery 'welcome, voyeurs'.

Erotic documents

Richardson, no, A1, 1998, Art direction: Laura Genninger, Design: Studio 191, Photography: Glen Luchford

Richardson magazine is a coffee-table show-stopper and that is where I first encountered it, next to the art and fashion mags on the reception area coffee table of one of London's most durable graphic stylists. To say that *Richardson*'s signals were provocatively mixed would be selling it short. From a first glance at its cover, it was clear that it offered an unusual fusion of art, luxury, editorial ambition and porn.

Let's start at the top. That pink masthead, spanning the full width of the cover – a surname? Yes, it belongs to Andrew Richardson, the editor-in-chief, but it is also, perhaps, an urbane kind of euphemism, a glammed-up version of 'John Thomas', 'todger', or 'dick(son)'. It's impossible to escape that reading, because under the masthead there is a woman with blonde tousled locks, hard stare, pierced navel, huge breasts with frank bikini tan lines, and porn-star pout. The issue number, AI, is printed with lascivious precision across her chest and Japanese-only cover lines in a hot pink circle (got that?) complete the tease.

Richardson has the heft, the spine-width and the glossy, dressed-to-the-nines self-confidence of a title from Condé Nast. For a first issue, it is beautifully put together and cleverly paced. It was designed, produced and published in Tokyo by a company called Little More, though the editing process is a bit of a mystery. Andrew Richardson turned out to be based in New York, but proved elusive when phoned. He may be the dishevelled fellow shown on page seven next to the reclining cover star, who toys with her own nipple. Then again, the rubric 'Editor's Picture' may just mean that it's an image he likes.

Certainly the magazine as a whole has a personal, connoisseurial feel. The front is a collection of curios: a rave for Amos Vogel's underground classic, *Film as a Subversive Art*; a Q&A with a female anthropologist ('a woman's submission is a very aggressive act'); a poem about shampoo bottles as dildos. But its idiosyncrasies are a sign of its authenticity as the expression of its editor's sensibility and taste, and that makes it quite different from the manipulative, oppressive, one-size-fits-all fantasyland of *Loaded*, *Maxim* and FHM. If *Richardson* is fascinated by the commercialisation of sex – there's an interview with American porn star Jenna Jameson; a grainy photo-report on erotic dancing – it doesn't leer at its subjects and it isn't prurient. It displays sexual imagery with a mixture of wonder and unashamed aesthetic delight. It can find space for anarchist writer Stewart Home on the male gaze, and the artist Richard Prince.

At a time when pornography is invading mainstream media, this is a challenging position to take. Is it acceptable to show sexual pictures? If so, what kind? In which contexts? How explicit? (*Richardson* AI resorts to cute masking effects when body parts exceed the limits of the law.) An issue of British GQ carried a lavishly-illustrated feature

on an American porn star who took on 620 men in an eight-hour marathon. By her own admission this was a 'freak show' and its presence in the pages of a magazine that apparently sees itself as a market leader raises awkward questions about the nature of exploitation. One problem with pornography's appropriation by commercial mass media is precisely that it isn't the real thing – neither sex nor pornography. It's possible to believe that we should be free to see uncensored sexual imagery (if we want it) while also questioning the cynical reduction of sexual desire to sleazy sexist spectacle and reliable sales tool among the lifestyle ads for watches, cars and *eau de toilette*.

Richardson, by contrast, is prepared to look squarely at sex for what it is. A collection of black-and-white photos – 'Lost and found' – has the same poignant erotic strangeness as the old snapshots exhibited in Amsterdam's Sex Museum, or the secret sexual photographs from the Kinsey Institute archives collected in the book *Peek* (2000). You are suddenly confronted with mysterious evidence, genuine documents of desire, from the hidden private universe of other people's sexual behaviour, fantasies and needs. At the back, an announcement seeks 'amateur porn positions and poses'. A 'readers' wives' for the visually literate – or something more interesting? *Richardson*'s debut issue gives the finger to the slickly marketed and spiritually inert world of mass-market pseudo-porn.

Death in the image world

The years before ten are vague. After that, it would be possible to put the images into chronological sequence, to arrange them as a timeline of sorts. Their order might be uncertain, but each of the early images is a personal landmark, a little revelation, a life-deflecting shock. Each one has stuck. Sifting the past, I always return to them and I imagine I always will. There must have been many others and it is likely that some of them were equally troubling at the time. These are the images I remember, though, and for that reason they are the images that matter – a stain in the mind that no solvent could ever erase.

Was it the guillotine that came first? Or the rock? Let's say it was the guillotine. I was seven, certainly no older, sitting by the window in the lounge, looking through an encyclopaedia. It was a simple, black-and-white, pen and ink drawing: a machine for chopping heads off – cold, mechanical, efficient, inescapable. The trapping of the head and the angled blade's controlled descent on the rope made it much more horrible somehow than a swinging axe and an executioner's block. The rock was equally surprising, a method of deliberate killing that had never occurred to me, suddenly disclosed in a jungle story told on the children's television programme, *Blue Peter*. It was the mid-1960s, so the medium of revelation was once again a line drawing – the narrator's words explained more than you saw. The tribe's victim was forced to place his head on a ceremonial rock and another huge stone was brought down on his skull to dash out his living brains.

Boys of my generation were obsessed with the Nazis. The war still felt very close and we encountered it everywhere: in people's memories, on television, at the cinema, in plastic model kits of exciting, swastika-marked Panzers and Messerschmidts, but, above all, in comic books. In 1965, on holiday at Tehidy in Cornwall, staying with one of my mother's friends, I sat in bed one evening, reading a war comic. An ally was being tortured in a farmhouse. Again, nothing explicit was shown. In one panel, we were up in the sky with a British dive bomber pilot, looking down on the farmhouse below. He

knew there was no way to save the prisoner and, as an act of mercy, destroyed the house to put him out of his misery. This was a startling idea: pain so extreme and unendurable that a person would be better off dead. At that point I started to grasp what it meant to be tortured. Before then, it was nothing more than a word, easily said. It was the beginning of an understanding, imparted by images, that the Nazis had been involved in deeds far more shocking than anything I had been told. In a friend's bedroom, I picked up a horror comic and read a story in which a Nazi boasted about owning a lampshade made of human skin, and this was shown. Visiting the house next door, I pulled a book about the Nazis from a bottom shelf and saw a photograph of a deformed leg that seemed to be the result of some kind of ghastly experiment.

It would be several years before I learned the unimaginable truth behind these hints. On the way to that knowledge, many other unwelcome images put down twisted roots in my head. If my father thought something on television was unsuitable for family viewing, he switched off the box. One Saturday evening, we watch a Hollywood film, set in the middle ages. As a punishment, a man's eyes are to be put out. In order to spare him and fool his tormentors, a friend crushes two grapes in his fingers and presents these pulps as the 'eyes' instead. Nothing has actually happened to the man, but the idea of such cruelty is enough. I am appalled. I start to cry. My father leaps into action. 'We're not watching this,' he exclaims, turning off the set. On another occasion, we watch James Cagney playing a hoodlum in *Angels with Dirty Faces*. It's the end of the film, where Pat O'Brien, as the neighbourhood priest, tries to persuade Cagney, his boyhood friend from the slums, to pretend he is yellow and go screaming to meet his death in the chair so the local street gang won't idolise him any more. Cagney seems to comply – or does he? I understand the ambiguity as an adult, but all I see, as a boy of eight or nine, is a charismatic tough guy reduced to abject terror at the prospect of being fried. I am distraught.

My father might have attempted to handle this by explaining the moral complexity of Cagney's possible decision to sacrifice his own reputation to help redeem others. His reaction is more unsettling, though not unexpected. He turns off the TV. I know even then that he is trying to protect me, but this only confirms my growing sense that the world is full of violence and horror that it would be better not to confront. Besides, the image has already been implanted. Even if it is eventually forgotten, the damage has been done. Now the story will end without resolution or understanding on this upsurge of shock. Somehow, in these moments after my father has retrospectively acted as censor, I always feel guilty, as though I have been caught looking at something I was not meant to see.

The words above the gateway say 'Enter at your peril'. It's 11.15 on a spring Saturday morning and the queue is already forming outside the London Dungeon, one of the city's most popular privately-owned tourist attractions – spin-off Dungeons have opened for business in York, Edinburgh and Hamburg. Immediately in front of me are a father and his young son, who looks about seven, and a mother and her two boys, perhaps seven and nine. Behind me are a young woman and her daughter, a little girl of five or six, wearing a pink puffa jacket. 'Do you really want to do this as a birthday treat?' her mother asks. The little girl is excited, full of anticipation. 'Yes, I like this sort of thing,' she says. She skips off to look at a poster. 'There's vampires,' she reports. 'I like vampires.'

Lurking in another doorway, under a sign depicting an axe and a chopping block dripping with blood, is a ghoul in a black cape, his face made skull-like with greasepaint. In the entrance, rusty chains and iron contraptions hang from the ceiling and a sign in a heavy wooden frame cautions parents that displays of an explicit nature may not be suitable for children. The little girl's mother is growing concerned and mentions the sign to her daughter. 'Are you sure you want to do this?' she asks her. The little girl is adamant. 'It's not real,' says her mother. 'It's only make-believe.' The queue takes us round a corner into a cemetery where skeletons slump in open graves from which clouds of dry ice rise as monks chant spookily from hidden speakers. Through an archway, which leads to the ticket desk, we can watch visitors posing for the Dungeon's resident photographer. A man pushes a teenager's head down on to a kind of blood-drenched pillory. Another family member levels an axe at his neck and someone holds a basket up for the head. They can collect the souvenir picture at the end of the tour.

It's eighteen years since my previous visit and inside much has changed. In the early 1980s, the Dungeon's use of its location, underneath the London Bridge railway arches, was simple, though overwhelmingly effective. The exposed brickwork was damp. It was musty, evil-smelling and oppressive. I wandered freely between revolting, life-sized waxwork tableaux of mutilation and death. Since then, the Dungeon has gone through many enhancements and updates. It has fans who visit it annually. New exhibits arrive, old exhibits are replaced. Hard luck if you want to see Vlad the Impaler's handiwork – they retired him years ago. Today, the ethos and audience management are much like a theme park's. You have no alternative but to follow a predetermined path. You join a tour group. You participate in funny routines with actors. You even go on a boat ride along the 'river of death' to Traitor's Gate.

At first, though, because you enter in small parties and the passages twist and

turn, the Dungeon seems strangely empty. Following the path past a series of wax models posed in filth-encrusted chambers, you can feast your eyes on boiling alive, flogging, crushing, beheading by axe or guillotine and burning at the stake. Plague victims make vile retching sounds, a torturer casually disembowels a prisoner, and another sufferer, force-fed with water, presents a stomach like a vast, infected boil, so obscenely distended it looks set to burst. There are history lessons, too. Anne Boleyn kneels, waiting for the executioner's uplifted sword. An actress's face, projected on to the figure, protests her innocence above the pauper's coffin, waiting for her body below. Three illuminated cabinets display rusty implements of torture, with captions for the slow-witted, detailing their use: flesh hooks, tearing tongs, the scold's bridle, a thumbscrew, iron flails for stripping the skin, and a knife for the removal of 'surplus' flesh. I see the mother and two boys from the queue. The younger boy doesn't want to look, but his parent says 'I do' and draws him in with her towards the glass. A little further on, a figure hanging from a gallows is jerking up and down on a rope. Only by walking past do you discover that his guts are slopping out of him like a mass of jelly. Another small boy sees this horror and rapidly looks away.

What do children learn here? In the 1960s, the smallest hints sufficed to intimate a universe of darkness. Youngsters visiting the London Dungeon in 2001 are offered, in the guise of a good day out, an advanced course in human depravity. Most of them must arrive feeling relatively secure in their bodies. They will have seen and experienced nothing more serious than cuts and grazes and, if they are unlucky, perhaps a few stitches or a broken bone. What they discover, from display after display, is that the body is a fragile container. It can be torn open like a parcel, violated, tormented, destroyed, its insides released into the air in a torrent of tissue and blood. There are people – monsters beyond any rational explanation – who do this and show every sign of enjoying it. Parents seem to accept these sights, view them as 'fun' and want their kids to share in them, too.

It's time now for the highlight of any visit to the Dungeon. An actress dressed in grimy, nineteenth-century, working-class clothes will be our guide. We gather around her – parents and children. There is awkwardness in the air, subdued anticipation. We are in a mock-up of a street called Buck's Row in Whitechapel, East London. Behind our guide, on the ground, something shapeless and alarming is concealed under a filthy sheet. The guide talks for a bit, setting the scene, then pulls off the shroud to reveal the effigy of Mary Nichols, known as Polly, murdered on 31 August 1888. She describes the mother of five's wounds: the puce gash to the throat running from ear to ear, the cruel mutilation of the belly. We have all heard about the legendary

Jack the Ripper (except, perhaps, for the youngest visitors) and this is what he did.

In the next display, another street scene, there are three illuminated windows above our heads, each one showing a mortuary photograph of a dead woman's face. The light flashes eerily behind the backlit sepia images. At this point, the exhibits have abruptly ceased to be imaginary, set in some distant barbaric past when things like this used to occur. These are photographs of real dead people from a time much closer to ours, as even young children will grasp and, whereas with the earlier exhibits, there will be little sense, for a child, of context or narrative, here the story is related by our guide, as if by a teacher or television presenter. A man is killing women, slashing their throats, doing horrific violence to their flesh, sometimes removing bits of their bodies; all of the women are prostitutes. These are hideous sexual crimes, impossible for a child to understand, and, again, the lasting image is of the softness of the stomach, the centre of the person, ripped open, the innards bestially eviscerated. Moreover, two of these women were mothers: could this happen to *your* mother? The final street scene is devoted to the Ripper's fourth and fifth victims and, as before, the lighted windows overhead draw the eye. In one, illogically, there is a flickering, full-length mortuary shot of the third victim, Elizabeth Stride's naked body. In the other, a staging in shadowplay of the slaughter of Mary Jane Kelly, the final murder and the only one to take place indoors. Jack the Ripper raises his knife and blood splashes the window panes. This fades to murky glimpses of the notorious photograph, taken at the crime scene, of Kelly's grotesquely mutilated remains.

After an interlude in a courtroom, where we run through the possible suspects, we file into a dark, low-ceilinged chamber to see what would have happened to Jack had he ever been caught. We gather around a walled pit, the children at the front, craning their necks to look over the edge at a huge, brown model rat. We can hear heavily amplified breathing that sounds like it is coming from inside a bag – it's the condemned man's breath. Suddenly, the gallows trap door above the pit swings open with a crash and the Ripper's body drops into our midst.

The Dungeon's final attraction, the Fire of London, is a bit of a non-event. As we wait for the blaze, I notice the mother and two boys who were in front of me in the queue. Both of them press in close to her side, gripping her hands and hiding among the taller grown-ups. The younger boy, in particular, seems glazed-over, passive, almost shell-shocked. His mouth hangs open. All the life has gone out of him. He is just getting through this now, wanting it to be over. He has his hood up. Earlier, I heard his mother ask him why. He returns my gaze with big, sorrowful eyes. After the 'Jack the Ripper Experience' and everything else he has seen here today, he probably fears the worst in

this room, but the worst is over – at least until bedtime. There will no more disembowellings today.

Outside, the queue stretches down Tooley Street, past the entrance to London Bridge station. Everybody is here for thrills and a great day out with the family. A couple have brought their daughters. The two little blonde girls are barely old enough to have started school.

It took a long time and I had to work at it, but over the years I have toughened up. I can look at almost anything now. Sometimes, I come across images that would once have troubled me for weeks and I feel hardly anything at all. I have become desensitised to a degree – not all the time, not with every kind of image, but often. I am not proud of this, though I don't think it is at all unusual. I certainly don't offer it as evidence of my own worldliness, sophistication or 'coolness'.

Another scene from my timeline: at school, when we were sixteen, they showed us an anti-drugs film, containing scenes in a mortuary. The trolleys, instruments and cold-storage units for the corpses were unsettling enough, but the dead girl junkie with the cracked-open chest, lying on an autopsy table, was a new order of horror. At least one boy fainted. I stayed upright, but I was deeply disturbed by this grisly colour close-up – even more disturbed, perhaps, than I had been by seeing concentration camp footage two or three years earlier. When I got home that day, I was still shaking. The numbing physical shock, a brutal new awareness drilled into the nerve endings, lasted for days. Years later, I can look at post-mortem images with something approaching detachment. I can be moved, but not viscerally shocked, because I accept that this is how things are. Back then, I felt as though a rent had been torn in reality and I had plummeted headlong, without warning, through the ragged portal of the dead girl's open ribcage and into a hellish underworld of abjection and despair.

While many prefer to avert their eyes, on some level everybody is fascinated by the facts of dying and death. 'When you look at death, you're trying to discover a secret about life,' says Dr Stanley Burns, an American archivist and historian, with a collection of more than 500,000 photographs. Burns has published a number of pictorial histories exploring aspects of death: memorial photographs, medical photographs, war photographs. He describes watching people at book signings look at these images. Sometimes they find them hard to handle, close the book, walk away, then return to look again. Burns believes that the desire to see is pathological only when it becomes a compulsion: 'If you never get the answer you are looking for, and only the constant question, I think that is when it becomes unhealthy,' he says.[1]

Children share this need to some degree, though it is doubtful that seven-year-olds have much to gain from pornographically explicit images of torture, execution and sex crimes, however strongly their parents are attracted to these things. In *Struwwelpeter*, published in 1844 and given a new lease of life in the theatre in the late 1990s, violence and mortality are put to cautionary use. Harriet plays with matches, despite being warned against it, and pays for her folly by burning to death. Augustus repeatedly refuses his soup, dwindles to a stick, and on the fifth day he is in the grave. In fairy tales, violent death has more complex psychological uses. The Grimms' telling of *Snow White* ends with the queen forced to put on a pair of red-hot iron slippers and dance until she drops dead. In *The Uses of Enchantment*, Bruno Bettelheim argues that this has a positive symbolic meaning, showing children how unrestrained sexual jealousy directed at others will end up destroying itself, and that 'outer and inner turbulence' must be eliminated before happiness is possible.[2] There is also, in children's literature, plenty of gratuitous lip-smacking over the darker side of human nature. The popular *Horrible Histories* series by Terry Deary, aimed at eight- to eleven-year-olds, promises 'History with the nasty bits left in!', while this typically gruesome titbit is to be found in John Farnham's *The Short and Bloody History of Knights*: 'Some were hung up by their thumbs and smoked liked kippers, some had burning things tied to their feet, while some had ropes twisted round their heads till their very skulls split and their brains exploded.'

The fascination may be natural, something to relish at a safe distance, to hear about rather than see, but images of violent death are becoming ever more lurid and extreme, and much easier to come by, too. Not long ago, anyone actively seeking this kind of material had to engage in a self-conscious mission. In 1991, a trio of young men in Stockport launched a 'zine called *Headpress* devoted to the trinity of 'Sex. Religion. Death'. It was an authentically subcultural project – cheaply produced, technically amateurish, fired up with strange attitudes and obsessions, a gleefully unsavoury, nightmare alternative to commercial publishing's upbeat concerns and formulae. The aim, wrote one of the editors, David Kerekes, in a first-issue editorial, was to lift the rock and see what was lurking in the ooze underneath. *Headpress* would 'show more because there is more to be seen'. The editors rejected the tame perspectives of everyday culture – 'The same old books, the same old ideas, the same old thing.' Instead, they urged readers to 'embrace life like you do your images of death (for these are certainly many, and frightening, and wonderful) . . . '[3] In the early 1990s, *Headpress* had the heady tang and dangerous allure of forbidden fruit. How modest – how tame – the grainy, photocopied images in its early issues seem now. In the space of a decade, the 'rock'

has shape-shifted into a high-tech vitrine, a public viewing zone, brilliantly illuminated. Anyone can take a look. Just visit an Internet site and click through images of gory death over a beer; pick up arty coffee-table compendia of archive snaps of American lynchings, murder scenes and car crashes, broken bodies strewn across the road; drop into any newsagent and buy the latest *Bizarre*, which, in February 2001, showed a series of police photos of a killer's victims, with multiple stab wounds and their penises and testicles cut off.

In the course of the 1990s, fictional violence, too, seemed to change. Perhaps, if truth be told, viewers were still secretly turned on by blood-letting, but, after Tarantino, the idea seemed to be to demonstrate your disengagement by barely reacting at all. Violent death was casually delivered, ironic, affectless, funny. In a word – cool. In *Lock, Stock and Two Smoking Barrels* (1998), the gang arrives at a pub, the pub door bursts open and a man in flames staggers out into the street. The gang give him mild quizzical looks, express no further concern or interest and continue inside for a drink. Viewers know perfectly well that burning alive is hideously painful, but the film encourages you to sever your natural empathy from the screen image and savour the gag as outrageous spectacle and proof of your unperturbable contemporary attitude. If you can see it as 'burning' rather than burning, then perhaps the gang's total indifference to 'suffering' really is a laugh. While it is still possible to create film images that convey a convincingly sickening sense of the reality of violence – as in the first half hour of *Saving Private Ryan* (1998) – such sequences often serve to remind us, by using 'documentary' styles of film-making, how much more powerful it is to look at unadulterated images of the real thing, if it is the spectacle of violent death we desire to see.

Yet the fictional and the real do have consequences for each other. There is unavoidable traffic between the two. There was a time when I would have found the burning man scene shockingly callous. How would I put it now? I think it is . . . regrettable. I can't take a film-maker who would create such a glib episode the slightest bit seriously, but I can't say I am actually shocked. Like everybody else, I have supped full of horrors. It takes a lot more to upset me. What happens, then, when you move from the burning man to one of the men with no genitals in *Bizarre*? Or one of the prostitutes killed by Jack the Ripper? They may be real people, but they are served up for our amusement on the same spectrum of 'entertainment'. Is it possible to cast aside your routine ironic detachment or salacious attraction and see these victims as human beings? If we are not able to do that and try to enter these images on their terms rather than ours, then there can be no prospect of discovering what Dr Burns calls 'a secret about life'.

I don't want to think that I have become unshockable. I know that I haven't. Ten years ago, browsing in a bookshop in Charing Cross Road, London, I stumbled across a series of photographs which afflicted me with the sense of nervous shock that I experienced at sixteen when I saw the autopsy film. These images occupy a key position in my timeline because they deposited a deeper, more corrosive stain than some of the others. Yet, in this case, my citation of these particular pictures – rather than countless, equally representative alternatives – is not merely personal. As I later discovered, these photographs are notorious. What they show is so horrible and disturbing that they have acquired a special status in photographic literature and debates. Others have singled them out for precipitating a moment of searing psychic revelation. The moral problems they pose for viewers are sometimes aired by photography writers and critics. They tend to be discussed rather than shown.

The aftermath of violence is easier to accommodate than the process of violence itself. When you look at a photographic image of a dead body, you become a voyeur. The technologies of seeing make everyone a voyeur, though, in all sorts of ways, and most of us don't worry too much about this any more. When you look at an image of someone doing violence or killing, you are implicated in much more unsettling ways. To empathise with the victim is emotionally painful and upsetting; to empathise with the tormentor or killer is to surrender to sadistic impulses. Published photographs and video images of the act of killing are unusual, even now. Those that are widely publicised often become the subject of media debate and sometimes, in their comparative rarity, they become almost iconic: the Saigon police chief shooting a Vietcong prisoner in the head, in 1968; the Bengali guerrillas bayoneting Biharis on a polo field, in 1972; the gunning down of a Palestinian boy, Mohammed al-Durrah, as he cowered for protection behind his father, in 2000 (though, in these images, the killer is not seen).

Photographs of torture are much more rarely published. As you read this, it is a certainty that people are suffering in this way. Since 1997, Amnesty International has received reports that torture or ill treatment by agents of the state is widespread in more than 70 countries and common in at least 80 other territories. Victims are beaten with sticks, whips, iron pipes, gun butts, baseball bats and electric flex. They are shackled, confined in leg irons that gnaw into the flesh; suspended, suffocated, submerged in water; tormented with thumbscrews; and viciously abused on the genitals with electro-shock batons openly designed and manufactured in Europe and the US. Judicial amputation is still practised in Afghanistan, Iran, Iraq, Nigeria, Saudi Arabia, Somalia and Sudan. Sometimes, after it is over, if the victims survive, we hear their appalling accounts through organisations like Amnesty and the Medical Foundation for the Care

of Victims of Torture. Torture is shameful. It happens in secret, in filthy cells, behind closed doors, without witness and beyond hope. No newsman is there to photograph the agony. Even if such pictures existed, they would not be shown widely: they would be unbearable to look at and regarded by publishers and viewers as tasteless beyond belief. We might accept the fact of torture in the world as a vague, impersonal abstraction, but it is too alarming to admit in our guts. 'Repressing each atrocity maintains the illusion that the world is fundamentally a tolerable place,' writes the moral philosopher Jonathan Glover. 'Bystanders know enough to see that knowing more will be uncomfortable. Looking away, there is little sense of an enormous evil it is urgent to stop.'[4] Worse, we somehow retain the idea that images of extreme torment, disassociated from twenty-first-century reality and notionally sanitised as 'make-believe', are fit to show the kids down at the Dungeon on a Saturday morning.

The four photographs I saw that day in Charing Cross Road record a Chinese state execution carried out in public in Peking in April 1905. They were published by Georges Bataille in *The Tears of Eros*.[5] I am not going to describe them at any length here. The condemned man, Fou-Tchou-Li, had murdered a Chinese prince. His punishment was called the Hundred Pieces and, in the pictures, he is slowly dismembered by his executioners, who saw off his arms and legs and strip away skin and flesh, leaving gaping wounds in his agonised body, as the crowd of spectators looks on. In 1925, Bataille was given one of the pictures by a psychoanalyst colleague and was obsessed with it, we are told, for the rest of his life, apparently finding it in some way 'erotic'. Other viewers have also described the images' overwhelming effect on them. The Swiss artist H.R. Giger, designer of *Alien*, tells how, in the 1960s, as a student at the Zurich School of Applied Arts, he was shown the pictures by a friend. They shocked him as nothing before. 'I was afraid to be alone,' he recalls. 'For a whole week I tried to stay awake for as long as I could. I dreaded falling asleep, because I was certain to dream about them.'[6]

I haven't returned to these photographs since I discovered them by chance. I considered looking at them again for this essay, but there is nothing to be gained. Quite the opposite. With another viewing, the shock might be – no, almost certainly would be – reduced, because it always is. I don't want to 'get used' to these images. Something was revealed in that moment in the bookshop, something awful and rarely disclosed. I want to leave it as it is, undiminished, intact.

If you didn't know it before you arrived at the gallery, and you moved through the room quickly, you might never realise how the glass cabinets are arranged. There are nine of

them altogether, spaced out so you can walk between them and view the exhibits from all sides. Only if you could somehow ascend into the air and look down from the ceiling would it be possible to see clearly how the vitrines, as a group, form the shape of a swastika. Not the hated Nazi swastika, however, with the right-pointing cross. The cabinets are organised to point the other way, suggesting – with caustic irony, as it turns out – the more benign, age-old uses of the device as a symbol of light and life.

For what the cabinets display could not be more 'hellish'. Indeed, this is the title of the piece – Hell – a work of art by the British artists Jake and Dinos Chapman, presented in autumn 2000 at the Royal Academy, London, in a group exhibition called Apocalypse.[7] The Chapmans have also seen the Tears of Eros photographs. An earlier sculpture, Cyber-iconic Man, shown at the ICA, London in 1996, was inspired (if that is the right word) by the victim's sufferings. At the centre of Hell is a volcano from which a lava of tiny Nazis vomits forth. They flow down its sides and swarm across wooden bridges and out into a nightmare landscape of torture and degradation worthy of Bosch. The London Dungeon offers visitors the spectacle of a few dozen wax figures. The Chapmans, like deranged junior modellers, have crafted, painted and glued 5,000 plastic figures . . . or is it 10,000? . . . no one seems certain, much like real atrocities, where the exact toll of victims is never finally known. On a first viewing, Hell's narrative is almost ungraspable. It assaults you in garish, over-detailed flashes. It demands a great deal of your time and, even then, few viewers will reach the nadir of its horrors. There is always another diminutive outrage to savour.

The Nazis are both tormentors and tormented. Naked mutants with multiple heads and limbs commit acts of unspeakable savagery on the Nazi hordes. There are hilltop crucifixions and hangings from telegraph poles and bridges. Hundreds of little decapitated heads impaled on sticks scar the hillsides like a pox. Vultures tug at ravaged flesh, goats feed on human remains under the trees, skulls line the church roof, the dead rise from their graves and skeletons ride forth in helmets like horsemen of the apocalypse. Mutant puppet-masters operate anguished Nazis by strings piercing their hands and feet. In a death camp, two mutants empty Zyklon B gas pellets through roof vents on to Nazis in the gas chamber below. A Nazi holds aloft a severed head, as other soldiers gorge themselves on human limbs. By peering through a broken skylight, it is possible to see an operating theatre or, more likely, a torture chamber, the walls and floor awash with blood, the shelves stocked with body parts. In the burnt-out church, a gorilla harangues a congregation of Nazis and mutants. The horrors surge on through a neoclassical ruin decorated with swastika banners. At the end of a jetty, a multi-limbed mutant appears to be battling with itself. The occupants of an armoured tank, its side

Detail of *Hell*, Jake
and Dinos Chapman,
1999–2000.
Photography:
Stephen White

cut away for viewing, are knee-deep in blood. On an island in a lake, there is a house with
a picket fence, but even here, in *Hell*'s most tranquil moment, a man is serving a head on
a tea tray. At the swastika's opposite corner, in a slimy pit full of bodies, limbs interwine
in a final, obscene, cankerous embrace and humanity is reduced to the level of garbage,
fit only to be thrown away.

The more intensely you peer into it, the more you acknowledge *Hell*'s horrible
fascination. Many people are intrigued by model train sets, miniature figures, trees,
vehicles, buildings and towns. *Hell*'s pleasingly tiny scale wrong-foots viewers by
obliging them to look closer, to press their faces to the glass, to descend into its blood-

soaked killing fields and death factories, to become intimate, even comfortable, with its depravities. Much of what it shows is familiar. We have internalised this terrible knowledge of who we are, what we have done and continue to do, even as we are unable to grasp the particularities of so much individual suffering and death. What we see in Hell represents just a fraction of the misery inflicted by mankind in the twentieth century, a miniscule proportion of the actual body count. Since the end of the Second World War, notes Stanley Cohen in *States of Denial*, some 25 million people have been killed, often by their own governments, in internal conflicts and ethnic, nationalist or religious violence.[8] Whatever the Chapmans' intentions might be, the absurd horror-movie-bloodbath exaggerations of their cannibal holocaust ridicule the inadequacies of our moral response. The toy-like scale mocks our distance and detachment. Measured by its content, *Hell* may be one of the most revolting works of art ever made and possibly the work most packed, per square inch, with atrocity. All kinds of people have come along to see it, but I hear no gasps of dismay. No one flees from the room in disgust. No one throws up. No one protests at this anti-humanist abomination (for this is its point: this is exactly what it is). Three young women are looking down into the death camp's yard, pointing, laughing, enjoying themselves, chewing gum. A man with a camcorder starts filming the vitrines, as though he is trying to bring the static tableaux to life, as though, for him, *Hell* is not quite exciting enough. 'It's very disturbing,' says a man in his fifties. The young man with him doesn't agree. 'No, it's all right.'

A few weeks later, I visit the new Holocaust galleries at the Imperial War Museum, London. Outside, there is a sign warning that the displays are not recommended for children under the age of fourteen. Several parents have decided to ignore this advice. Two little sisters in soft, black leather coats are running around among the harrowing exhibits. One mother is conducting her reluctant son, a dark-haired, solemn-looking boy of about eight, between the displays, with a great sense of purpose. They stop in front of a large blow-up photograph of a vast open grave at Proskurov in the Ukraine, filled with the contorted, unclothed bodies of 7,000 Jews massacred by Einsatzgruppe C, one of the Nazis' mobile killing squads. The mother leans down close to her son's ear and, tenderly but firmly, continues with the little boy's introduction to hell.

Che is risen

1. TOKEN REVOLUTIONARY Branding is increasingly talked about these days in terms of religion. The brand demands a loyalty, an act of faith in the impalpable inner light of a product or service, that seems to function as a surrogate, in a secular society, for at least some aspects of religious feeling. Yet the church itself – the Christian church – once so ruthless at reinforcing its 'brand identity' through the iconography of the annunciation, the virgin birth, the cross and the resurrection (see 2,000 years of art history) no longer has any real grasp of how to use imagery to convey its message to an image-based society.

This failure troubles the more media-minded Christians and at Easter 1999 a British organisation called The Churches' Advertising Network (CAN) made its latest attempt to inspire the masses through ads. The famous image of Argentinian Marxist revolutionary Ernesto Che Guevara, endlessly reproduced on badges, posters, T-shirts and keyrings, has a Christ-like quality that has often been noted. Reversing the conceit, the CAN campaign, devised by a group called Christians in Media, renders the Son of God in the black-and-red poster style of Che. Christ, too, is seen from below, his resolute gaze fixed on some distant visionary goal, his dark unkempt hair and beard framing his face. The martyred guerrilla leader's beret, with five-pointed star, is replaced by a crown of thorns.

CAN wanted us to see Christ not as a 'wimp' in a nightshirt, but as a revolutionary figure who rejected materialism, challenged authority and threw the money-lenders out of the temple. But the precise ways in which the image of Che-Christ is supposed to signify are vague. Assorted clerics were quick to point out that while Christ is the twentieth century's greatest revolutionary, he was – breathe easy, Middle England – certainly no Red. One of the Christian creatives behind the campaign admitted that Che was selected as the 'Trivial Pursuit' or 'token' revolutionary. For CAN, Guevara wasn't a real historical figure with real political motivations: he was an icon with the romantic glamour of dead stars like Dean and Monroe.

So is Che – shot to death by a Bolivian army sergeant in a mud-floored schoolhouse in 1967 – still a meaningful figure? The Che-Lives.com website and substantial biographies

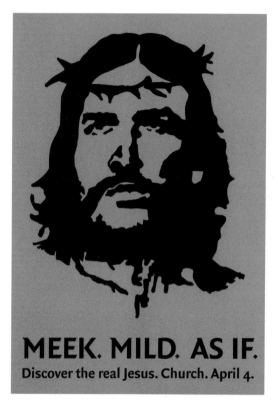

MEEK. MILD. AS IF.
Discover the real Jesus. Church. April 4.

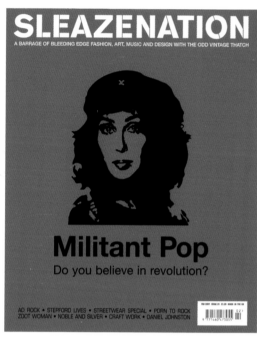

SLEAZENATION
A BARRAGE OF BLEEDING EDGE FASHION, ART, MUSIC AND DESIGN WITH THE ODD VINTAGE THATCH

Militant Pop
Do you believe in revolution?

AD ROCK • STEPFORD LIVES • STREETWEAR SPECIAL • PORN TO ROCK
ZOOT WOMAN • NOBLE AND SILVER • CRAFT WORK • DANIEL JOHNSTON

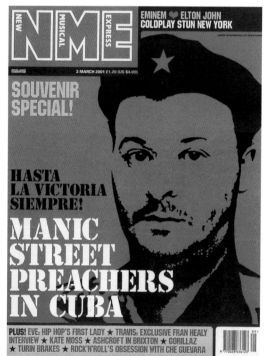

NME
NEW MUSICAL EXPRESS

EMINEM ❤ ELTON JOHN
COLDPLAY STUN NEW YORK

3 MARCH 2001 £1.20 (US $4.00)

SOUVENIR SPECIAL!

HASTA LA VICTORIA SIEMPRE!
MANIC STREET PREACHERS IN CUBA

PLUS! EVE: HIP HOP'S FIRST LADY ★ TRAVIS: EXCLUSIVE FRAN HEALY
INTERVIEW ★ KATE MOSS ★ ASHCROFT IN BRIXTON ★ GORILLAZ
★ TURIN BRAKES ★ ROCK'N'ROLL'S OBSESSION WITH CHE GUEVARA

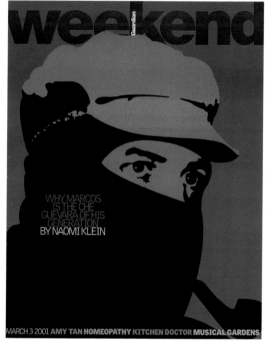

weekend
Guardian

WHY MARCOS
IS THE CHE
GUEVARA OF HIS
GENERATION
BY NAOMI KLEIN

MARCH 3 2001 AMY TAN HOMEOPATHY KITCHEN DOCTOR MUSICAL GARDENS

Top left: Poster,
The Churches'
Advertising Network,
Agency: Christians
in Media, 1999,
Top right:
Sleazenation,
February 2001,
'Cher Guevara',
Illustration:
Scott King,
Bottom left: New
Musical Express,
3 March 2001,
Illustration:
Simon Cooper,
Bottom right:
Guardian Weekend,
3 March 2001,
Illustration:
Liz Couldwell

by Jorge Castañeda and Jon Lee Anderson, published in 1997, attest to his enduring interest for some. In 1999, at an exhibition of Cuban posters at the Sho Gallery in London, the images of Che sold best. The website and biographies are for the seriously committed, but the rest is fashion and, in the case of the posters, quite probably kitsch. It's doubtful that the visual allusion to Che means as much as CAN thinks it does to the average passer-by.

The poster's language – 'Meek. Mild. As if.' – is equally unsure of its target. The portrayal of Christ as meek and mild comes from the eighteenth-century hymn by Charles Wesley ('Gentle Jesus, meek and mild') and seems more like CAN's riposte to the sentimentality of fellow Christians than an accurate picture of the non-believer's point of view. The expression 'as if' originated on American campuses as an exclamation of disbelief and is now widely used. Its colloquial style jars with both the outdated religious language and the image. Does the viewer care about the tension the poster tries to set up between its verbal and visual content? As if.

In early 1999, CAN could not have chosen a less revolutionary moment to resurrect a revolutionary conception of Christ and it is hard to imagine this ad persuading a single non-believer into church. Only the *Pocket Canons* series of books from the Bible, designed by Angus Hyland, has come anywhere near to 'rebranding' Christianity in visually convincing terms, and it did this by repositioning the Word of God as literature rather than religion. If the Church of England could find the fees, updating its fusty Victorian image would be the ultimate challenge for some master manipulator of brand identity and equity – and the ultimate sign that the national religion is now just another lifestyle option fighting for survival with all the other brands in the chaos of the marketplace.

2. MILKING AN ICON When supermodel Kate Moss, pop star Robbie Williams, or TV presenter Mariella Frostrup wear the bearded Marxist's face on their chests, it is unlikely that they hope to signify solidarity with his revolutionary teachings or struggle. Nor does any conscious irony appear to be intended. It's not that the wearers are either for Che or against Che. He embodies a charisma, a commitment and a martyrdom so heady, so different from a frantic life of parties, press receptions and fashion shoots, that, even after countless iterations on everything from beer bottles to Swatch watches, his image still casts the wearer in a flattering light.

At the same time, while it might be hard to imagine on the dance floor in a club in London or New York, there are people who take the image straight. There is a long tradition of revolutionary art, especially in Cuba and Latin America, that uses Che's iconic visage in a straightforwardly inspirational way. Even in western rock music, the

American group Rage Against the Machine offered Che as a signifier of old-fashioned, unironic rebellion. When the British publisher Pimlico reissued Guevara's *Bolivian Diary* in 2000, they opted for the late Alberto Korda's 1960 photograph, source image for so many graphic derivatives and posterised versions. Restored to the context of his own life, Che's rugged serenity and romantic visionary presence are undiminished.

CAN's misconceived poster suggested a third way of milking his iconic value. Now that public protest against capitalist excess is back on the media's agenda, Che's image is being reactivated within popular culture as a signifier of authentic rebellion. It is not necessary to depict Che himself; it is enough merely to evoke the idea of Che in relation to the new message – as in the Che-Christ – and this can be achieved through the image's graphic treatment and invocation of a few highly familiar details.

The British youth culture magazine *Sleazenation* took this approach with its 'Militant Pop. Do you believe in revolution?' cover by creative director Scott King. The pop singer Cher – rechristened 'Cher Guevara' – is portrayed in the instantly recognisable style of the Cuban Revolution's mythic hero, with a beret and untamed hair, the simplified black rendering of her face displayed, poster-style, on a red background. Cher's use in this way is clearly ironic, but it is an irony predicated on our understanding that Che himself was for real. The magazine's rabble-rousing cover story concludes, without so much as a nudge or a wink, that only apathy stands in the way of the return of genuinely radical pop.

At the *New Musical Express*, the Manic Street Preachers' visit to Cuba, where they played to an audience of 5,000 that included Fidel Castro, provided another opportunity to clothe a musician in Che's image – the metamorphosis made even smoother by the fact that vocalist James Bradfield sometimes sports Che-like facial hair. The music weekly may have been poking gentle fun at the band, but the portrait's dignified demeanour will have done no harm to their credentials as self-styled revolutionaries of rock.

The most telling reference to Che, appearing the same week as the *NME*'s, introduced a *Guardian Weekend* cover story by Naomi Klein about Subcomandante Marcos, public voice of the revolutionary Zapatistas, then engaged on a long march from Chiapas to Mexico City. 'Why Marcos is the Che Guevara of his generation', says the cover line, but even without it the link would be obvious. While key personal details are different – the beret becomes a peaked cap; the beard becomes a mask worn by Marcos to hide his identity; he puffs on a pipe, rather than the Cuban cigar favoured by Che – the graphic streamlining, treatment of the eyes and use of red take for granted the reader's grasp of what Che represents. After years as a tourist souvenir, poster pin-up, fashion statement and rebel denuded of a cause, Che re-emerges, against the odds, as a symbol of what he actually stood for: a man prepared to give his life for his political beliefs.

Under the knife

People in design take it for granted that design is inherently a good thing. Something that has been 'designed' – rather than haphazardly conceived and thrown together – is by definition better. What design as a profession offers the world is a service dedicated to improving the way things look (and sometimes, though not nearly as often, how they function). Design adds shine, boosts perceived value, enhances desirability and increases profits.

I find this line of thought easy to understand because I used to feel the same way. I started writing about design in the mid-1980s for no other reason than that it interested me. It spoke to me and I found myself responding to it. I understood what it was saying (or thought I did). Offered a 'before' and 'after' choice between something in its raw, undesigned state and its improved-by-design state, nine times out of ten I would almost certainly have gone for design. Design's job was essentially virtuous. It was about effective communication. Its aim was to help the product, service or organisation to express its inner essence as clearly as it could. Even as recently as the 1980s, designers and design sympathisers could quite reasonably think of themselves as campaigners. Their task was to convince everyone of the huge benefits that design could bring.

Few designers talk that way any more. Why should they? Design is no longer news. The world outside design heard the message and design literacy is at an all-time high. The kids on the street are design-aware, shops are design-aware, businesses of every kind are design-aware and even politicians are getting the hang of it. Whether this has much to do with design's big claims for itself is debatable. Far more likely is that design has benefited from broader social and cultural trends that it contributed to, but did not cause. We value design so much because, increasingly, we value appearances, and design is just one of those image-based disciplines – alongside photography, film, TV, fashion, advertising and new media – concerned with how things look and what their surfaces express.

The problem we now face comes from the triumph of design. The seductive images

we so expertly conjure are supposed to express the inner reality of the things they represent, but all too often they become ends in themselves, substitutes for genuine content and depth. In the sphere of politics, everybody understands this. The gulf between image and reality is an accepted part of everyday political discussion and media reporting, and we see this awareness most clearly in the phenomenon of 'spin' – the latest term for the age-old way that politicians and their advisers attempt to control our view of events. Spin presents inconvenient developments in the most positive light. It has little connection with the underlying reality. There is straight-talking design, just as there are honest politicians, but when spin is accepted as the normal way of conducting public affairs, how do you tell which is which? Moreover, we are now so accustomed to all forms of spin that its absence can be positively unnerving.

A recent experience brought home to me in the most personal way how much I depend on the mediations of design to establish the right 'context' for an event. I needed two small hernia operations and decided that a predicted ten-month wait for surgery on Britain's National Health Service, followed by a second operation eight months later, was much too long to leave the problem untreated. (The NHS is a textbook example of spin's failure to mask a public service in deep crisis.) Someone told me about the British Hernia Centre – a private clinic dedicated to the condition – and I visited its website. Its design was far from stylish, but it was clear, informative and promising. I liked the sound of their innovative surgical techniques and took note of their long list of published research papers. I filled in an e-mail questionnaire, giving details of my earlier diagnosis, and the next day the clinic called me. Given the straightforwardness of my case, it seemed that a preliminary visit would not be necessary. Both procedures could be done at the same time. All I had to do was turn up at the centre on the appointed day.

What did I expect? Certainly not quite what I found. The 'clinic' was an ordinary residential house next to a thunderous highway in north London. There was an incongruous blue plastic sign across the front of the building and another, with a coat of arms, in the front garden. A makeshift placard had been Blu-Tacked to the front door. Further along the road, a 24-hour vet was advertising itself in the same way. For the first time, I had deep misgivings. The whole thing looked painfully D.I.Y. Who were these people? Were they as clumsy with the scalpel as they were with their first impressions?

Reasoning that this must be an acute case of image failure, since the centre's surgical successes have been much praised in the British media, I steeled myself and went inside. The house was pleasantly fitted out, with a reception area in the hall, the staff were friendly and attentive, the surgeon was likeably direct, and everything went smoothly. In the waiting room, I picked up a copy of their printed brochure. The content

was once again persuasive, though its clumsy, 'printshop' typography and scruffy tint panels left much to be desired.

So here, on the face of it, is a classic case for design. These doctors show every sign of needing a few lessons in visual presentation. The service they offer is excellent. The centre is a national leader in its field, with a growing international reputation. To reflect its standing – a design consultant might suggest – it requires a classy new location, impressive premises and a visual identity, expressed through signs and promotional literature, that embodies its mission to bring hernia treatment into the twenty-first century. The coat of arms transmits a vague sense of British 'heritage' that might impress a few overseas visitors, but what has this got to do with pioneering surgical techniques and dramatically quicker recovery times? Maybe the bodybuilder shown on the brochure cover was back in the gym, straining every sinew, three days after surgery – but he is still tacky.

Does it actually matter, though? You could argue that devoting so little attention to image suggests a supreme confidence in the quality of the service on offer and the professionalism with which it is delivered. Seen in this way, no design, or even awkward design, becomes a sign of seriousness: they – and you, the patient – have more important things to think about than choosing the right typeface. The commercial world has to worry about these issues, but medicine transcends such trivial considerations. Except that this is not public health care, funded by taxes, but a private service that must bought, like a new suit, a ticket in business class, or a weekend break. You are a patient, but you are also a 'customer', who might choose to go elsewhere. In the world of competing services, image is everything. Perhaps private hernia surgery in Britain has yet to reach a stage of development where questions of image must come into play.

These days, I still sometimes fall in with a design – a brand or a shop interior – finding myself accepting and trusting its spin almost without question, because it happens to suit my taste. Increasingly, though, like a lot of people, my first reflex is scepticism. There is simply too much design and image manipulation now, babbling for attention, flipping all the right switches with smooth professional precision, to just 'believe in design' without qualification, with the authentic campaigning enthusiasm felt by earlier design people. Every so often, a design heretic stands up and suggests the unthinkable: there may be occasions when designers should tell potential clients, after having appraised their needs and weighed up all the pros and cons, 'In our view, design is not the solution here.' It's a beguiling thought. Of course, it could never really happen, now could it?

2. The resistance meme

Too much stuff

There is an extraordinary scene, towards the end of Jean-Paul Sartre's philosophical novel *Nausea*, where the book's narrator experiences a kind of crisis examining a tree in a municipal park. As he looks from tree to tree, and at all the things that surround him, he is consumed by a profound sense of their superfluousness and of the arbitrary nature of the relationships between them. Why so many existences, he wonders, since they all resemble each other? 'What was the use of so many trees which were all identical? So many existences failed and stubbornly begun again and once more failed – like the clumsy efforts of an insect which had fallen on its back.'[1]

Personally, I have never had this sort of problem with trees, though I did once experience something similar walking along London's Fulham Road. I was passing Jerry's Home Store when I noticed a window display on the theme of the New Jersey diner. Now I am as fond of American diner style as the next person – in American diners – but Jerry's had thoughtfully made all the elements available here in London: diner tables, diner chairs and bar stools, chunky diner mugs and cobalt-blue dining car glasses. Inside, Jerry's was piled high with all the Dualit toasters, KitchenAid mixers, Waring juice extractors and galvanised canisters you need to piece together something resembling your very own New Jersey diner experience.

This was unnerving in two ways. The first was the more familiar sensation that it was just too much. You can experience this anywhere, in any shop or high street or shopping mall, at any time. Too much variety. Too much duplication. Too many choices to make that have nothing to do with need. Too much fantasy. Too much *stuff*. In this case, it was the highly specialised nature of Jerry's display that had jolted me into a renewed awareness of what the existentialists would have called absurdity – an overwhelming, almost physical, even nauseating sensation of the utter superfluousness of all these things. On this occasion, outside Jerry's, my queasiness was compounded by a sense that matter had come unstuck from its usual moorings, which give it some particularity and meaning (in the diners of New Jersey) and was drifting frivolously,

fantastically and arbitrarily through the international networks of consumption and exchange.

And here is the central dilemma for any designer working today. When it comes to consumer goods, every new design (or old design re-editioned as if new), no matter how well considered, sincerely intentioned, or just plain alluring, contributes to the gigantic over-production of things. Whatever it is, in any purely rational assessment, we almost certainly don't 'need' it, keenly as we might desire it. Truly new object types are rare. Within established object types, significant innovations are rare. Most seasonal changes are matters of aesthetic styling, their purpose simply to stimulate the urge to buy, so that even if you own the thing already, and it fulfils its function adequately, a part of you will hanker after a new one in more up-to-date stylistic garb. Small technological 'improvements' – in cameras, for instance – serve much the same purpose. People were taking brilliant pictures before any of these aids and add-ons existed. We know this, of course. Most of the time, though, we prefer to forget it.

Well, so what, you might protest. That's the way things are; that's the way people are. A bullish apologist for this view is American professor of English, James B. Twitchell. 'Human beings like things,' he writes in *Adcult USA*, a breathtakingly uncritical study of American advertising. 'We buy things. We like to exchange things. We steal things. We donate things. We live through things. We call these things *goods* as in goods and services. We do not call them *bads*.'[2] We are not the dupes of scheming manufacturers eager to offload a surplus of crummy products, insists Twitchell. 'We have created a surfeit of things because we enjoy the process of getting and spending.'[3]

Not so long ago, if you were a design buff, it was possible to believe that the progressive response to this unquestioned urge to get and spend, as well as the overwhelming profusion of things, was to make informed and selective choices: to reject the mundane and invest in the best. Those in the know, you could be assured, would pick up your signals. 'Showing people who understand the code a Mont Blanc is enough to set them off on a whole train of contingent deductions,' noted Deyan Sudjic in 1985. 'Own one of those pens, goes the assumption, and you will also own this, wear that, live there and so on.'[4] This was a kind of social determinism enacted through objects and it is no wonder that the marketing people loved it: everything they needed to know about a person (to sell them more stuff) could be read off the surface. A decade or more later, the result for some design-watchers is a kind of paralysis. You may not want to speak this language, you may reject its glib reductions of human possibility, but once you have acquired a certain design knowledge, it is impossible to revert to a condition of semiotic not-knowing. Even if you could, others would still be able to decipher your

unintentional messages. Just as there is no such condition as 'no style', so there is no such thing as 'not making a statement'.

We are all design-aware now. Design as consumption, design as business opportunity, design as lifestyle choice and status symbol have become the order of the day. These are the only forms of design thinking and activity recognised on TV and in the newspapers and they achieve a depressing apotheosis in the pages of *Wallpaper**, a buy-it-all bible of 'urban modernism' lacking even a glimmer of critical distance. An alternative vision of design, not dedicated to consumerist over-production, has all but disappeared, within design itself as well as the press. 'There are professions more harmful than industrial design,' Victor Papanek declared, notoriously, in *Design for the Real World*, first published in 1971, 'but only a very few of them.'[5] Papanek may have overstated the case for a socially responsible design and overemphasised rationalism at the expense of the perfectly valid human need for fun and fantasy – earning himself the vilification of designers as a result – but at least he kept discussion open by offering an alternative. In 1993, when design historian Nigel Whiteley published *Design For Society*, a rare and carefully argued critique of consumerist design, not a single British design magazine took the trouble to review it – a shameful sign of the unassailable dominance, by that time, of 1980s design values.

Can anything be done? Can designers themselves do anything to redirect significantly their efforts from the production of surplus to more socially useful forms of designing? As Whiteley points out, because of the prevailing system and ethos of consumerism, groups promoting socially useful design can exist only at the margins of society, where their effects will be limited: 'None is large enough in terms of resources to assert itself in a marketplace which favours vested interests and those who uphold the status quo of consumerist goods.'[6]

By encouraging us to carry on consuming, design as we now practise and promote it helps to sustain this system. A profound shift towards socially useful design will only come about as a result of a correspondingly profound socio-political shift. In Britain, under a New Labour government, such a development is improbable. This is not the time to resurrect discredited fantasies of sweeping revolutionary change, but it is certainly a moment when initiatives might be seized. Blair's government has shown an awareness of design and it may be, were designers to mobilise, that they could argue the case that design is about more than the competitive restyling of radios, toasters and coffee pots. It is hard to shake off the conviction that we have more than enough already.

Design is advertising

A survey suggests there are four kinds of response to advertising in Britain and, as is so often the case with research of this kind, each category has a catchy title. Best news for advertisers are the Enthusiasts. This obliging group of citizens – 35 per cent of those surveyed – can't get enough advertising. They often prefer ads and commercials to the editorial and programming that surrounds them, love to be intrigued by new approaches and generally want to get involved. Acquiescents – 21 per cent – are a more cautious bunch. They are confused by anything that is overly creative and feel threatened by the avalanche of direct mail, but, broadly speaking, they also like advertising. More troublesome, if you have something to sell, are the 22 per cent of us whom the survey dubs Cynics. This group resents advertising's intrusiveness and trusts only the mildest specialist ads. Last, keeping their heads down at the back, are the Ambivalents. They have no interest in advertising, do their best to ignore it, but take the fatalistic view that one way or another the damn things will probably get to them anyway.[1]

While it is encouraging to learn that a dissenting view is assumed, at least in Britain, to be running as high as 44 per cent, the purpose of this research is revealing in itself. This is not the disinterested report of a sociology department: it is a tool – created by a media-buying company called CIA Medianetwork – to help advertisers understand their audiences. One way or another they *will* make you listen.

What few people contest any longer, whether Enthusiast or Cynic, is that advertising is now the 'culture' against which everything else, including our individual attitudes to advertising, must be defined. 'Advertising has become not only the most universally recognised "art" form but also the most widely disseminated form of public address in American society,' notes Stuart Ewen, a long-time Cynic and one of American advertising's most incisive critics.[2] American academic James B. Twitchell agrees. 'Advertising is not part of the dominant culture,' he enthuses. 'It is the dominant culture.'[3] The professor's book is here to document and celebrate its 'triumph'. In the US, says Twitchell, advertising has soaked into everything. You cannot escape it and

there is nowhere it cannot be found. Once a phenomenon is thoroughly naturalised in this way, one might add, its 'transparency' makes its actions significantly harder to perceive.

Advertising, aided by design, is now the texture of everyday reality, the omnipresent conductor, the whispering intruder in our fantasies and dreams. It is becoming ever harder for those who have grown up living 'the advertised life', as it has been described, to imagine what the condition of *no advertising* would be like. You have to immerse yourself in a historical film or have visited a former communist bloc country before McDonald's and Marlboro and Coke moved in and put down their graphic markers to know what the streets feel like without the pervasive grid of commercial messages. To us, thoroughly tuned in and responsive to the omnipresence of advertising, this peculiar emptiness – for that is how it now seems – feels both strange and liberating. In these moments, purged of the graphic clutter and non-stop clamour of ads, it is as though your thoughts are temporarily returned to you. There are no images to measure yourself against, apart from other human beings and the street itself, and no one is asking you to do or be or buy anything at all.

Of course, looked at globally, there are differences. If America represents advertising at its most extreme and invasive, and American TV – if you can stand to watch it – is the ultimate example of a communication environment whose overriding reason for being is to get you to watch advertising, the situation in Britain isn't quite so bad. There are still two terrestrial channels where for an entire evening you can watch television without seeing a commercial. Yet, as you savour the respite from advertising and the reminder that there are, or ought to be, other ways of being in the world, you are only too aware that this is a state of affairs that cannot last. It isn't normal. It isn't the way things are everywhere else. You have entered a specially-funded enclave that exists, for now, under sufferance. The inexorable pressure is towards advertising and sooner or later, in ten years or twenty, but probably fewer, the advertising will roll in.

ONE BIG HAPPY NEXUS If advertising is the dominant culture, whereabouts, in relation to advertising, stands graphic design? This is one of the most important issues that graphic design has to face at this point, but it is not a question that graphic designers show many signs of wanting to address. In an essay on the historical relationship of graphic design and advertising in the US, Steven Heller argued, unequivocally, that, 'If advertising is the function, then graphic design is the form.'[4] Speaking in 1998, Richard Seymour, then a candidate for the presidency of British Design and Art Direction, was similarly insistent on the links. 'Art direction is design,' he said, 'just as surely as pack design is advertising.

We're all part of the same nexus, but D&AD still has a way to go to make that obvious.'[5] This was an interesting remark. Seymour may have been thinking of public perceptions of the two disciplines, but it is far more likely that he was talking about the reluctance of advertising and graphic design – yoked together as a single entity in Britain by D&AD in 1962 – to recognise that they are two sides of the same coin.

At the most pragmatic level, graphic design and advertising are not the same thing. Four decades of cohabitation within D&AD has failed to convince British designers and ad people that they are part of the same 'nexus' because, however close the two factions may have been in the early days, in the post-war period they have led largely separate lives – as businesses, as professions, and as career paths for those they attract to their ranks. These professional cultures have their own commentators and their own specialist publications. It is quite possible, as a journalist, to write about 'graphic designers' and never venture anywhere near an advertising agency, just as it is possible to write about the activities of advertising 'creatives' and never have any contact with the leading names of design. Few commentators successfully straddle both worlds.

This separation encourages both sides to imagine that they are engaged in wholly different pursuits. Certainly, there are differences not just in the kinds of work that designers and agencies do, but differences of fundamental approach. From a graphic designer's point of view, what advertising once evinced, from A.M. Cassandre to Paul Rand, but long ago gave up, was any claim to significant graphic innovation. Designers set much greater store by the satisfactions of craft and in the possibility of personal expression and fulfilment in the act of designing. To agency people, with their sights set on larger strategic goals involving colossal budgets, designers' preoccupations with the minutiae of designing can look laughable. Yet, as Heller suggests, advertising is only allowed into histories of graphic design – as though design were the dominant practice – when it is deemed (by design people) to have reached a sufficiently high aesthetic level: at that point, the base material of mere advertising is transmuted into the gold standard of 'graphic design'.

The paradox implicit in graphic designers' invariable prioritisation of form is that it unwittingly confirms Heller's definition of the relationship between advertising and graphic design: advertising is the function and design is one of the formal means by which advertising is done. The fact that graphic designers fail to acknowledge the routine design work undertaken by agencies as graphic design does not make it any different in method and kind from the bulk of graphic output. A definition of graphic design that insisted on exceptional quality as qualification for entry would have to

exclude most of the work done by designers, too. Most graphic design is aesthetically ordinary, if not, in many cases, poor.

The added complication, in recent years, has been the much remarked on use of graphic designers by the advertising agencies. This, more than anything, has had the effect of appearing to confirm graphic design's continuing usefulness as a hothouse for cultivating new kinds of form. It was exciting for designers to see typography made so central again – in the work of David Carson, Tomato, P. Scott Makela, Jonathan Barnbrook, Robert Nakata and others – and experience advertising that depended for its effect on graphic form. It seemed, on the surface, to be a reassertion of the cultural necessity of graphic design: *see! they can't get by without us.* For those in design education, where most of these new forms had their origin, it was a moment of vindication: *there! we weren't crazy encouraging our students to do this stuff – it has real uses out there in the world.*

The ultimate effect, however, of ten years of the digital 'new typography' movement (if movement is what it was) was to confirm, in a literally spectacular way, the total dominance of advertising as the measure and use-value of design innovation. It is understandable, on one level, that some designers, knowing exactly what was likely to happen to their typographic ideas once they became fashionable, were happy to co-operate with the agencies while the going was good. Considerable reward and high visibility was the result for the lucky ones. Trying to resolve the nagging feeling that they were letting the side down, these designers sometimes explained their 'interest' in seeing for themselves how advertising operated, when it might have been closer to the truth to say that they were getting high on the sudden proximity of advertising's money and power, its very real connection to the heart of things. These designers, hoping to have it both ways, to maintain credibility while pocketing the cash, spoke of using the proceeds, Robin Hood-style, to fund their own projects. The less perceptive (or more dishonest) affected not to see any problem in their position at all.

As time passed, that is increasingly how it seemed. To younger designers, who were still in high school when the typographic experiments of the 1980s began, and have only the haziest idea, if any, that these experiments were ever part of a 'new discourse' that sought to expose and criticise the operations of design, there is no problem.[6] They wear the swoosh on their feet, the ads are the last word in typographic cool, so what could be more desirable, or natural, after design school, than working on campaigns for Nike? Design's complicity with advertising's use of these styles wasn't exactly hindered by the kind of criticism so concerned to discover 'coded' meaning in the contents of our shopping bags that it no longer troubles to ask larger questions about who ultimately benefits from the transaction at the till. Such questions are overtly

political, and politics, in the oppositional sense, was off the agenda in design in the 1980s and 1990s just as surely as it was exiled from the wider social discourse – so tedious, so passé!

Yet the rhetoric of opposition persists. With impressive sleight of hand, some of those designers who made the transition to advertising continued to talk up their work as though it were the very embodiment of rule-breaking radicalism and progressive change. While any sober assessment can see that this is nonsense – there is nothing remotely radical about upholding the status quo, however stylishly you do it – it is part of a larger tendency to claim for the consumer the language and 'attitude' of uncompromising rebellion. American social critic Thomas Frank argues that, from Burger King's slogan 'Sometimes you gotta break the rules' to Hugo Boss's command to 'Innovate, don't imitate', when it comes to American business, 'perpetual revolution and the gospel of rule-breaking are the orthodoxy of the day'.[7]

The most widely celebrated graphic design of the 1990s has seen the implosion of all the old formal rules of the craft. In the super-cool, up-for-it, irony-with-everything world of advertising, these new design styles encountered not resistance, but a ready understanding that such powerful signifiers of freedom and non-conformity could be pressed into persuasive commercial use. Disappointing as this outcome might be for anyone committed to the critical possibilities of the new discourse which invented these approaches, it doesn't necessarily follow that graphic design cannot find other ways to act as a medium for authentically 'radical' intentions, or that the discipline can have no viable existence separate from advertising. However, if design is to sustain and develop a professional and public identity based on a function other than selling, the question remains as to how and through what channels this goal is to be achieved.

COLONISING THE STREETS Whatever else you might think of it, the billboard advertising Ford's Ka, seen on the streets of London in the summer of 1998, was an unusually bare-faced statement of the issues involved. Under the copyline 'London's Alternative Transport', the outline of the Ka emerged from a multi-coloured network of tyre marks rendered in the immediately recognisable shape of Henry Beck's famous London Underground map. Forget public transport, said the ad – it will only let you down. Wise up, abandon the declining infrastructure, jump into the cutely proportioned Ka and drive into London . . . to join the other private car drivers in the capital's increasingly clogged and slow-moving centre.

A few days after I first came across this shamelessly misleading ad in a street near where I live, some unknown member of the public answered back. Slapped across the

chassis of the Ka, small but unmissable in neat, black line-work, was a poster bearing the hand-drawn words 'Let London breathe' and the image of a woman's bicycle. This changed everything. Suddenly the Ka billboard ceased to be a monologue, a piece of highly resourced and one-sided propaganda for a commercial point of view, and became a dialogue in which a radically different perspective was shown to exist. From this other viewpoint, the 'alternative' was not more cars on London's streets, but fewer cars and other ways of solving the transport problem. Anyone looking at the modified Ka billboard now would have to think about the meaning of its claim to offer an alternative to public transport, even if they then went on to dismiss the cyclist/clean air point of view.

The poster-sticker's modest intervention and the unexpected rupture of the ad's slick surface also served to expose the reality of contemporary advertising. Billboards might occupy narrow shards of private space – leased from the poster-site owner – but they project their messages across collective airspace into notionally 'public' streets. You would have to keep your eyes fixed on the ground, or the dashboard of your Ka, not to see them. Street ads are a privileged form of address and the space they commandeer is disproportionate. Only the rare sight of a community mural comes anywhere near to equalling the scale, intensity and impact of this public imagery. Advertising's right to colonise the physical environment of the street and act as primary shaper of the mental environment is taken for granted and there is no officially sanctioned public competition for the thoughts, beliefs, imagination and desires of the passer-by. Apart from other ads.

'Let London breathe' was a small but telling reminder of all that is routinely excluded and denied official expression in our supposedly public highways, but it was also significant in another way: it was a piece of graphic design. Not *professional* design. Sophisticated metropolitan imagineers would almost certainly have scoffed at the folksiness of the lettering and the antique air of the bike. The poster was awkwardly trimmed around the word 'Let', which projected beyond the main image area, suggesting it might have been cut from a larger image; perhaps it was made for some previous protest. Yet despite these oddities (partly because of them) it had graphic force. It had been designed for a use – and applied: it read well and one couldn't miss it. If an amateur activist with a felt-tip pen, a pot of paste and the most rudimentary graphic skills can make you pause, what might a more professionally conceived form of graphic activism accomplish?

POISED AT THE DOOR While 'graphic agitation', considered historically, has an honourable tradition and receives an occasional airing in graphic design circles, in the

'Am I dead yet?'
Neon sign for Camel
cigarettes altered
by the Billboard
Liberation Front,
San Francisco, 1996.
Photography: Nicole
Rosenthal

1990s it was far from the centre of the profession's concerns. The spray-can 'sniping' – as it came to be called – documented in Jill Posener's *Spray it Loud* in the early 1980s, has evolved into highly effective forms of billboard alteration or 'refacing' (as opposed to defacing) in Britain, Australia and the US. In the UK, Saatchi & Someone rework Benetton ads into safe sex and pro-lesbian mother messages. In Chicago, Ben Rubin's 'I keep getting mugged in my sleep' thought bubble, glued on to more than 1,000 ads, many in the city's subway, aims to expose sexism, racism and other 'dehumanising ideologies'. In London, the duo AVI (Active Visual Intervention) wage the 'semiological guerrilla warfare' proposed 30 years ago by Umberto Eco by imitating billboard typography to devise seamless graphic insertions that look official and provoke new readings by keeping the audience guessing.[8] Their theoretically informed disruptions of the capitalist media spectacle, first described and analysed by the Situationists, are a far cry from the frontal assaults mounted by the politically motivated designers of earlier decades. AVI explain: 'We are looking to open up constructive spaces of doubt and introduce a little instability into the relation between author, reader and context.'[9]

Pointed they may be, but these are interventions by artists using the tools and techniques of graphic design, not by graphic designers. Professional designers, if

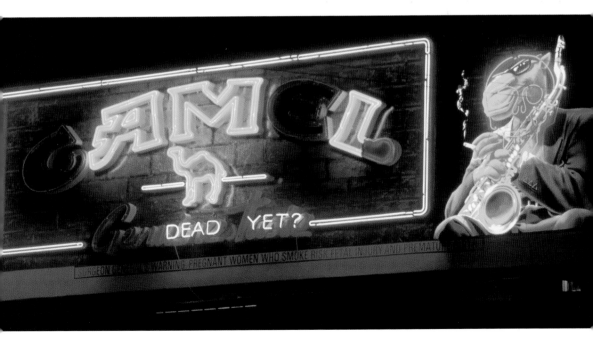

they consider the issues at all, seem uncertain how to proceed. One of the most thoughtful discussions of the subject, by British design educator Russell Bestley, works painstakingly towards the tentative and far from galvanic conclusion that 'the possibility of intervention still remains'.[10] Has it ever been in doubt? The same sense of being forever poised at the door, but never quite ready to leave the building, has characterised the activities of the Jan van Eyck Akademie in Maastricht, where the director, Jan van Toorn, a 1970s Dutch graphic activist of considerable renown, promised to integrate fine art, graphic design and cultural theory in a new critical synthesis. At van Toorn's 'design beyond Design' conference, dedicated to the role of the critical practitioner, design theorist Gui Bonsiepe suggested once again that 'The designer acting as designer, that is, within the framework of his profession and with the tools of his profession, faces the particular challenge to translate his critical stance against the status quo into a design proposal.'[11] Well, yes. But what? How? None of the speakers had much to say about that and some of the younger designers present, charged to go forth and intervene, were not convinced.

Nor is there much understanding among older activists of the ways in which the attitudes of younger designers differ from their own. British designer Tony Credland was in many ways a model Jan van Eyck Akademie participant. Politically motivated and active, he is a long-standing contributor to the mail art network and co-publishes *Cactus* magazine, a non-profit vehicle for exchanging ideas, and *Feeding Squirrels to the Nuts*, a poster discussion project. He enrolled at the academy in 1996 because he was tired of living a double life and hoped to discover ways to incorporate politics into his commercial work. To his disappointment, he found that few of his fellow graphic design participants shared the director's radical commitment, regarded the academy's stated public agenda as a personal priority, or wanted to engage in sustained and searching debate about the possibilities of intervention in the sphere of commercial design.

'There is less [sense of] utopia around,' Credland reflects. 'It's not so simple any more. It's a very contradictory society at the moment. Maybe before you could quite easily do work that was outside the commercial world and do political work, too. But now there is hardly anything you can do outside the commercial world. Once you're in there, to actually start fighting it is a mind game. Why confuse yourself if you can just get the money? There is a lot of money out there in design. A lot of young designers are going for it and you can't blame them. It's not just down to money, though. There is a lack of belief that you can change anything, a deep cynicism and no sign that it's going to change.'

Cynicism is an excuse for doing nothing, a self-fulfilling prophesy. Rejecting this too easy get-out, Credland's *Debate* poster series, undertaken in his final year at the

academy, and mailed to 150 activists, designers, artists and educators, was a call for discussion with a view to developing a contemporary strategy for the inclusion of politics in visual communication. As areas of concern, Credland highlighted three issues: (a) recuperation, the process by which radical gestures are incorporated, neutralised and sold back to the audience as commodities by the dominant forces of capitalism (as happened with the style-fixated 'new typography' of the 1990s and the use of bad taste and shock – once central strategies of the artistic avant-garde – in recent ad campaigns); (b) whether exposing the mass media's processes of commodification can lead to greater democracy; and (c) the daunting, recurrent question, by which the enterprise thrives or fails, of whether, and how, it is possible to find ways to intervene graphically into corporate culture to contest its global dominance.

Credland concedes that the responses published by *Debate* declined to move very far beyond the established territory of professional discourse. Yet, as he knows, outside the profession, in cultural theory and media activism, these issues are being addressed. If graphic design is failing to generate its own theories and strategies of resistance, it becomes all the more necessary to look elsewhere.

CULTURE JAMMERS In 1998, writing in a Sunday paper about 'the most powerful and arrogant world order in human history' – the global free market system – the political commentator Neal Ascherson had this to say to the British middle classes: 'The rebellion, when it begins in the 21st century, will be unfamiliar. It will not be Marxist or Communist, and will have only an indirect ancestry in socialism. It will be in some sense for equality and against privilege. But my guess is that it will not talk the language of majorities and will instead be a guerrilla struggle conducted by inchoate, unstructured groups of highly qualified people who can disrupt institutions, corporations, communications, even cities. These groups will form coalitions, and will sometimes seek to enlist the excluded victims of the system.'[12]

In the twenty-first century, media activists are sharpening the tools of contemporary dissent. The ideas they advance, the methods they use, the goals they set out, and the alliances they form are much as Ascherson describes. They occupy an unfamiliar political position that is neither left nor right, as we once understood these ideologies. In North America, where some of the more visible activists work, their project has acquired a generic name – culture jamming – a term coined in 1984 by the American experimental music and art collective, Negativland, to describe billboard liberation and other forms of media banditry: 'As awareness of how the media environment we occupy affects and directs our inner life grows, some resist . . . The

studio for the cultural jammer is the world at large.'[13] American cultural critic Mark Dery's *Culture Jamming* (1993) was the first publication to answer the question 'what shape does an engaged politics assume in an empire of signs?' by codifying such non-graphic tactics as media hoaxing and audio agitprop, as well as the more familiar techniques of billboard refacing. It remains one of the movement's essential texts.

These days, some culture jammers are positively bullish. Visitors to the website of Canadian anti-advertising magazine *Adbusters* – published by the Media Foundation, started in 1989 by former marketing man Kalle Lasn (www.adbusters.org) – will find this 'Media Manifesto':

'We will take on the archetypal mind polluters – Marlboro, Budweiser, Benetton, Coke, McDonald's, Calvin Klein – and beat them at their own game.

'We will uncool their billion dollar images with uncommercials on TV, subvertisements in magazines and anti-ads right next to theirs in the urban landscape…

'We will culture jam the pop culture marketeers – MTV, Time Warner, Sony – and bring their image factories to a sudden, shuddering halt.

'On the rubble of the old media culture, we will build a new one with a non-commercial heart and soul.'

Adbusters has drawn regular criticism for the slickness and apparent contradiction of its self-marketing, but this has helped to build its profile as a campaigning organisation bold enough to take on the most powerful players in the communications conglomerate, and the foundation has scored some notable hits. Lasn's *modus operandi* is to fight fire with fire. Now in his fifties, soft-spoken, articulate and absolutely convinced of the rightness of his cause, he accepts the forms of existing media – 'There's nothing wrong with the medium. I think what's wrong is the people who are controlling the medium right now' – but demands the democratic freedom to express opposing points of view.

The Media Foundation is engaged in continuous and costly battles with North American TV stations to infiltrate the adbreaks with provocative 'uncommercials' made by its Powershift agency, such as 'Obsession Fetish' ('Why are 9 out of 10 women dissatisfied with some aspect of their bodies?') and 'The Product is You' ('Cast off the chains of market structured consciousness!'). Spoof print ads – 'subvertisements' – relentlessly needle the likes of Calvin Klein ('Calvin Klones'), Gucci ('Pucci – tight collars, short leashes'), and Camel cigarettes (*Adbusters*' chain-smoking 'Joe Chemo' looks perpetually at death's door). To encourage others to carry on the fight, the 'Culture Jammer's Toolbox' on *Adbusters*' website offers practical advice on jamming a focus group, buying TV airtime and creating a print ad.

What role does design have to play in this struggle? 'I think design is all-important,' Lasn tells me from his Vancouver base. 'Political movements in the past, especially political magazines, have relied almost totally on text. They believe that text is the only way to get these important ideas across. I think that in our current age that simply doesn't work, so we are going to be the first movement that's been launched by TV spots and subverts and by putting up billboards and by this more image-oriented thrust. In that sense, graphic artists are the cutting edge of what we are doing. Not only that, but I've found that graphic artists are in some sense the perfect people to launch another revolution because they have an openmindedness that I don't find in other professions.'

From the outset, says Lasn, designers, photographers and others in the creative professions, sometimes from within advertising itself, volunteered their services anonymously. As a result, uncommercials that would otherwise cost $100,000 can be made to the highest standards – essential if they are to compete with advertising – for $3,000. 'I realised that there is a huge percentage of graphic artists within the advertising industry who are profoundly unhappy with their industry's ethical neutrality,' says Lasn. 'Given the chance they would dearly love to be using their skills for other purposes, and these people finished up being very powerful allies for us.'

TACTICS OF DISAPPEARANCE While Lasn and *Adbusters* exemplified the public face of corporate resistance in the 1990s, and ran the constant risk of recuperation (witness a British TV commercial for the Vauxhall Vectra, in which environmental activism is ridiculed – 'Get a job', the smug driver tells the 'loser' tree protester), some of the most suggestive analysis of contemporary conditions came from theorists who proposed small, mobile, anonymous units as a vital operational principle.

One of the most influential ideas in these circles is Hakim Bey's concept of the 'temporary autonomous zone' (or TAZ). In a long, lyrical essay, Bey deliberately refrains from defining his idea, preferring to encircle it with flashes of poetic illumination. 'If the phrase became current,' he writes, 'it would be understood without difficulty . . . *understood in action* [my italics].'[14] The TAZ, a space, a place, a hide-out, a platform, a launchpad, may be short in duration; it will certainly be finite in life. For as long as it lasts, its occupants have complete freedom to plan, to act and to proceed as they like. The TAZ, by its nature, exists within a larger body – an organisation, a company, the State – and while it remains unnoticed it can contravene the aims, rules, conventions and expectations of its host. When it is discovered, or conditions otherwise change in a way that prevents it functioning with its previous autonomy, it simply dissolves. Its builders may be able to find suitable conditions to reconstitute the TAZ elsewhere, like

nomads who wander from one campsite to the next, or they may regroup and make new alliances to form other kinds of TAZ.

Adbusters appropriates the barricade-storming rhetoric of past revolutionary struggles. One issue is headlined 'Blueprint for a revolution' and, inside, an editorial declares that 'The next revolution – World War III – will be waged inside your head.' Fought in the media and cyberspace, rather than in the sky and forests, or on the seas and streets, 'It will be a dirty, no-holds-barred propaganda war of competing worldviews and alternative visions of the future.'[15] This might not be an armed insurrection, along the lines of earlier revolutions, but it is still visualised, like all revolutions, as an all-out battle – 'for ourselves and Planet Earth' – in which the new society will be built on the figurative 'rubble' of the old. Bey takes a far less utopian view of our historical situation. He points out that revolutions never achieve the anarchist dream of a truly free society and culture, because 'as soon as "the Revolution" triumphs, and the State returns, the dream and ideal are *already* betrayed'. This is not the time for such a huge undertaking: 'Absolutely nothing but a futile martyrdom could possibly result now from a head-on collision with the terminal State, the megacorporate information State, the empire of Spectacle and Simulation.'[16]

The temporary autonomous zone makes no claims to be a revolution. It is an impermanent *uprising*, a liberatory 'power surge', in Bey's words, which in no way rules out other forms of organisation. Can a TAZ exist within the structures and activities of design? Potentially, a TAZ could exist anywhere. Do any such zones exist? By definition, that is a question that can probably only be answered retrospectively. The TAZ, as Bey explains, is in some sense a 'tactic of disappearance'. The unwelcome news, for designers hooked on the idea, glamour and goal of celebrity, is that anonymity gives the greatest freedom of manoeuvre when it comes to genuine acts of resistance.

In their book *Electronic Civil Disobedience*, the American artists and activists Critical Art Ensemble develop an analysis of the ways in which power and capital have become nomadic, rendering previous leftist conceptions of insurrection redundant. There is no 'centre' of power anymore, no citadel to storm and take; the battle cannot be fought in the streets, CAE argue, because 'as far as power is concerned, the streets are dead capital'.[17] It follows that the only way to fight a decentralised power is by using decentralised, nomadic forms of resistance, as Hakim Bey suggests. Since power now inhabits cyberspace, CAE break with earlier models of activist thinking by proposing to move the resistance to cyberspace, too, where a new kind of activist will disrupt errant corporations and repressive communications in the way that Neal Ascherson predicts. To this end, CAE conjecture a somewhat unlikely sounding alliance of

directionless computer hackers, who have the digital know-how, and activists, who have the ideological purpose.

If this sounds like a nihilists' charter for the end of civilisation as we know it, it should be stressed that this is not CAE's intention. Like Hakim Bey, they believe that 'revolution is not a viable option' and that 'authoritarian structure cannot be smashed; it can only be resisted'.[18] If we value true democracy, this resistance must continue but it has to take into account the conditions of contemporary power; only then might it be able to turn the spectacle against itself. These ideas are, in any case, at such an early stage of development, as CAE acknowledge, that the role of the designer has yet to be defined (CAE do, however, advance a trenchant critique of art). In *Electronic Civil Disobedience*, they propose the formation of secret cells of four to ten people, bound together by trust, mutual interdependence, a shared political perspective and a range of skills – activist, theorist, artist, hacker, lawyer. If CAE leave design out of the list, even though it is possible to imagine occasions when it could play a central role in digital assaults on power's symbolic order, perhaps it is another sign of design's own slowness to develop new possibilities for graphic resistance in the digital era.

Then again, it may be, as Kalle Lasn suggests, that there is more resistance within the design sphere than anyone suspects. It is in the nature of clandestine acts that they have no visible authors. Perhaps everyday gestures of refusal and defiance, graphic pranks and media hoaxes, simply aren't being picked up by the fickle radars of the personality-led design press – of any press. 'A lot of people won't know the things we've done because we do them anonymously. There's a lot of that sort of thing going on,' says Tony Credland, who agreed to talk because of his commitment to the issues, rather than out of any desire to publicise himself. Hakim Bey proposes a secret movement – immediatism: 'Publicly we'll continue our work in publishing, radio, printing, music, etc., but privately we will create *something else*, something to be shared freely but never consumed passively, something which can be discussed openly but never understood by the agents of alienation, something with no commercial potential yet valuable beyond price, something occult yet woven completely into the fabric of our everyday lives.'[19]

Think of them now: a hundred – a thousand – unknown dissidents of the electronic age, poetic terrorists seeding the system with the uncontainable flowers of a new democracy and freedom. They don't want you to know who they are. They do want you to feel the tremors of their disturbance. And, in the coming years, we shall.

First things first

When Ken Garland published his *First Things First* manifesto in London in 1964, he threw down a challenge to graphic designers and other visual communicators that refuses to go away. As the twenty-first century begins, this brief message, dashed off in the heat of the moment, and signed by twenty-one of his colleagues, is more urgent than ever; the situation it lamented incalculably more extreme.

It is no exaggeration to say that designers are engaged in nothing less than the manufacture of contemporary reality. Today, we live and breathe design. Few of the experiences we value at home, at leisure, in the city or the mall are free of its alchemical touch. We have absorbed design so deeply into ourselves that we no longer recognise the myriad ways in which it prompts, cajoles, disturbs and excites us. It's completely natural. It's just the way things are.

We imagine that we engage directly with the 'content' of the magazine, the TV commercial, the pasta sauce or perfume, but the content is always mediated by design and it is design that helps direct how we perceive it and how it makes us feel. The brand-meisters and marketing gurus understand this only too well. The product may be little different in real terms from its rivals. What seduces us is its 'image'. This image reaches us first as a visual entity – shape, colour, picture, type. But if it is to work its effect on us it must become an idea. This is the tremendous power of design.

The original *First Things First* was written at a time when the British economy was booming. People of all classes were better off than ever before and jobs were easily had. Consumer goods such as TVs, washing machines, fridges, record players and cars, which North Americans were the first to take for granted, were transforming everyday life in the wealthier European nations – and changing consumer expectations for ever. Graphic design, too, had emerged from the austerity of the post-war years, when four-colour printing was a rarity, and designers could only dream of American clients' lavish production budgets and visual panache. Young designers were vigorous and optimistic. They organised meetings, debates and exhibitions promoting the value of design.

Professional associations were started and many leading figures, still active today, began their careers.

Ken Garland studied design at the Central School of Arts and Crafts in London in the early 1950s, and for six years was art editor of *Design* magazine, official mouthpiece of the Council of Industrial Design. In 1962 he set up his own company, Ken Garland & Associates, and the same year began a fruitful association (a 'do-it-for-love consultancy', as he once put it) with the Campaign for Nuclear Disarmament. He was a committed campaigner against the bomb, and his 'Aldermaston to London Easter 62' poster, with its huge, marching CND symbol, is a classic piece of protest graphics from the period. Always outspoken, in person and in print, he was an active member of the Labour Party.

Garland penned his historic statement on 29 November 1963, during a crowded meeting of the Society of Industrial Artists at London's Institute of Contemporary Arts. At the end he asked the chairman whether he could read it out. 'As I warmed to the task I found I wasn't so much reading it as declaiming it,' he recalled later; 'it had become, we all realised simultaneously, that totally unfashionable device, a Manifesto.'[1] There was prolonged applause and many people volunteered their signatures there and then.

Four hundred copies of *First Things First* were published in January 1964. Some of the other signatories were well-established figures. Edward Wright, in his early forties, and the oldest, taught experimental typography at the Central School; Anthony Froshaug was also a Central typographer of great influence. Others were teachers, students, or just starting out as designers. Several were photographers.

The manifesto received immediate backing from an unexpected quarter. One of the signatories passed it to Caroline Wedgwood Benn, wife of the Labour Member of Parliament, Anthony Wedgwood Benn (now Tony Benn). On 24 January, Benn reprinted the manifesto in its entirety in his weekly *Guardian* newspaper column. 'The responsibility for the waste of talent which they have denounced so vehemently is one we must all share,' he wrote. 'The evidence for it is all around us in the ugliness with which we have to live. It could so easily be replaced if only we consciously decided as a community to engage some of the skill which now goes into the frills of an affluent society.'[2]

That evening, as a result of the *Guardian* article, Garland was invited on to a BBC TV news programme to read out a section of *First Things First* and discuss the manifesto. It was subsequently reprinted in *Design*, the *SIA Journal* (which built an issue round it), the Royal College of Art magazine *Ark*, and the yearbook *Modern Publicity 1964/65*, where it was also translated into French and German. This publicity meant that many people,

not just in Britain but abroad, heard about and read First Things First. Garland has letters in his files from designers, design teachers and other interested parties as far afield as Australia, the United States and the Netherlands requesting copies, affirming support for the manifesto's message, or inviting him to come and speak about it.

That First Things First struck a nerve is clear. It arrived at a moment when design was taking off as a confident, professionalised activity. The rapid growth of the affluent consumer society meant there were many opportunities for talented visual communicators in advertising, promotion and packaging. The advertising business itself had experienced a so-called 'creative revolution' in New York, and several influential American exponents of the new ideas-based graphic design were working for London agencies in the early 1960s. A sense of glamour and excitement surrounded this well-paid line of work. From the late 1950s onwards, a few sceptical designers began to ask publicly what this non-stop tide of froth had to do with the wider needs and problems of society. To some, it seemed that the awards with which their colleagues liked to flatter themselves attracted and celebrated only the shallowest and most ephemeral forms of design. For Garland and the other concerned signatories of First Things First, design was in danger of forgetting its responsibility to struggle for a better life for all.

The critical distinction drawn by the manifesto was between design as communication (giving people necessary information) and design as persuasion (trying to get them to buy things). In the signatories' view, a disproportionate amount of designers' talents and effort was being expended on advertising trivial items, from fizzy water to slimming diets, while 'more useful and more lasting' tasks took second place: street signs, books and periodicals, catalogues, instruction manuals, educational aids, and so on. The British designer Jock Kinneir (not a signatory) agreed: 'Designers oriented in this direction are concerned less with persuasion and more with information, less with income brackets and more with physiology, less with taste and more with efficiency, less with fashion and more with amenity. They are concerned in helping people to find their way, to understand what is required of them, to grasp new processes and to use instruments and machines more easily.'[3]

Some dismissed the manifesto as naïve, but the signatories were absolutely correct in their assessment of the way that design was developing. In the years that followed, similar misgivings were sometimes voiced by other designers, but most preferred to keep their heads down and concentrate on questions of form and craft. Lubricated by design, the juggernaut rolled on. In the gentler, much less invasive commercial climate of the early 1960s, it was still possible to imagine that if a few more designers would

only move across to the other side of the vehicle balance would be restored. In its wording, the manifesto did not acknowledge the extent to which this might, in reality, be a political issue, and Garland himself made a point of explaining that the underlying political and economic system was not being called into question. 'We do not advocate the abolition of high pressure consumer advertising,' he wrote, 'this is not feasible.'[4]

But the decision to concentrate one's efforts as a designer on corporate projects, or advertising, or any other kind of design, is a political choice. 'Design is not a neutral value-free process,' argues the American design educator Katherine McCoy, who contends that corporate work of even the most innocuous content is never devoid of political bias.[5] Today, the imbalance identified by First Things First is greater than ever. The vast majority of design projects – and certainly the most lavishly funded and widely disseminated – address corporate needs, a massive overemphasis on the commercial sector of society, which consumes most of graphic designers' time, skills and creativity. As McCoy points out, this is a decisive vote for economic considerations over other potential concerns, including society's social, educational, cultural, spiritual and political needs. In other words, it is a political statement in support of the status quo.

Design's love affair with form to the exclusion of almost everything else lies at the heart of the problem. In the 1990s, advertisers were quick to co-opt the supposedly 'radical' graphic and typographic footwork of some of design's most celebrated and ludicrously self-regarding stars, and these designers, seeing an opportunity to reach national and global audiences, were only too happy to take advertising's dollar. Design styles lab-tested in youth magazines and obscure music videos became the stuff of trainer, soft drink and bank ads. Advertising and design are closer today than at any point since the 1960s. For many young designers emerging from design schools, they now appear to be one and the same. Obsessed with how cool an ad looks, rather than with what it is really saying, or the meaning of the context in which it says it, these designers seriously seem to believe that formal innovations alone are somehow able to effect progressive change in the nature and content of the message communicated. Exactly how, no one ever manages to explain.

Meanwhile, in the sensation-hungry design press, in the judging of design competitions, in policy statements from design organisations, in the words of design's senior figures and spokespeople (on the few occasions they have a chance to address the public) and even in large sections of design education, we learn about very little these days other than the commercial uses of design. It's rare to hear any strong point of view expressed, by most of these sources, beyond the unremarkable news that design really can help to make your business more competitive. When the possibility is tentatively

raised that design might have broader purposes, potential and meanings, designers who have grown up in a commercial climate often find this hard to believe. 'We have trained a profession,' says McCoy, 'that feels political or social concerns are either extraneous to our work, or inappropriate.'[6]

The new signatories' enthusiastic support for Adbusters' updated First Things First reasserts its continuing validity, and provides a much-needed opportunity to debate these issues before it is too late. What is at stake in contemporary design, the artist and critic Johanna Drucker suggests, is not so much the look or form of design practice as the life and consciousness of the designer (and everybody else, for that matter). She argues that the process of unlocking and exposing the underlying ideological basis of commercial culture boils down to a simple question that we need to ask and keep on asking: 'In whose interest and to what ends? Who gains by this construction of reality, by this representation of this condition as "natural"?'[7]

This is the concern of the designer or visual communicator in at least two senses. First, like all of us, as a member of society, as a citizen (a word it would be good to revive), as a punch-drunk viewer on the receiving end of the barrage of commercial images. Second, as someone whose sphere of expertise is that of representation, of two-dimensional appearances, and the construction of reality's shifting visual surface, interface and expression. If thinking individuals have a responsibility to withstand the proliferating technologies of persuasion, then the designer, as a skilled professional manipulator of those technologies, carries a double responsibility. Even now, at this late hour, in a culture of rampant commodification, with all its blind spots, distortions, pressures, obsessions and craziness, it is possible for visual communicators to discover alternative ways of operating in design.

At root, it's about democracy. The escalating commercial take-over of everyday life makes democratic resistance more vital than ever.

First things next

Naïve. Elitist. Arrogant. Hypocritical. Pompous. Outdated. Cynically exploitative. Flawed. Rigid. Unimaginative. Pathetic. Like witnessing a group of eunuchs take a vow of chastity.

No doubt about it, the First Things First 2000 manifesto, signed by thirty-three designers, design educators and critics, got right under some people's skins. These are just a few of the barbs and catcalls hurled at the 400-word text and its signatories by individuals who may have rejected its every line and sentiment, but apparently felt sufficiently rattled by its arrival to fire off a public response. In fifteen years as a design writer, I have never observed anything in the design press to compare with the scale, intensity and duration of international reaction to First Things First.

'You've given us a manifesto that is nothing more than a political pipe dream, full of brash accusations, not too much thought . . . crap,' retorts Gary Williams of Pasadena.[1] 'The revised manifesto presents an ostensible call to arms against consumerism, yet on closer inspection the criticism is seen to be deeply saturated with the commercial messages it decries,' scoffs Nick Shinn of Toronto. 'Product marketing is exactly what this manifesto revival is all about: it's a promotion for Adbusters!'[2]

Rudy VanderLans, a signatory and editor of Emigre, a Sacramento-based design journal, unrepentantly defends the text. 'To me, the First Things First manifesto is inspirational and encouraging. It tells me there are many design professionals who have social standards that influence whom they choose to work for and what kind of work they do. The manifesto's aim is not to hold designers culpable for the world's social and economic problems. On the contrary, it sees designers as having real potential to help cure its ills and make this world a better place.'[3]

To anyone who doesn't belong to the intense and often self-regarding design community, all this might seem like nothing more than a noisy squabble between a bunch of insiders. But something of crucial importance for everyone is being debated here. We live in an increasingly designed world and design is widely understood now as

an essential tool of capitalist consumerism. What we are rapidly losing sight of, in the rush to add seductive stylistic value to commercial goods and services and to transform life into a brand- and status-obsessed shopping spree, is the idea that design, as a way of thinking about systems, structures and relationships – large and small, conceptual and visual – could have uses other than commercial promotion. That it might also be an imaginative tool for solving non-commercial problems; for shaping a sustainable environment and an equitable public realm; for encouraging democratic participation and new kinds of social interaction; for expressing ideas, values and ways of feeling that originate down below, among ordinary people – us! – in our own neighbourhoods, from our own concerns. That it might be used in service to our collectively determined community needs, not just to deliver top-down fashion diktats and purchasing imperatives from megacorp boardrooms and conquer-the-world marketing teams. That design is not only an activity that trendy metropolitan design 'creatives' engage in: it's a universal human life-skill, a way of ordering, interpreting and enhancing our artefacts, images and surroundings, in which all of us should have a stake.

The text that created this unprecedented ruckus was launched in August 1999 by *Adbusters* and concurrently ran in five design magazines – *Emigre* and the *AIGA* Journal in North America, *Eye* and *Blueprint* in Britain, and *Items* in the Netherlands. In the following months, it also appeared in the American titles *I.D.*, *Communication Arts* and *Print*, the British titles *Design Week* and *Creative Review*, Germany's *Form*, Japan's *Idea*, the Czech Republic's *Typografia*, *Buletin* and *Deleatur*, and Norway's *Visuelt*, among others. A group of Croatian designers in Zagreb made an animation out of the text. A Dutch designer, clearly no fan of *FTF*", was provoked to start his own website – 'Innovation and Design for Information Empowerment' – as a forum in which to thrash out issues raised by the manifesto. A Turkish designer put up a page declaring how much *FTF* meant to her. At the *Adbusters* website, more than 1,650 people have now added their names to those of the original thirty-three signatories.

All the while, e-mails and letters to the various editors kept flooding in; some positive and supportive, some boiling with righteous indignation, some just plain perplexed. In design schools, there has been a lasting show of interest. *FTF* has been used as a discussion topic, as its authors hoped, and many signatories have received questions about autonomy, responsibility and ethical practice from students researching essays and projects based on the text. There has been public discussion, too, at specially organised events and lectures in the United States – in New York, Chicago and Boston – and in the UK and the Czech Republic. Here, though, there is still much to be done. Design organisations mindful of their members' commercial

A manifesto for 2000

We, the undersigned, are graphic designers, art directors and visual communicators who have been raised in a world in which the techniques and apparatus of advertising have persistently been presented to us as the most lucrative, effective and desirable use of our talents. Many design teachers and mentors promote this belief; the market rewards it; a tide of books and publications reinforces it.

Encouraged in this direction, designers then apply their skill and imagination to sell dog biscuits, designer coffee, diamonds, detergents, hair gel, cigarettes, credit cards, sneakers, butt toners, light beer and heavy-duty recreational vehicles. Commercial work has always paid the bills, but many graphic designers have now let it become, in large measure, what graphic designers do. This, in turn, is how the world perceives design. The profession's time and energy is used up manufacturing demand for things that are inessential at best.

Many of us have grown increasingly uncomfortable with this view of design. Designers who devote their efforts primarily to advertising, marketing and brand development are supporting, and implicitly endorsing, a mental environment so saturated with commercial messages that it is changing the very way citizen-consumers speak, think, feel, respond and interact. To some extent we are all helping draft a reductive and immeasurably harmful code of public discourse.

There are pursuits more worthy of our problem-solving skills. Unprecedented environmental, social and cultural crises demand our attention. Many cultural interventions, social marketing campaigns, books, magazines, exhibitions, educational tools, television programmes, films, charitable causes and other information design projects urgently require our expertise and help.

We propose a reversal of priorities in favour of more useful, lasting and democratic forms of communication – a mindshift away from product marketing and toward the exploration and production of a new kind of meaning. The scope of debate is shrinking; it must expand. Consumerism is running uncontested; it must be challenged by other perspectives expressed, in part, through the visual languages and resources of design.

In 1964, 22 visual communicators signed the original call for our skills to be put to worthwhile use. With the explosive growth of global commercial culture, their message has only grown more urgent. Today, we renew their manifesto in expectation that no more decades will pass before it is taken to heart.

Jonathan Barnbrook
Nick Bell
Andrew Blauvelt
Hans Bockting
Irma Boom
Sheila Levrant de Bretteville
Max Bruinsma
Siân Cook
Linda van Deursen
Chris Dixon
William Drenttel
Gert Dumbar
Simon Esterson
Vince Frost
Ken Garland
Milton Glaser
Jessica Helfand
Steven Heller
Andrew Howard
Tibor Kalman
Jeffery Keedy
Zuzana Licko
Ellen Lupton
Katherine McCoy
Armand Mevis
J Abbott Miller
Rick Poynor
Lucienne Roberts
Erik Spiekermann
Jan van Toorn
Teal Triggs
Rudy VanderLans
Bob Wilkinson

First Things First 2000 manifesto, presented as a poster in *Blueprint*, 1999. Design: Andrew Johnson

interests have been notably reluctant to acknowledge the manifesto and encourage full and open debate.

The problem for some designers, it seems, is that they had been so lulled by the complacent political atmosphere of the 1980s and early 1990s that they had no idea where this note of protest was coming from. The old ideological enemy, communism, had imploded and, after 1989, capitalism was hailed by many as the swaggering, uncontested master of the universe. This was the era of the free market and the rise of globalisation, a period when political philosophers could seriously declare that history had ended, as though ideological struggle had finally run its course. It was hardly surprising that, for designers who took all this for granted and regarded politics as a crashing bore, the manifesto's arrival, apparently out of the blue, looked like the last feeble gasp of a moribund way of thinking. 'It coats itself in the language of intelligent debate,' pronounced one British design journalist, 'but its content belongs back in the rigid structures of unimaginative Seventies college campus Marxism.'[4]

This penetrating *aperçu* was published in early November 1999; just a month later, the terms of public discussion experienced a force-ten shock. If the remarkable explosion of international anti-corporate feeling seen in Seattle was a watershed event, a second key moment, in early 2000, was the publication by Canadian journalist Naomi Klein of *No Logo*, a blistering attack on the way relentless enforcers of globalisation such as McDonald's, Nike, Calvin Klein and the Gap attempt to exploit the marketing opportunities in every last inch of cultural space. By the end of 2000, the same design pundit who had jeered a year earlier at *FTF*'s 'simplistic' attempts to broaden the scope of debate was busy recommending *No Logo* to his readers.

The design profession has not, in any case, swung round to a *No Logo* point of view, even if the book's incongruous presence in the design book shops lurking among the piles of hot-graphics titles might seem to suggest that it has. In conversation, Klein told me that she was struck by the way in which design people who invite her to speak at conferences often seem to misunderstand *No Logo*. They interpret her criticism of branding as evidence of 'failure to communicate' and imagine the book to be a wake-up call intended to help them deliver their clients' messages more effectively. Its critique is, in fact, fundamentally opposed to much of what they do, and Klein has added her signature in support of the manifesto.

THE SIMPLE GIFT OF DOG BISCUITS This reluctance to face up to the real issues being raised typified responses to *First Things First*. One line of attack taken by its critics was to zero in on the thirty-three signatories themselves, making wild generalisations about a

'professional élite' who supposedly concentrate on rarefied projects for the cultural sector and have little experience of the commercial work they snobbishly condemn. In reality, many of the signatories have years of commercial experience. Milton Glaser, Gert Dumbar and Erik Spiekermann – to single out three of the list's best-known and most influential names – have multinational corporations as clients, as did the late Tibor Kalman. Bill Drenttel worked for a decade as senior vice president at Saatchi & Saatchi, promoting AT&T cell phones, Pampers nappies and square hamburgers. Jonathan Barnbrook collaborates on TV commercials about Vicks cold remedy and Guinness for British advertising agencies. Meanwhile, other critics preferred to dismiss the signatories as hypocrites precisely *because* they have first-hand experience of the commercial world. 'People are looking for any excuse not to address the real issues,' says Rudy VanderLans. 'It's easier to accuse the signatories of hypocrisy or of taking hollow vows than to address the challenge put forward in the manifesto.'

It was also striking how much offence some people took to the list of commercial products given as examples in the manifesto ('dog biscuits, designer coffee . . . butt toners' etc.). This provided yet more evidence, they claimed, of the 'élitism' of designers who may have no occasion to value these items in their own lives, but seemed to want to deny others their perfectly legitimate needs and pleasures. Why shouldn't dog owners be given the 'simple gift' of a well-designed dog-biscuit package? as Michael Bierut, president of the American Institute of Graphic Arts, puts it in one of the most incisive published attacks. 'What makes dog-biscuit packaging an unworthy subject of our attention, as opposed to, say, a Walker Art Center catalogue? Don't dachshund owners deserve some measure of beauty, wit and intelligence in their lives, too?' Bierut demands to know.[5]

This is a fair point – though you might raise an eyebrow at the implication that when it comes to beauty, wit and intelligence, some of us have to settle for dog-biscuit boxes. Here, in retrospect, the manifesto's writers probably made a tactical error by following Ken Garland's original 1964 First Things First and including a product list at all. While some specificity seemed to be called for – otherwise, what does 'commercial work' mean? – almost any solid example will be problematic for someone. The point of the list, however, is not to fixate on dog biscuits or butt toners, or to damn all forms of product packaging, but to sketch in a broad domain of activity: the domain that dominates visual production and monopolises designers' talents and energy.

GREAT DESIGN FOR DESIGN'S SAKE If *FTF* was a 'Marxist' throwback for some observers, it certainly didn't provide any occasion for celebration at the headquarters

of *Living Marxism* magazine, where readers were solemnly informed that it is a graphic designer's neutral and impersonal task to communicate messages to 'whomever about whatever'.[6] Yet this cavalier dismissal of *FTF*'s ethical challenge was by no means unique. According to the representatives of a British design 'thinktank' called Design Agenda, being a designer is merely a job, no different in essence from being an accountant. At work, they insist, designers should concentrate on creating 'great design for design's sake', while political commitment should be confined to any remaining free time. 'Who you work for and what projects you end up working on is largely a career and not a political issue.'[7]

The alienation felt by some designers in the workplace is all too clear from letters published in *Adbusters*. 'I have been struggling with "satisfying the client" and not my own needs,' writes Tod Ramzi Karam of Seattle. 'Where and when can we draw the line?'[8] The only answer the 'design for design's sake' faction offer those who feel the longing to reconcile talent and conscience, to integrate work and life, is to get their heads down, grit their teeth and get on with it – because that's what designers do.

Hand in hand with the 'neutral designer' argument comes the claim that visual communicators need not worry about the value of the messages they convey because consumers are more than capable of deciding for themselves. To think anything else is to reveal yourself to be a 'sneering and puritanical' élitist, with a lamentably low opinion of the public's intelligence, according to Design Agenda. The gross generalisation in this piece of sophistry masks a more complicated reality. First, designers are consumers, too. If, as a consumer, you disagree with something, why shouldn't you apply this awareness to your choices and practice as a designer? Second, people vary enormously. Some are extremely sceptical and hard to persuade, some are pushovers and most of us fall somewhere in between. Advertisers and marketers know this and devise their strategies accordingly. It is often repeated that western consumers are exposed to something like 3,000 advertising messages a day – we can safely conclude that the number is huge. It belittles nobody's intelligence to say that, deluged with commercial messages day after day, most of us are simply not in a position to decode each one rationally on its merits and undertake the time-consuming research required to discover the truth about a particular company, product, or claim.

If we want to know how advertising actually works and what its goal is, who better to ask than an adman? Step forward Jelly Helm, a professor of advertising, former senior vice president at The Martin Agency, and ex-creative director at Wieden & Kennedy – in other words, a man who has sat at the nerve centre of advertising cool. 'Advertising's goal, of course, is to make you want something,' explains Helm. 'To create desire. That

begins by making you unhappy with what you currently have, or don't have. Advertising widens the gap between what you have and what you want. Wanting to buy something, then, is a response to the feelings of dissatisfaction, envy and craving. A perpetual state of conflict.

'It's on these emotions that a world economy and a dominant philosophy have been built, encouraging the act of spending to increase personal happiness, well-being, and ultimately, one's identity.'[9]

Reading the commentary that greeted FTF, it was surprising how few of its critics fully embraced its most urgent points. The fact that some advertising is amusing and well made is irrelevant, since what matters is the combined impact on the viewer of all advertising as the dominant mode of public speech. Here, the medium truly is the message, and the message is a value system embodying an ideology that many of us do not share and want to resist. As Helm puts it: 'When you build a system on a foundation of desire, dissatisfaction, envy and inadequacy, people buy things, yes, but it's no surprise that it happens at the expense of some damage to the psyche.'

CONFISCATION OF SPACE First Things First is not so unrealistic as to imagine that there could be no advertising at all. The text doesn't prohibit commercial work, or argue that such work should be of inferior quality, or demand that designers throw up their hands in horror and abandon any attempt to help shape commercial and civic space. It does, however, point out that designers who devote their efforts primarily to advertising, marketing and brand development are thereby helping to construct and endorse a mental environment that is having profound effects on the way people think and behave. The manifesto asks designers to consider where they stand in this system and, if they don't like what they see, to take responsibility for their part in this process. 'Media space is confiscated more and more by advertising and this is very frightening,' says Dutch signatory Armand Mevis. 'We need to be more critical of this but it seems there is no resistance going on. As a designer you can't change it but you can be aware of what you're doing and who you choose to work for.'[10]

Bill Drenttel, a Connecticut-based designer who withdrew from advertising after ten years to start his own design company, agrees. 'I believe that the mass of advertising and pressure of marketing lie at the root of this problem. This is not to say that selling things is bad. But I am saying that there's an excess of marketing – the sheer volume and endless pitch of it is just too much. For this reason, I'm glad I left advertising. I'm not against it. I just think it's an industry trapped in a paradigm of more-is-better – more media, more hype, more brands.'

This, more than anything, is what *FTF* is about: the increasingly desperate need to preserve a space for other forms of thinking, other shades of feeling and other ways of being in the world – a protected zone free from the banal, unceasing, invasive, mind-scrambling dazzle and clamour of the commercial inferno.

A NEW KIND OF MEANING For some observers, this was not nearly enough. They found themselves excited, ambivalent, confused. Perhaps they were half in agreement with the manifesto, but they were not at all sure what they were supposed to do next. '*FTF 2000* provokes questions but doesn't supply tangible solutions,' chides a British academic.[11] The short answer to this is that there are no handy, off-the-shelf, one-size-fits-all solutions. The manifesto states a point of view, issues a call and acts as a kind of starter motor, but it doesn't prescribe how people should respond to its challenge. That is entirely a matter of personal values and individual choice, and any number of scenarios or degrees of response are possible. One designer might decide to commit herself entirely to non-commercial projects; another might choose to work mainly in the commercial sector while making a consistent effort to prise open space for lower-paying community or cultural jobs. A designer might undertake work for charities or other non-profit causes, or become a dedicated member, after hours, of a group of campaigners or activists.

'I don't see how there can be a unifying "big idea",' says Siân Cook, a London-based signatory, who is a committed member of the women's design research unit, WD+RU. 'There is too much to tackle. But if every designer was part of a "small idea", maybe concerning single-issue politics or local campaigns, then that would be a start.' American signatory Katherine McCoy, a highly respected design educator, likewise notes the need to become involved in community, environmental and political issues at a local level. 'Yes, we can do the occasional pro bono piece. We can also load our work more richly with cultural, social and humanistic connotations and insist on adding non-commercial content. We can design provocative messages that stimulate our audiences to interpret and clarify their values, to make active choices. So much design communicates unitary, static messages.'

This goes some way towards answering another question often prompted by *FTF*: does it allow for the possibility that designers might work for change from within the system? In theory, there is no reason why one shouldn't attempt to disrupt established power structures from within, or use one's position as a professional mediator to intervene and challenge reductive forms of commercial speech. In practice, while this is sometimes proposed by students who have yet to try it, or by educators who probably

never will, few seem to pull it off. In the case of the handful that do – it's always Oliviero Toscani and Tibor Kalman, both working for Benetton, who spring to mind – the results are controversial, highly ambiguous and ultimately inconclusive. I have interviewed many designers who are doing their utmost to steer their clients towards 'good' design (if this can be termed an 'intervention'), but I have yet to encounter anyone, with the possible exception of Kalman, who overtly claimed to be using his or her position 'on the inside' to disrupt power structures from a consciously ideological standpoint. Kalman was a hugely charismatic personality, a design star, a special case. Designers with a high degree of socio-political conviction and motivation usually prefer to adopt positions in which they can operate with the greatest possible freedom.

Other signatories might disagree with this assessment, but that is inevitable given that the manifesto attempts to condense the views of thirty-three people (and now 1,680). Andrew Howard, for instance, a British designer based in Portugal, calls for nothing less than the 'politicisation' of all design discourse and practice.[12] Dutch supporter Jan van Toorn believes that *FTF* is not nearly strident enough. 'The declaration shows how politically naïve the design world still is when it comes to its own role in the circulation of material and symbolic commodities,' he says. Milton Glaser argues that, on the contrary, such militant language will only scare ordinary, unpoliticised designers away. The strategic objective, he argues, should be to work to reverse the old idea of professional neutrality (which dies hard, as we have seen) and make it seem unprofessional for designers and the organisations that represent them not to be actively concerned about these issues. In other words, a structural reorientation of design practice not by aggressive confrontation, which will fail, but by stealth.

AIGA president Michael Bierut's decision in early 2001 to sign *FTF*, despite his earlier criticisms, is an encouraging sign that its argument is making headway, even at the heart of the profession. 'I made no secret of my misgivings when *FTF* was first published,' he says. 'I felt then – and still feel now – that it presents designers with an implied world of black-and-white choices. Yet a good manifesto paints a picture of stark contrasts, and *FTF* has launched a worldwide debate that has elevated our profession and, by challenging us to respond, has made us better designers. Bad design is made by designers who don't think about what they're doing or why they're doing it. Whether you agree or disagree with it, *FTF* makes designers think. I support thinking designers and I support *FTF*.'

In his initial response, Bierut, like many others – including some signatories – complained about the vagueness of the line 'a new kind of meaning'. Why not just 'meaning', full stop? The phrase's virtue, though, is its openness. It suggests a degree

of honest uncertainty, indicates a provisional path with the prospect of territory to be discovered and makes no secret of the awesome scale of the task. It also acknowledges that at this point in the gathering global debate about corporate power, calls for a single, defining 'big idea', like the monolithic ideologies of the recent past, are entirely premature. A resistance is gradually taking shape, but its goals and its ultimate configuration have yet to be defined. Determining the 'new kind of meaning' is a huge collective project beyond the scope of a brief manifesto and a creative task in which all those who can imagine other possibilities are free to participate.

Thirteen provocations

CLOSING-DOWN SALE Tibor Kalman's decision, in 1993, to wind up M&Co and shut down his New York office was an existential enactment of everything he had been saying about design right up to and including the publication of his essay 'The End' (with Karrie Jacobs) in the same year. 'What we're calling for,' they wrote, 'is the end of a design profession that has, as its sole purpose, the propagation of style devoid of content, form devoid of function, and commerce devoid of culture.'[1] Kalman had seen it from the inside. He had tried it, been handsomely rewarded for it, and he wanted no part of it.

SIXTIES PROTEST In 1968, as a student at New York University, Kalman joined the political group Students for a Democratic Society, which had organised the first mass protests, in 1965, against the war in Vietnam. He attended demonstrations, threw rocks at the police and describes himself as 'highly politicised' at this time. Looking back, he believed that his real education was gained from the upheavals outside the classroom, as a student activist, rather than from the routine lessons taught within. In 1969, the SDS split into two factions, the Progressive Labour Party, committed to old-guard politics and the Revolutionary Youth Movement, which was more responsive to the hippie counter-culture. The following year, returning from a trip to Cuba, Kalman joined a group of NYU drop-outs and former SDS members who belonged to the neatly shorn, doctrinaire wing of the movement and were setting up a commune in New Jersey with the intention of organising workers in a car factory. Kalman, rapidly deciding this was not for him, abandoned the commune, hitchhiked back to New York and returned to his job in the bookstore that eventually became the Barnes & Noble chain.

NON-VISUAL DESIGN Most designers are designers because of an exceptional intensity in their response to visual form coupled with a degree of talent for manipulating it. Kalman was unusual among those who choose design as a profession in not being a visually motivated person in this sense. He was red-green colour blind and, although this was not

severe, it meant that he treated colour as an 'idea' rather than as a sensation to which he responded according to intuition or taste. He knew intellectually that 'sky blue' was called for to get an effect he wanted to achieve without being able to specify for himself which shade of blue it should be. Visually-inclined collaborators were therefore vital to the successful formal realisation of his ideas.

As a bookish teenager, Kalman owned volumes about artists such as Rembrandt, Van Gogh and the Impressionists, yet he has said that he did not learn how to take time to really *look* at a picture until he was taught to do so by Ingrid Sischy, editor of *Artforum*, in the mid-1980s. This, again, suggests someone for whom the pursuit of the visual as a compelling source of personal pleasure was not a primary drive. Kalman gave no sign of being captivated, seduced or swayed in his thinking by aesthetic concerns. He stumbled into design at Barnes & Noble by accident, and went on, throughout the 1970s, to produce sales literature, posters and displays without taking much notice of 'graphic design' as an established profession. 'I didn't really care about it. It wasn't on my screen,' he recalled. He acknowledged that the things he designed for the store – with great practical enjoyment on his part – were 'ugly'. The split subsequently seen in early M&Co work between routine jobs for money and the more creative projects that came to characterise M&Co's output from 1984 can, perhaps, be explained partly in these terms. An aesthetically motivated designer would have suffered the compromise in the fibres of his being, but Kalman simply didn't *feel* it this way. He continued to make design decisions according to the dictates of the underlying idea rather than aesthetic preference.

BEING BAD In the late 1980s, Kalman became steadily more disillusioned with design. He had been widely fêted, written up in the design magazines and style supplements as a quintessential New York designer crackling with energy and ideas, but success, when it arrived, had come too easily. Kalman's involvement as a board member of the American Institute of Graphic Arts in the late 1980s gave him a privileged glimpse, from the inside, of a professional community unknown to him a decade earlier. He was deeply suspicious of the AIGA's motives and scathing about the self-serving design community it represented. Now that he had access, as a design expert, to the senior executives of banks and department stores, he began to question the way in which professional design functioned as an uncritical support system for these enterprises. By degrees, the anti-establishment attitudes he had held as a student in the 1960s, and put to one side during the Barnes & Noble years and early days of M&Co, began to re-emerge. As the decade came to an end, a broader political reassessment of the Reaganite 1980s was

under way, with widespread revulsion at its 'greed is good' excesses.

Kalman's disaffection came to a head at the AIGA's 'Dangerous Ideas' conference in San Antonio, Texas, in October 1989. In his presentation to the conference (co-written with Karrie Jacobs) he urged designers to be disobedient and insubordinate, to pull the clients' briefs from their hands and rewrite them, to forget what it means to be a 'professional' and *learn how to be bad*. 'Bad means subverting what we've come to accept as the design process . . . If we approach clients with our own agenda, we may be able to do more than change a typeface or an annual-report concept. We might be able to have an impact on how companies do business. We might be able to make them better, or smarter, or more socially responsible.'² One of the problems with this critique is that it shrinks from discussing the political foundations of design as it is practised under capitalism. Despite its stirring rhetoric, which was undeniably fresh and invigorating after a decade of cynical 'designerism', it mistakes the symptom for the malady and leaves itself open to the charge that its concerns are stylistic rather than systemic. It wants to reform design practice – 'to inject art into commerce' – but not, fundamentally, to change it.

RED SQUARE M&Co's promotional work for Red Square, a 130-unit residential block on New York's Lower East Side, was the project that most clearly exposed the contradictions in Kalman's position at the end of the 1980s – and drew fire for doing so. Kalman himself became fiercely self-critical of a commission that cannibalised the familiar M&Co signifiers of New York graphic hipness – as well as a poem by Frank O'Hara, famed for his sense of the city – to bolster the real estate developer's attempt to gentrify the blue collar neighbourhood.

THE DESIGNER AS EDITOR Kalman's progression to the editorship of Benetton's *Colors* magazine, in 1991, was one of the most striking instances, in recent years, of a graphic designer moving into the role of content-maker and it remains a significant test case for any future discussion of the phenomenon. Kalman's intentions as editor were openly didactic. He was sick of designing the packaging for someone else's product; now he wanted to use his skills as a communicator to 'change the way things are'. Taking issue with the uncertain meanings and visual complexity of 1990s design, he argued, in defiance of fashion, for graphic design's 'higher purpose' as a medium for 'telling the truth'. In Luciano Benetton, he had found a client and patron who, for the thirteen issues he was editor, would give him complete freedom to determine the magazine's direction and content according to his idealistic beliefs.

NEW FRONTIERS Kalman's achievement with *Colors* was a personal triumph – the professional experience of his life – but the magazine was problematic in a number of ways. *Colors* as a project was preceded by Oliviero Toscani's notorious advertising campaign for Benetton, which had attracted (as intended) a mountain of publicity for the Italian knitwear giant. The meaning of these images, starting in the 1980s with shots of children from different ethnic groups, and moving on to 'shock' advertising such as the black and white hands joined by handcuffs or the African soldier holding a human femur behind his back, has been endlessly debated. Benetton's vision of itself as a 'global group open to the world's influences and engaged in a continuing quest for new frontiers', using its 'United Colors' campaign as a supposedly benign ambassador for its globalism, has been criticised as a form of cultural and economic imperialism.

It was inevitable, therefore, that a new Benetton magazine would be seen by sceptics as a promotional extension of the advertising campaign and as a vehicle for treating 'the rest of the world' – flagged on the cover as its subject matter – as territory for escapist fantasy and exoticism. As a corporate product, *Colors* was, in fact,

Colors, no. 13, 1995.
Editor-in-chief:
Tibor Kalman.
Editorial director:
Oliviero Toscani

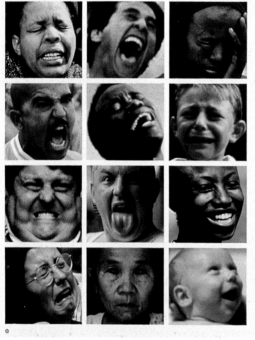

remarkably free of direct editorial messages and promotional features about Benetton and its product line, though Toscani's presence on the masthead as editorial director – Kalman described Toscani's role as that of 'enabler' – and the inclusion of ads such as the two mentioned, established an unambiguous connection to the company.

FAMILY OF MAN Kalman's aims as editor were self-consciously political. Inspired by the photography-led American news magazine *Life*, which he read as a boy in the early 1960s, Kalman attempted to use communication techniques long ago refined by advertising – arresting images, short blocks of copy – to transmit progressive 'leftist' ideas to his fifteen to twenty-five-year-old readership. *Colors* would celebrate human diversity and show its international audience the ways in which people and cultures were both similar and different; it would encourage them to 'think global, act local'. In its optimistic faith in 'The Family of Man', and its quest to document universal human experience, *Colors* often recalls Edward Steichen's 1955 exhibition at the Museum of Modern Art.[3] Kalman ran articles on racism, pollution, energy consumption, recycling garbage, using the media, the fate of the rain forests, the global distribution of wealth ('here's where the money lives') and an entire issue – arguably *Colors'* finest hour – on AIDS. The magazine was, as a result, frequently criticised for patronising its young readers, though the assumptions made every day by the owners of thousands of advertising-packed publications about their audiences' solipsistic obsessions with stardom, lifestyle, consumption and babes seem no less patronising. In such a context, *Colors'* celebrity-free assault on the narrow conventions of the 1990s newsstand deserved more credit than it received. The more fundamental contradiction embodied in the sponsorship of a magazine celebrating multicultural diversity by a company whose commercial activities – like those of other multinationals – are helping to erode precisely those differences is harder to answer. By the eleventh issue, devoted to travel, *Colors* itself acknowledged that globalism will destroy cultural diversity within its readers' lifetimes: 'Forget about stopping it; you can't.'

COLOSSAL PHONE BILLS *Colors* was an enormous editorial undertaking, with a $3 million annual budget. No small independent publisher could have attempted such a publication and no large corporate publisher would have risked it. During its two and a half years in New York, editorial phone bills alone amounted to over $20,000 per issue. Working on a Moscow story in 1992, the editorial team dealt with the restricted number of phone lines into the city by leaving their connection open for hours at a time until all their business was done: losing a line could mean waiting two days to get another.

TEMPORARY AUTONOMOUS ZONE In an essay published in 1991, the American theorist Hakim Bey considers the possibility of political, social and cultural resistance in a post-revolutionary world and proposes the idea of the 'temporary autonomous zone'.[4] For Kalman, *Colors* functioned as a temporary platform for his own political message-making, while his host, Benetton, picked up the awesome tab. He had tried working with charitable organisations – the more conventional way of going about this – but claimed to find them too cumbersome, bureaucratic and slow-moving for his temperament. He conceded, though, that the privileged relationship it was possible for him to sustain with Benetton was a by-product of his high degree of success as a commercial designer and of the bargaining power this brought him. If *Colors* became a kind of TAZ under his editorship, it is one that depended on highly unusual conditions that will not be easily repeatable elsewhere, even by those who pursue a similar career path.

TIBOR BEING TIBOR In his 1980s rise to design-biz stardom, Kalman commanded attention by becoming a 'character', the 'bad boy' creative with the cutting quip. The witty publicity portraits – the pencil clenched in mouth, the painting by a portrait studio in Bombay – were acts of self-mythology. But the humour was double-edged. The wisecracks made the message listenable but they also made it easier to shrug off: it's Tibor being Tibor. To treat Kalman as a colourful character, a 'dyed-in-the-wool contrarian', as one observer put it, is to defuse and deny the challenge of an exceptional career. Did Kalman have an important point to make about design and its relationship to society and politics, or not?

WORLD WITHOUT WORDS *Colors*, no. 13, the wordless issue, is one of Kalman's most interesting experiments. It moves, like the second half of Charles and Ray Eames' educational film *Powers of Ten*, from macro to micro: the first image on this human odyssey is the Milky Way, the last an atom of helium. For Kalman, the rejection of picture captions was an attempt to make the reader pause – as he had learned to pause – long enough to study each image closely and consider its relationship with the images around it. It was an exercise in defamiliarisation, in making the strange familiar and the familiar strange. 'By taking the words away, we sort of put you in the position of a tourist who can't speak the language,' explained a short editorial. 'The only way for you to understand what's going on is by looking.'

In the book *Voyeur* (1997), the German artist Hans-Peter Feldmann attempted something similar using hundreds of small, captionless, black-and-white photographs taken from newspapers, advertising, feature films, pornography and ethnographic

studies.[5] Feldmann scrambled his images of disaster and domesticity, the natural and the man-made, sex and death, with a randomness that plunges the viewer into a disturbing world of causal disconnection and unfathomable complexity. *Colors*, by contrast, develops, like 'The Family of Man', according to a structured programme of visual themes. The early photographs mix images of the natural world with signs of human intrusion – a lizard takes on the colour of road markings – and it is not until page twenty-four that we see a gallery of human faces, in the grip of strong emotions. Sequences focused on the body – the foot, the nose, the genitals (a Benetton ad) – are followed by body adornment, dress conventions, smoking, kissing and the body in motion.

At the mid-point, however, as the images become representations of underlying social and political events, the issue's premise begins to falter. The picture of men in suits clutching at the face of another man takes on much greater meaning, as an image of political failure, when you discover from the information that is provided at the back of *Colors* that these are members of the opposition in South Korea's National Assembly attempting to stop a politician from speaking before an imminent budget deadline. What the picture unwittingly confirms is the essential contribution to understanding that captions can make. Denying such a photograph the possibility of contextual meaning – its origins in the actual experiences of real people in a particular time and place – runs the risk of encouraging the viewer to become a tourist in the nowhereland of the image.

COMMERCE PLUS CULTURE Kalman, who died in 1999, pursued a trajectory that has few, if any, parallels among American designers operating at his level. He courted controversy and his outspoken analysis of contemporary design practice, and personal rejection of it, created high critical expectations of his work. Content-makers can expect much more exacting assessment than those who simply supply the packaging. A self-proclaimed socialist, in a country and at time when that was not a comfortable or popular position to adopt, Kalman depended, as a communicator, on finding sympathetic corporate collaborators to sponsor his message-making. This is a high-risk strategy fraught with difficulties for anyone seeking to maintain a dissenting voice, but one of the few options available in an era when commerce and culture are ever more tightly entangled. Kalman's experiments address the urgent need to find new ways to bring old causes to life for new audiences. For those trying to discover more meaningful ways to work in design, his daring example will assume increasing importance in the years ahead.

Surface wreckage

Jonathan Miller has an international reputation as one of Britain's most versatile figures in the arts. He qualified as a doctor, came to fame as a satirist and performer, directed a television film of *Alice in Wonderland* and wrote a slim volume, sharp as a stiletto, debunking Marshall McLuhan. His thirteen-part TV series on the history of medicine, *The Body in Question*, is a milestone. In his spare moments, he has directed more than fifty opera productions in London, New York, Paris, Florence and Berlin.

Photography:
Jonathan Miller,
from *Nowhere in
Particular*, 1999

What we had no way of knowing, until the publication of Miller's book *Nowhere in Particular*, is that for nearly thirty years he used a cheap automatic camera to take photographs of details – 'pictures of bits', as he calls them – in the street.[1] *Nowhere in Particular* shows dozens of images of torn, scuffed, battered, rusted, cracked and peeling surfaces. Miller describes them as 'negligible things to which one would normally pay no attention at all. Nevertheless,' he continues, 'these fragments and details attracted my eye and I felt the irresistible urge to record them.'

In his introduction, he draws comparisons with the scenic details painted around 1800 by artists who felt them worthy to be pictures in their own right. This is interesting, but gives little sense of the contemporary context for an activity that Miller seems half inclined to play down as 'random scavenging'. What he doesn't mention is the degree to which such 'bits' have seduced many artists, photographers and designers in the twentieth century. The torn posters on the cover of his book – one face appears almost to be dreaming the other – belong to a well-established, though admittedly off-beat, genre of image-making. Part of the fascination of *Nowhere in Particular* lies in observing this poetic way of seeing being pursued for many years, almost obsessively, by a casual, non-professional photographer with no immediate artistic use for the images in mind.

The American photographer Walker Evans was one of the first to focus on street posters and signs as sources of insight into the society that created them. In *Torn Movie Poster*, taken in 1930, the movie stars' glamorous heads are divided by a gash that begins

in the top right corner and narrows to a fissure across the starlet's face. Evans' tight close-up excludes most of the poster because it is the fault line destabilising the image that he wants us to see. In *Minstrel Showbill, Alabama* (1936), he shows the entire poster, with some of the surrounding wall. This time, a much greater proportion has been torn away and the bricks are re-emerging from behind a patronising scene of 'comical' black folk running round a yard. The abrasions of the elements, assisted perhaps by the hands of passers-by, strip away a dubious piece of racial propaganda.

Even more significant in the evolution of this aesthetic of the 'negligible' was another American photographer, Aaron Siskind – in his book, Miller briefly acknowledges an affinity with Siskind's pictures. By the 1940s, Siskind had abandoned his early documentary approach, always notable for its attention to formal qualities, in favour of a preoccupation with flatness and surface texture usually compared to Abstract Expressionism, although Siskind's artistic interests developed in parallel with those of painters like Mark Rothko, Franz Kline and Clyfford Still. 'First, and emphatically, I accept the flat plane of the picture surface as the primary frame of reference of the picture,' Siskind wrote in 1950. Despite being based on the most inconsequential subject matter, his black-and-white close-ups of rocks, sand, seaweed, paint-smeared walls, fragments of buildings, graffiti, details of decaying signs and peeling posters achieve the raw formal language and heightened expressive power of abstract paintings. In pictures such as *Jerome, Arizona* (1949) and *Degraded Sign* (1951), distressed and damaged surfaces resonate with a promise of deeper metaphorical meaning.

The idea that mangled street posters might be literally appropriated for artistic purposes is attributed to Léo Malet, a French poet, who was briefly a member of André Breton's Surrealist group. In the mid-1930s, observing the processes by which pristine printed images were transformed, Malet proposed a new form of Surrealist street poetry shaped by chance. 'Soon,' he wrote, 'collage will be executed without scissors, without a razor, without paste . . . Abandoning the artist's table and his pasteboard, it will take its place on the walls of the city, the unlimited field of poetic realisations.'[2] Commercial artists would supply the raw materials, and passing pedestrians, aided by wind and rain, would intervene to unlock new meanings never intended by the designers or their clients, as mysterious fragments of earlier images, hidden below the top poster, were once again exposed to view.

Malet's idea of *décollage* remained a theory until the 1950s when two French artists, Jacques de La Villeglé and Raymond Hains, began, unknowingly, to put it into practice. Hains was unhappy with the black-and-white photographs he had been taking of torn posters and decided to pull down these ready-made collages and take them home. He

later moved on to other forms of artistic practice, but Villeglé – a mixture of artist, collector and documentarist – stayed loyal to this way of working for his entire career. Each piece would be titled with the place of discovery, the month and year – 'Windsor-Cinéma, February 1959', 'Boulevard Richard Lenoir, 22 September 1964', and so on. Cut loose from their original poster sites, mounted on canvas and displayed in the quiet of the art gallery, they have enormous gestural energy and an aesthetic power that comes from endless, unpredictable collisions of colour, ragged line, word-shape and image.

To describe the random forces that brought these images into being, Villeglé coined the term *Lacéré Anonyme*. He saw this 'anonymous lacerator' as the mythic embodiment of the crowd's anarchy and dissent as it defaced every attempt at persuasion by commercial and bureaucratic authorities. His own modest role was to act as curator and select singular specimens from the lacerator's vast *œuvre*.

For designers, the public fate of their efforts offered a spectacle both peculiar and fascinating, as dreams of abundance were reduced to images of transience and decay. In the early 1960s, while Hains, Villeglé, Mimmo Rotella, Asger Jorn and other *affichistes* wrenched posters from the hoardings, Herbert Spencer was documenting these chance depredations with his camera. In his pictures of 'strange juxtapositions revealed through the sad ribbons of torn posters', he set out to record the dissolution of an order he spent his days as a design consultant attempting to impose.[3] His photographs of broken shop-front lettering, scarified posters and graffiti-pocked walls disclose an urban panorama in which signs of official communication have frayed into an impromptu poetry of tattered logos, shattered copylines and stuttering letterforms. In a picture of a St Pancras street, the one-way sign is sucked in and nullified by a churning backdrop that, if it weren't for a Heinz label, would feel closer in mood to an Abstract Expressionist daub by Robert Motherwell than an ad.

Designers were quick to see that the street's haphazard visual fabric could be used as inspiration for new kinds of design. In 1961, the most concentrated analysis of these possibilities came from Robert Brownjohn, an American designer then resident in London. Brownjohn's photo-essay 'Street level', for Herbert Spencer's *Typographica* magazine, has thirty-one pages of his pictures taken on a single trip around the city. They catalogue irregular word spacing; missing, misaligned, eroded and overlapping letters; hand-written signs; type distorted by glass. 'The things they show have very little to do with Design, *apart from achieving its object*,' Brownjohn notes (my italics). 'They show what weather, wit, accident, lack of judgement, bad taste, bad spelling, necessity, and good loud repetition can do to put a sort of music into the streets where we walk.'[4]

By displaying professional design projects next to samples of primitive and

Posters of former
president Slobodan
Milosevic, central
Belgrade, June 2001.
Photography: Darko
Vojinovic/AP Photo

accidental street typography, Brownjohn transformed an *ad hoc* way of seeing common to many designers into a manifesto for purposeful scanning of the street. In the years that followed, a 'street level' sensibility and fascination with vernacular design became one of the international cornerstones of experimental graphics. From the late Swiss typographer Hans-Rudolf Lutz to pop deconstructionist David Carson, designers embraced the street's disorder as an alternative ordering principle in their work. The camera continues to be an essential tool for gathering these chance-formed treasures, especially when travelling abroad. In 1991, Lutz published a photo-essay based on photographs of South American streets.[5] In some of his most arresting examples, the same found poster image of a grimacing woman in glasses is shown six times, each example subject to a different type or degree of environmental attrition.

Carson has sometimes noted his aesthetic debt to Lutz, and in his lectures in the 1990s he showed slides of peeling posters seen on walls in Mexico and elsewhere that inspired his own typographic method. He didn't necessarily import these images directly into his designs any more than Brownjohn and his colleagues had done thirty years earlier. Usually, it was a matter of allowing the shapes and colours to percolate in his mind, and then devising combinations of type and image with similar qualities of randomness, unpredictability and ambiguity. Brownjohn summarised the method, with laconic precision, in *Typographica*: 'Bad word spacing can happen. Or it can be designed.'[6]

Why do images of torn posters and damaged signs exert such a powerful hold on the imagination and emotions? What quality is it that distinguishes one specimen of 'chance art' – as Herbert Spencer called it – from the next? 'The fact is, most of the torn street posters or hand-lettered signs that I come across are not interesting,' Carson told an interviewer. 'But every now and then, the elements come together in a way that I find pleasing . . . and that's totally subjective and intuitive on my part. I'm not sure I understand myself what makes one thing visually interesting to me, while another strikes me as being just ordinary.'[7]

What is so striking about Jonathan Miller's 'negligible' images is how aesthetically resolved, how right to the eye, they seem. They are compelling as a collection, but many stand up as separate pictures. Miller and his designers have taken a number of decisions that intensify their impact. The majority are shown at the same size as the original prints and, except for a few full-bleed pages, most are surrounded by white space. There are no page numbers or captions and Miller makes no attempt to give their origins in time and location (hence the title: *Nowhere in Particular*), although there are sometimes internal clues. The unanticipated colour changes produced by a cheap developing process –

Miller, like Carson, used an ordinary snapshot service – introduce a further element of chance and level of disassociation from the original scene. 'In the final outcome,' says Miller, 'I preferred what I got to the picture I thought I was taking.'

For Miller, these images are 'abstract designs' drawn from the wreckage of real surfaces, but even at their most abstract they are still artificial constructions readable as traces of the people who made them and viewed them, an unseen but persistent presence. That they offer documentary evidence of things no longer working or wanted, of demolition and undoing, of entropy at large in the world of matter, only adds to their poignancy (Spencer's 'sad ribbons'). Where fragments of people are glimpsed – an arm, an eye, a pair of lips – this sensation is even more acute. In one picture, a man's face has been neatly excised, leaving only an immaculately combed head of hair. Among the torn edges of his new face is the sharp form of an uppercase 'A', a visual rhyme with the triangular shape of his hairline and brow. Whoever he was, whatever he was trying to tell us, he has become 'Exhibit A' in a case that will never be solved.

'Every photographed object,' writes Jean Baudrillard, 'is merely the trace left behind by the disappearance of all the rest. It is an almost perfect crime, an almost total resolution of the world, which merely leaves the illusion of a particular object shining forth, the image of which becomes an impenetrable enigma.'[8]

In characteristically ecstatic language, Baudrillard comes closest, perhaps, to capturing the magnetic lure of the torn poster image. In an essay prompted by his own activities as a photographer, he reflects on the 'dizzying impact' and 'magical eccentricity' of the perpetual photographic detail, and on the world's refusal to yield up its meaning in photographs. Discontinuity and fragmentation are inescapable conditions of photography, and if this is always a factor drawing us to a photograph – any photograph – then the torn poster photograph carries a double charge. In its ravaged paper surface, an inherently discontinuous medium finds a perfect, enigmatic match.

This is a record cover

This is a RECORD COVER. This writing is the DESIGN upon the
record cover. The DESIGN is to help SELL the record. We hope
to draw your attention to it and encourage you to pick it up.
When you have done that maybe you'll be persuaded to listen to
the music - in this case XTC's Go 2 album. Then we want you
to BUY it. The idea being that the more of you that buy this
record the more money Virgin Records, the manager Ian Reid and
XTC themselves will make. To the aforementioned this is known
as PLEASURE. A good cover DESIGN is one that attracts more
buyers and gives more pleasure. This writing is trying to pull
you in much like an eye-catching picture. It is designed to get
you to READ IT. This is called luring the VICTIM, and you are
the VICTIM. But if you have a free mind you should STOP READING
NOW! because all we are attempting to do is to get you to read
on. Yet this is a DOUBLE BIND because if you indeed stop you'll
be doing what we tell you, and if you read on you'll be doing what
we've wanted all along. And the more you read on the more you're
falling for this simple device of telling you exactly how a good
commercial design works. They're TRICKS and this is the worst
TRICK of all since it's describing the TRICK whilst trying to
TRICK you, and if you've read this far then you're TRICKED but
you wouldn't have known this unless you'd read this far. At
least we're telling you directly instead of seducing you with
a beautiful or haunting visual that may never tell you. We're
letting you know that you ought to buy this record because in
essence it's a PRODUCT and PRODUCTS are to be consumed and you
are a consumer and this is a good PRODUCT. We could have
written the band's name in special lettering so that it stood
out and you'd see it before you'd read any of this writing and
possibly have bought it anyway. What we are really suggesting
is that you are FOOLISH to buy or not buy an album merely as a
consequence of the design on its cover. This is a con because
if you agree then you'll probably like this writing - which is
the cover design - and hence the album inside. But we've just
warned you against that. The con is a con. A good cover design
could be considered as one that gets you to buy the record, but
that never actually happens to YOU because YOU know it's just a
design for the cover. And this is the RECORD COVER.

Punk was such a compelling moment that its legacy and – improbable as it might seem – its cultural capital are still being claimed, more than twenty years later, on behalf of everyone from young British artists to digital media theorists. That its influence is just as keenly felt in visual media as it is in music is perhaps not so surprising. With the passage of time, punk is memorable as much for its imagery and for its ferocious graphic signature as for its snarling assaults on the eardrum. An exhibition held in – of all places – London's Royal Festival Hall bashed the point home with hundreds of record sleeves, fanzines and posters from 1976 to 1982. At least some of the fun came from watching the crowd: the early middle-aged revisiting the site of youthful excitement, energy and anger, the occasional punk's-not-dead anarchist in tatty leathers and, since this was the South Bank, the well-heeled home counties oldsters, casting a tolerant eye over the mayhem, long past being shocked by anything as nicely packaged as this.

In such an environment, the exhibition's title, 'Destroy', only served to confirm punk's terminal domestication. The curators (Paul Khera and Maria Beddoes) went to enormous trouble to assemble a fascinating body of material but, disappointingly, attempted no commentary beyond a handful of routine captions. The year-by-year layout didn't lend itself to the thematic appraisal the material cries out for now. There was no catalogue. As design, punk and new wave graphics have received plenty of lip service. It is well known that some key figures – Malcolm Garrett, Neville Brody, Peter Saville – emerged from the subculture. But there has been hardly any analysis of punk's visual legacy, apart from a couple of necessarily selective books: *Street Style* (1987) by Catherine McDermott and *Cross-Overs: Art into Pop/Pop into Art* (1987) by John A. Walker.

Authentic punk graphic design, like punk music, was shortlived. By 1977, in a four-colour poster for the Dead Boys' 'UK Invasion Tour' (hollow boast), the torn edges and stencilled letters familiar from a hundred scabrous fanzines, cut and glued and scrawled in suburban bedrooms, were no more than a reflex, empty of critical content. The same year, Nicholas de Ville, designer in the early 1970s of the Roxy Music covers, created a 7-inch sleeve for *Gary Gilmore's Eyes* by The Adverts which aestheticised the thrown-together look into an exquisitely tasteful fusion of rhythm and colour. The mannerisms hung around for a while on the largely forgotten sleeves of groups like Stiff Little Fingers, Television Personalities and Subway Sect, but by the end of 1977, in Britain, punk as a viable graphic style had run its course.

Punk graphics was always most biting where its devices were used in the cause of a larger idea. Jamie Reid, pure punk's only designer with a passing claim to greatness, wielded confrontational imagery with the force and accuracy of a burglar's cosh: the

safety-pinned Queen, the Boredom and Nowhere buses, the cracked glass in an empty frame for the Sex Pistols' *Pretty Vacant*. The ransom note lettering wasn't merely expedient: it sniggered 'deviant' and 'criminal' at the authorities. Reid's black-on-yellow 'Never Mind the Bans' poster, a crazy-paving montage of correspondence refusing the Pistols the right to play, exposes local censorship and rubs the faces of assorted directors of tourism and leisure in their own pusillanimity. His calculated acts of Situationist *détournement* never failed to hit the mark – as the threat of litigation showed. The *Holidays in the Sun* cover was withdrawn after complaints by the Belgian tour operator whose promotional material had been swiped, and American Express failed to see the funny side of Reid's Sex Pistols credit card sleeve for *The Great Rock 'n' Roll Swindle*.

In retrospect, Reid's poster for the record is one of the definitive graphic texts of the period, a bottom-line summary of the music business that leaves little more to be said. Under the heading 'YOUNG FLESH REQUIRED', Reid lays out the transaction between the artist (The Prostitute), the record company (The Pimp) and the business (The Swindle). The object of the business is to exploit your talent for maximum profit while paying you as little as they can. Everyone is at it, including the manager, the promoter, the press and the disc jockeys – 'and if you're smart, You'. In the post-punk period, there was a growing cynicism about the realities of commerce. Malcolm Garrett designed a plastic carrier bag for the Buzzcocks emblazoned with the word 'Product'. The cover of Public Image Ltd's first LP (1978), with a spruced-up 'corporate' John Lydon, resembles a glossy magazine: the P(ublic)I(mage)ME logo on the back cover is a take-off of *Time*.

Oddly, the most extreme and perfectly realised example of the self-referential, post-punk cover came from a design team known for its work for the previous wave of 'dinosaur' rock groups. Hipgnosis' sleeve for XTC's album *Go 2* (1978) turns the marketing mechanics of designing a cover into the design itself by filling front and back with an incisive, typewritten, running commentary. 'This is a RECORD COVER,' it begins. 'This writing is the DESIGN upon the record cover. The DESIGN is to help SELL the record. We hope to draw your attention to it and encourage you to pick it up. When you have done that maybe you'll be persuaded to listen to the music . . . Then we want you to BUY it.' The text goes on to admit quite openly that these devices are tricks and that the worst trick of all is that the record company is describing the trick as yet another way of seducing the buyer. The record is a product, the consumer's role is to consume it, and you are a fool if you let the cover design influence you one way or the other. In its conceptual approach and typographic style – white out of a black background – the cover owes an obvious debt to Joseph Kosuth, who, in the 1960s, produced conceptual paintings defining words such as 'thought', 'universal' and 'idea'. The originality of *Go 2*

lies in its tactical use of this form of estrangement to expose the normally invisible processes of market persuasion that operate even in the ostensibly 'uncommercial' genre of independent rock.

These foregrounding devices rapidly became a regular strategy, as though the artists hoped that by winking at the buyer they could be let off the hook, while at the same time they did indeed have every intention of following Jamie Reid's advice and cashing in now. In the space of three years, Scritti Politti moved from the design-zero of their first single, *Skank Bloc Bologna*, to a 12-inch sleeve by Keith Breeden for *Asylums in Jerusalem/Jacques Derrida* (1981) that distils elements from the Courvoisier cognac label into a graphic metaphor for the irresistible lure of luxury and the commodification of consumer desire: acknowledge how good it makes you feel and enjoy it, while further savouring your theoretical sophistication in brazenly claiming your share of Barthesian *jouissance*. In Heaven 17's *Penthouse and Pavement* (1981) the group's mission to be their own right-on corporation, while chanting rousing anthems such as '(We don't need this) Fascist Groove Thang', is made explicit in a bland, corporate brochure-style cover illustration that depicts the upwardly mobile young trio – 'The New Partnership that's opening doors all over the world', according to a cover line – coming on like contenders for a Businessmen of the Year award. Here, if you can forget the ponytails and revolting ties, is a prescient early blueprint for the power-suited self-determination of the City-minded 1980s.

Most intriguing of all, though, because twenty years later the informing sensibility is still so hard to pin down, are the sleeves of Throbbing Gristle, the band that emerged from Genesis P-Orridge and Cosey Fanni Tutti's COUM Transmissions performance art group – responsible in October 1976 for the notorious 'Prostitution' exhibition at the ICA. The lugubrious techno-dirge *United* (1978), released on their own Industrial Records label, juxtaposes canisters of the Nazi's Zyklon B extermination gas with a domestic shower scene. The design is austere but considered – that's part of its horror – and has the passionless 'objectivity' of technical literature; it is certainly not 'punk' in a graphic sense (TG designs were uncredited, though band member Peter Christopherson had belonged to Hipgnosis). *20 Jazz Funk Greats*, on the other hand, an album of musical disturbance and lyrical trauma released in 1979, is packaged in an open-air portrait of the kind usually found on terminally dull easy listening albums. The four group members, otherwise given to wearing paramilitary uniforms and heavy boots, pose on a cliff in 'nice' casual clothes, in front of their distant Range Rover.

There is black humour here, but there is also something fundamentally recalcitrant, forever just out of reach, a power that punk and post-punk's more explicit

graphic testaments rarely attain. The exact ways in which sophisticated music graphics interact with musical content to establish a tone or a stance, to direct or even determine interpretation and response, remains a subject that has hardly been considered. When a group's work is repackaged for reissue, it will often seem subtly weaker and less compelling once detached from imagery with which it has become tightly linked – just as a tape-recording, minus the original graphics, misses some of the intensity and pleasure of the package as a whole. It's almost Pavlovian, as the punk Situationists well understood. Looking at these fabulous covers is enough to make you want to listen to the music all over again.

Fighting ads with ads

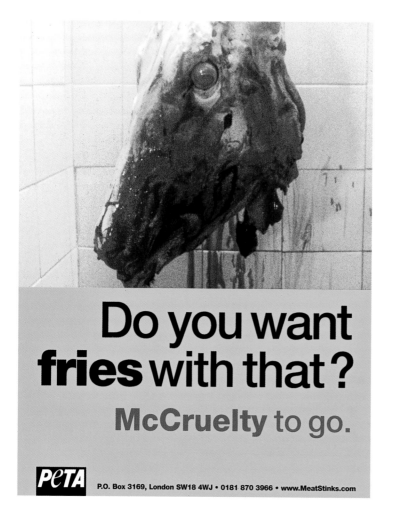

Jesus was a vegetarian. Does that notion disturb you in any way? How about a large billboard using the same phrase, with a picture of the Messiah, a Sacred Heart and a halo formed from a slice of orange? This image, paid for by People for the Ethical Treatment of Animals (PETA), certainly got them hot under the dog collar on the Falls Road in West Belfast. In 1999, after the Roman Catholic Church objected to the poster, it was removed. It wasn't the message they deplored – apparently, theologians differ on the delicate issue of whether or not the Lamb of God was partial to lamb himself – but the use of Jesus' image in any context other than the sacred.

The swift reaction to PETA's poster confirms that, when it comes to delivering an awkward message, the street is still one of the most sensitive places to attempt to say something that other people don't want to hear. These flimsy sheets of paper, visible to anyone passing by, can arouse passions like few other forms of communication. The big, printed image has an imposing, territorial presence that gives it an appearance of public legitimacy which cannot be allowed to go unchallenged if you happen to disagree. Make so bold as to say that 'Jesus was a vegetarian' in a magazine, a book or a website, even with a picture, and it is unlikely that the church would move to shut you down.

Given the presence, power and simplicity of street advertising, it is surprising that more campaigning organisations and special interest groups don't try to reach us through this channel. Admittedly, the British system of advertising bodies and industry regulations presupposes that the purpose of advertising is, on the whole, to sell us things. It's the very 'naturalness' of advertising, though, our collective readiness to accept it as part of the background noise of everyday life, that makes it such an effective transmitter for any group wishing to plead a cause, register a protest, or plant a few well-chosen seeds of doubt.

The most outspoken of these taboo-breakers sometimes become permanently lodged in popular memory. The pregnant man in his cardie ('Would you be more careful if it was you that got pregnant?') is thirty years old. Equally enduring is Lynx's no-holds-barred campaign against the fur trade. In a searing ad-shock classic, an elegant, long-legged woman drags a fur coat oozing a trail of blood across the floor. 'It takes up to 40 dumb animals to make a fur coat. But only one to wear it.' Try making a convincing public defence for fur-wearing after that.

PETA, founded in the US in 1980, operates in the same tradition of gut-wrenching ethical shocks. Advertising is the beating heart of its international strategy. For ten years its campaigns have been devised by London agency Lawrence & Beavan, which has a lasting commitment to animal welfare causes. PETA's 'McCruelty' campaign

excoriating McDonald's makes the Lynx poster look almost tastefully restrained. 'Do you want fries with that?' snarls the copyline, next to a bloody, skinned cow's head.

The animal welfare campaigners have the law on their side. At the end of the 'McLibel' trial in 1997 – a notorious PR disaster for McDonald's – a high court judge ruled that the burger giant was 'culpably responsible' for cruelty to animals used in its meals. The McCruelty campaign followed two years of negotiations that left PETA unconvinced of McDonald's' intention to reform its meat suppliers' practices. Nor is this the first protest campaign to target a particular company in its ads. Greenpeace billboards gave Ford a roasting until it fitted catalytic converters to its British cars.

However, the PETA campaign proved too strong for some stomachs. Only *Ethical Consumer* magazine agreed to run it on its pages. *Time Out*, the *Independent* and the *Sun* said no. There were reports that the Advertising Standards Authority and Outdoor Advertising Association were mobilising to reject the billboard even before the campaign had been launched. In the US, the response was much the same. No poster site owner in Chicago would accept the ad, so a city businessman came to PETA's rescue by allowing a 20-foot banner to be hung from the side of his building. In Britain, PETA sidestepped the site owners by taking a mobile billboard on a tour of London, Birmingham, Liverpool and Nottingham. It responded with the same tactic after the Falls Road ban.

Media-owners may be reluctant to offend a big spender, but it is hard to think of any other reasons why these ads should be suppressed. To say they are distasteful is to put decorum before reality, and we are no longer that kind of society. To suggest they are in some way unfair because they use emotional appeal rather than argument to promote a change in behaviour would be to indict an entire advertising industry predicated on this form of persuasion. If it is acceptable to entice families with promises of a 'Happy Meal', it is just as reasonable to permit the message that the meal involves practices that might, if you knew about them, kill your appetite. A campaign such as PETA's is backed up with plenty of research, information and detailed argument for those who wish to pursue it further.

One thing is certain: media-conscious protesters will quickly learn from such campaigns and demand access to publicity channels that commerce now has at its disposal. The web is already used in this way – see PETA's website (www.peta-online.org) – and cyberspace's open door is a constant reminder of closed doors elsewhere. In North America, the right to media access has become a campaigning issue in itself. The Media Foundation in Vancouver, publisher of *Adbusters* magazine, fights a running battle with the US television networks for the chance to air its

Poster for *Adbusters*,
Las Vegas, 1999.
Design: Jonathan
Barnbrook. Text:
Tibor Kalman.
Photography:
Tomoko Yoneda

provocative 30-second 'social marketing' campaigns about fashion, the car and environmental issues.

But, significant as they are, our private experiences with TV and the Internet will not supplant the billboard's public power to ambush the viewer. Conventional advertising shows no sign of abandoning the street. In 1999, in Las Vegas, *Adbusters* put up a typically confrontational, 48-foot poster, aimed at 3,000 designers attending a conference, urging them not to go anywhere near corporations that want them to 'lie'. Smoothly mimicking the style of corporate ads, it was a stunning foretaste of what professional anti-advertising might look like in the near future, as the struggle between opposing belief systems is increasingly played out in the social arena of our city streets.

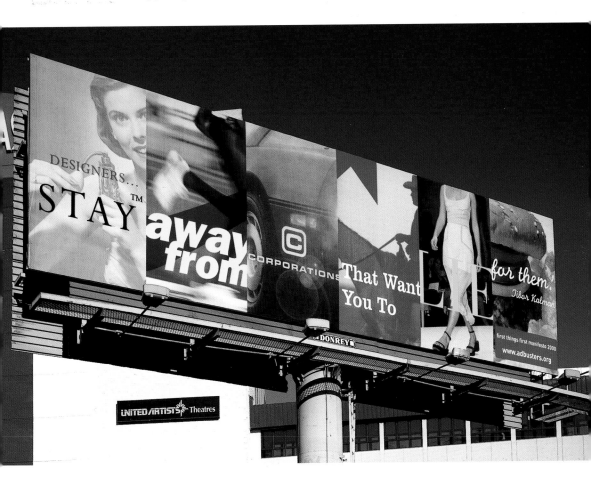

Barnardo

GIVING CHILDR
BACK THEIR FUTU

John Donaldson | AGE 23

Battered as a ch
it was always possible th
John would turn to dru

With Barnardo's he
child abuse need not le
to an empty futu

Although we no longer r
orphanages, we continue to he
thousands of children a
their families at home, sch
and in the local commun.

To make a donation
for more informatio
please call 0845 844 01

A child's fate?

Print ad for
Barnardo's, 2000.
Agency: Bartle Bogle
Hegarty. Creative
team: Alex Grieve
and Adrian Rossi.
Photography: Nick
Georghiou

There can be few more sensitive or emotive issues in the media today than the way we treat our children. For the past twenty years, western societies have been slowly bringing to light the profoundly alarming catalogue of maltreatment and exploitation to which our most vulnerable members are subjected. Much of it beggars belief: child prostitution, systematic abuse by trusted care workers, physical and sexual abuse in the supposedly safe haven of the home.

These are harrowing revelations and the campaigners battling to improve children's lives rightly employ the most powerful communication techniques. It is possible to be too uncompromising, though, as Barnardo's, the children's charity, discovered when it ran a full-page ad in the British papers, showing a baby yanking on a tourniquet with his teeth and about to jab a syringe into his flesh. Above him it said, 'John Donaldson. Age 23'. The copy continued: 'Battered as a child, it was always possible that John would turn to drugs. With Barnardo's help, child abuse need not lead to an empty future.'

Predictably, there was an outcry. Not about the issue addressed by the ad, but about whether it was too shocking for some viewers. The Committee of Advertising Practice asked newspapers not to run it, and some toed the line. Barnardo's ended up creating a benign alternative ('The ad we wish we could have run') with a smiling baby. Despite this setback, another ad in the series – the sixth – was launched. Like the others, it shows a child in an adult situation that could lie ahead for the neglected. This time it's Kim Vale, a prostitute about to climb into a john's parked car.

Once again, the ad is a galvanically persuasive piece of communication. It is only too easy to write off adults. We do it all the time: it's their own fault, it's one of those things, it's life. But the campaign reminds the viewer that tragic futures – homelessness, alcoholism, prison, suicide – happen to people who were once innocent children, like our own, and cannot possibly have 'deserved' such a fate. Their emotional force as narratives lies in their apparent realism, but it is a heightened, expressive

realism in which every element of the image is focused to dramatise the child, who shines forth from dingy backgrounds – alley, tunnel, prison cell – in an optimistic glow of colour. These are brilliant digital illusions. The baby heroin-taker, who in reality was eating a chocolate bar, appears to sit in a filthy corner. Young Martin Ward – 'made to feel worthless as a child' – seems to teeter suicidally on the edge of a hand rail, at the top of a multi-storey carpark, on a dismal-looking estate.

Barnardo's no longer runs orphanages and wants to shed its old image. The ads, devised by Bartle Bogle Hegarty, are a particularly hard-hitting form of rebranding. They were so effective as attention-getters that others tried a similar approach. In the Imperial Cancer Research Fund's print and billboard campaign, three girls sit on a stone wall, looking at the clouds (read: 'the future'). Above their heads, it says 'Lawyer', 'Teacher' and 'Cancer'. According to the copy, on current statistics, at least one in three people will contract the illness at some point in their lives. This ad also drew fierce criticism, not because it is disquieting as an image – it's mild as soapsuds – but because the idea itself is deeply insensitive, seems to offer little hope and reduces sufferers to 'cancer victim', as though this were the defining aspect of their life and identity.

What distinguishes the Barnardo's series, by contrast, is that, even as the campaign confronts viewers with these unwelcome tableaux, it does offer hope. In his innovative TV play, *Blue Remembered Hills*, the late Dennis Potter asked adult actors to play children, a disturbing and unforgettable fictional conceit. Using small children to play damaged adults provides an equally heartwrenching compression of before and after, cause and effect. The ads are a kind of time travel. They project their imaginary subjects into a hypothetical but all-too-plausible future and ask whether this is really the way we want it to be.

Preparing for the meme wars

1. OBEY THE GIANT In 1998, a Dutch design and advertising agency, KesselsKramer, came up with an idea that turns conventional concepts of branding on their head. The usual method is to start with a product, advertise it, and then as it becomes successful, create a brand. Instead, KesselsKramer proposed to start with the brand itself, and then go looking for products consistent with the brand's values, to which the brand image could be attached. The firm's 'do' concept (the reference to Nike's famous injunction is hard to miss) consists of nothing more elaborate than a bold sans-serif 'd', a black-and-white thumbprint and a copyright symbol.

KesselsKramer's proposal doesn't appear to be satire and, given the centrality of branding in everyday life, it could be seen as an entirely logical development. It is often said that an established brand is worth more than any amount of material or infrastructure. A company can replace its buildings, its fleet of trucks, its sales force, but without its brand image, instantly recognised by eager consumers the world over, it would be just another outfit clamouring for attention in the hubbub of the marketplace.

Acknowledging the tremendous global power of branding, some of graphic design's more playful experimentalists have made the nature of brand identity a central preoccupation of their most speculative work. The Designers Republic and Jonathan Barnbrook both conjure up a rogues' gallery of sometimes imaginary logos that entertainingly expose our Pavlovian readiness, after decades of consumer training, to respond to an intriguing looking brand. The Designers Republic's sheet of 'new & used logos' displays fifty-three pictograms, trademarks and symbols designed for pop groups and other clients. A promotional note from the designers explains: 'If you are the owner of a large multinational company and you think you need to improve your public image (and believe us, you all do), then why not get with today's craze by commissioning The Designers Republic to bastardise your logo in the name of Art . . . For an additional fee we can even claim we designed the logo in the first place.'[1]

Jonathan Barnbrook's Apocalypso series is even more acerbic. Each lovingly

crafted symbol embodies a nightmare scenario (an exploding jumbo jet, a hole in the ozone layer) or appears to represent the untoward activities of some disturbing group or cause (logos proclaim: 'Genuine messiah', 'Arms for sale', 'Fatwah for you'). Barnbrook's ambivalent symbols suggest that our willingness to place our faith in the idea of an established brand has reached a point where it is now possible for almost anything to be pasteurised, logo-fied and consumed. In Barnbrook's transubstantiation of the ghastly into a seductive graphic idea, image prevails over content, fantasy overrides reality. If you find yourself amused by these witty symbols, you have already been 'infected' and the point is made.

Clever as they are, what these projects lack is any real connection with the world outside design. It has taken a crudely rendered image of a huge wrestler, Andre the Giant, to bring an exploration of the ambiguous nature of branding into the public domain. Anyone living in a major American city (New York, Boston, Baltimore, Philadelphia, Los Angeles, San Francisco, Seattle) is likely to have come across the late Andre Rousimoff's face stickered, postered or stencilled on buildings, street signs, telephone poles and any other handy urban surface. There have been sightings as far afield as London, Paris (where he reportedly showed up on Jim Morrison's grave at Père Lachaise), Germany, Russia and the Caribbean.

Apocalypso font,
1997. Each symbol
corresponds to a
keyboard character.
Design: Jonathan
Barnbrook

The first stickers – carrying the words 'Andre the Giant has a posse' as well as the popular pro wrestler's gigantic stats (7′4″, 520lb) – began to appear around 1990. The simple design, created with a stencil by Shepard Fairey, a skateboarder and illustration student at Rhode Island School of Design, was intended as little more than an absurd graphic gesture (why a wrestler?) for the diversion of fellow skate punks. But the response of his circle in Providence was enthusiastic and Fairey just kept on going. In the last decade, he has produced hundreds of thousands of stickers, giving them to friends to distribute and sending copies to anyone who asked. In Fairey's inventive series of 'Obey Giant' posters, the wrestler's heavy face morphs into the features of Che Guevara, Gene Simmons of Kiss, and Ringo Starr. 'Power to the posse', 'You are under surveillance' and 'Obey the giant', the posters shout.

What does it mean? According to Fairey, the sticker means absolutely nothing at all. There is no significance in the choice of Andre the Giant as the image, or in the statement that he 'has a posse'. The stickers exist only to provoke a reaction. For Fairey, it is a form of Rorschach test, a floating signifier, on to which viewers project their own meanings according to their individual personalities, sensibilities and ways of looking at the world. Some consider the stickers an eyesore; some enjoy a patently ridiculous activity; some feel threatened, equating the Giant's persistent presence with subversive

intentions; some want to acquire the stickers as consumer items or souvenirs, motivated, suggests Fairey, by a desire to belong; some just see him as a shameless self-promoter. Most of all, the Giant campaign is embraced by rebels who relish what he calls its 'disruptive underground quality'. Every unsanctioned image of Andre that goes up in a public place is a small blow against the colonisation of the streets by paid-for advertising.

In some ways it is a shame that we know who is responsible for Andre the Giant. Giving the project a point of origin and ascribing it a purpose, as Fairey now does, as a 'phenomenological' experiment, is bound to narrow the range of possible interpretations and reduce its suggestiveness for those in the know. These days, the media-conscious Giant has a website (www.obeygiant.com) and a project sometimes interpreted as a critique of advertising comes equipped with its own range of merchandise – posters, T-shirts, skateboards, and so on.

Yet the irony of this is revealing in itself. So conditioned are we to expect advertising and almost no other form of address in our public spaces that we naturally assume that a printed, mass-produced image must be there to sell something. Viewers were primed by long experience of the semiotics of commerce to perceive Andre the Giant as a brand and this is what he eventually became – if only to generate revenue to keep the project going. On the Giant's back, Fairey has co-founded Black Market, a San Diego-based visual communications agency, which offers 'the art of underground business' and 'black marketing on a corporate scale' to the likes of Sony Music, DreamWorks, Chiat/Day, Pepsi-Cola and Ford. What the Giant confirms is that a company such as KesselsKramer (www.dosurf.com) is right. When a strategically constructed brand image has achieved sufficient penetration and generated a compelling enough range of associations in the public mind, it will seem quite natural for people to buy the products created to go with it – an inevitable consummation, after the fact, of their experience of the brand. In summer 2001, the Guardian newspaper asked branding experts to devise a fictional brand – Joy – with no accompanying product or service, to see how much interest it could provoke. Its launch ads, published in the paper and displayed on poster sites, showed a naked man with a black rubber ring leaping into thin air. 'Sing laugh drive sleep eat breathe cry,' said the slogan, 'but do it with Joy.' By the end of the brief experiment, the ads for the non-existent brand had generated 1,562 website or phone responses from members of the public.[2]

2. SPREAD THE VIRUS If it were possible to rank words in terms of their degree of inherent threat, 'virus' would almost certainly come somewhere near the top of the table.

Stalin/Lenin poster
from the 'Obey Giant'
campaign, 1999.
Design: Shepard
Fairey

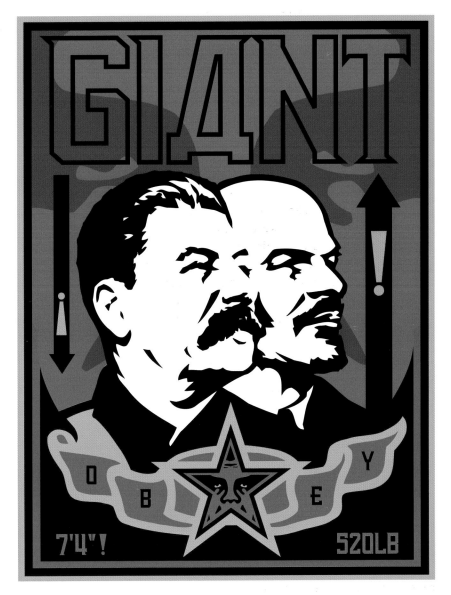

Viruses may be as old as history, but they seem to embody a uniquely contemporary danger. As if the global AIDS epidemic wasn't an alarming enough health crisis, experts issue regular warnings about the devastating potential of Ebola, Hanta, and Marburg – the virus so contagious and deadly that scientists locked it up in the laboratory and threw away the key. Every computer user lives in fear of the day a computer virus – Melissa, I Love You, or the charmingly monikered Back Orifice 2000 – turns the contents of their hard disk to useless mush.

For William Burroughs, the image of the virus was one of the central metaphors in his influential cult novels. Viruses were control systems, an alien conspiracy to take over humanity, and the suggestion that this parasitical process could have a positive side was unthinkable. 'The virus gains entrance by fraud and maintains itself by force,' he writes.[3] Viruses use the cellular material of their hosts to make copies of themselves and this is almost invariably damaging to the carrier. Burroughs believed that words were a form of virus, and that images were just as bad. 'Word begets image and image is virus,' he said.[4] This was such a memorable idea that, in 1980, Laurie Anderson made a weirdly catchy song about it, 'Language is a virus from outer space'. In the 1990s, Jonathan Barnbrook dubbed his type facility the Virus Foundry. 'Welcome to the cult of Virus,' says his type catalogue. 'Virus is the language you use to speak to others.'

Barnbrook intended this as a kind of millennial satire, yet even as he crafted his catalogue, the virus idea was slowly mutating from an unambiguous threat into something that seemed – at least in some people's eyes – to be rather a good idea. In 1997, an American marketing man, Steve Jurvetson, coined the term 'viral marketing' to explain the huge success of Hotmail, which signed up over twelve million subscribers in its first eighteen months. Hotmail took the old notion of 'word of mouth' and applied it to e-mail; every time a subscriber sent a message to a friend they spread the word in the automatic, sign-off line – 'Get your private, free e-mail from Hotmail' . . . and slash our costs by advertising it yourself.

The business and marketing press has been wetting its Calvin Kleins with righteous excitement ever since. In summer 2000, Seth Godin, another American marketer, published *Unleashing the Ideavirus*, a breathless, best-selling guide to creating your own viral marketing campaigns. Its message: forget expensive, unreliable, old-style 'interruption' marketing; instead – think viral! 'An idea that just sits there is worthless,' Godin instructed readers of *Fast Company* magazine. 'But an idea that moves, grows, and infects everyone it touches . . . that's an ideavirus.'[5]

The rhetoric of joyful infection should be enough to make any sane person's virus alarm start clanging, but the concept of an 'ideavirus' – only the coinage is original to

Godin – has a fascinating background. As long ago as 1976, the biologist Richard Dawkins proposed a new word, 'meme' – defined as 'a unit of cultural transmission, or a unit of imitation' – to describe how ideas replicate by leaping from mind to mind. As examples, he gave tunes, catchphrases, fashions in clothing, ways of making pots or building arches. Graphic styles such as the enthusiasm for distressed letterforms, all-lowercase text, or blurred images, are memes. Andre the Giant is another exceptional example of a meme, devised by an individual, then propagated by others: the more it spreads, the stronger it becomes. The study of evolutionary models of information transmission – memetics – now attracts thinkers from biology, psychology, anthropology and cognitive science. American philosopher Daniel Dennett, a leading proponent, visualises the human mind itself as 'an artifact created when memes restructure a human brain in order to make it a better habitat for memes'.[6]

Dawkins called memes 'viruses of the mind' and the viral image was propagated in books like Aaron Lynch's *Thought Contagion* and Microsoft Word writer Richard Brodie's more populist *Virus of the Mind* (both 1996). Dawkins suggests that successful mind viruses, like computer viruses, will be hard for their victims to detect. The more vigorously someone denies a meme's influence, the more fully it has succeeded in restructuring the brain, and the more inevitable and unassailable it will seem. Dawkins, famously sceptical when it comes to religion, points out how religious belief prides itself on being impervious to evidence or reason: lack of evidence is a positive virtue where faith is concerned. 'Once the proposition is believed,' notes Dawkins, 'it automatically undermines opposition to itself.'[7]

Where the memetic theorists entirely agree with the gurus of viral marketing is in warning that mind viruses are highly contagious. Brodie is at one with William Burroughs when he argues that they can program us to think and behave in ways that are destructive to our personhood. 'Successfully programming your mind to believe that you prefer that brand, advertising agencies are among the most brazen and calculating of the mind virus instigators,' says Brodie.[8]

And the marketing mavens are more than happy to admit it. They positively relish the language of contagion: consumers are a passive population, they say, waiting to be infected by their ingenious ideaviruses. People have built up 'antibodies' to traditional marketing – hence the need for more powerful techniques. Some consumers, so-called 'sneezers', are more likely to spread ideaviruses than others, so always begin your campaign by infecting them first. The aim is to infect the greatest number and totally dominate your target group. Ideaviruses are the currency of the future, and the future belongs to those who unleash them on everyone else.

While viral marketing has rapidly become the latest get-rich-quick dream – thousands have reportedly downloaded Godin's bible – memetics itself is such a new discipline that few marketers use the term. In London, Brand Genetics, which boasts American Express, General Motors and GlaxoSmithKline as clients, offers a range of tools that apply evolutionary science to marketing. The company – it sounds like one of those rogue biotech outfits in a David Cronenberg movie – uses a technique called 'meme mapping' to understand consumer behaviour, devise new brand promises and select 'winning concepts'. This was demonstrated, on its website, by a series of diagrams charting the semantic web of associations elicited by the Sunny Delight fruit drink from more than 300 respondents. The design task begins only after the 'design space for innovation' has been identified in this way.

Brand Genetics was started in 1996 by Dr Paul Marsden, who is also a member of Meme Lab, an online research unit, and a regular spokesman on mind viruses in the press. In a review of New Yorker writer Malcolm Gladwell's The Tipping Point – the book which inspired Unleashing the Ideavirus – Marsden questioned Gladwell's 'Brave New Worldesque' proposal to reduce cigarette addiction among teenage smokers, which you might suppose a worthwhile goal. For Marsden, though, this would be social engineering, or 'ideational eugenics'.[9] Elsewhere, he told a reporter that he had refused to apply meme theory to an anti-smoking campaign. 'We said we didn't want to change the way people think. We won't do any political work either.' Yet, in virtually the same breath, Marsden talked about engineering a 'memetic idea or product that could sweep through a population . . . like a measles epidemic.'[10]

There is little doubt that, in the next few years, these ideas will become increasingly familiar to designers. They pose a naggingly persistent dilemma. Is communication's purpose to manipulate the consumer? If it is, then anything goes. Or is it about opening up genuinely participatory, non-manipulative channels of interaction? And if so, are memetic techniques legitimate when the cause is just? The twenty-first century will see a proliferation of deliberately designed graphic viruses, as image-manipulators of every persuasion refine and develop these powerful media techniques. Only by becoming aware of viral programming is there any chance of disinfecting our minds of parasitic resident viruses and armouring ourselves against the blitzkrieg of incoming memes.

The designer as reporter

For some time now two-dimensional design has been gripped by an identity crisis. The term 'graphic designer' no longer seems adequate. A parade of thinkers, apologists and special interest groups has proposed one new model of design practice after another. We have heard about the designer as author, editor, producer, translator, performer, director and information architect. At the risk of sowing further confusion, I would like to suggest another way of thinking about communication design. It has elements of several of the definitions above, but is even more specific about the approach some might choose to take in years to come. The idea I have in mind is the designer as visual journalist.

I first heard this term a number of years ago in a lecture given by the Dutch designer and educator Jan van Toorn, well known for his activist stance. Wherever possible, van Toorn uses his design commissions to develop his own graphic commentary on Dutch institutions, companies and political issues. Especially in the 1970s, many of his projects became a form of personal research, an impassioned, sceptical and sometimes combative response to the cultural moment and conditions in which he found himself working. His approach had much in common with that of a campaigning or investigative journalist, except that his medium of expression was design and the image rather than the written word.

There is a sense in which almost any piece of graphic design could be seen as a kind of 'visual journalism'. The most effective visual communications are almost always of their time. Design captures and condenses into seductive graphic form the mood, concerns, inspirations, aspirations, fads, obsessions and stylistic tics of the day. It functions as a constantly updated report on the way we live now. This is why it dates so rapidly and eventually becomes such a vivid reminder of the era that gave it life. Even design that aspires to bypass this process and somehow become 'timeless' usually ends up tethered to its point of origin in some way.

The designer doesn't even need to be conscious of this effect – it is an inevitable

Fresh Kills Landfill,
Staten Island, New
York, Photography:
Harmen Hoogland, from
Here, 1999

by-product of designing and will happen regardless. The visual journalism suggested by van Toorn's work, on the other hand, is a self-willed activity. What if the designer were to function more like a journalist? In other words, develop a sphere of knowledge and expertise, select a subject, conduct research, gather material, then create an appropriate final form, using all the resources of design, both words and images, to communicate the story or argument.

Clearly, many designers already do this to a degree. Think of all those brochures and annual reports that graft some extra thematic layer on to the basic marketing story. Designers' self-promotions and Christmas gifts are another outlet. But the truth is that in the main these projects are not serious. The vast majority are vanity items, luxury add-ons meant to connote a quality product, harmless unread pieces of whimsy, or little rewards to the creative team for getting the job done. A fully engaged visual journalism would require a significant shift of emphasis. It would be inner-directed and much less constrained. It would proceed from the designer's commitment to, and knowledge of, subject matter, themes, ideas and causes outside design. Design would be an essential part of the story-telling process, much more fully integrated than is usually the case, but it would not be the point of the exercise any more than a financial journalist would undertake a story about junk bond fraud solely for the satisfaction of stringing words together on paper.

It's worth dwelling on this issue because it is a critical point that appears to have been overlooked in all the hoop-la about designers as 'authors'. To be an author, in the literary sense, the first requirement is to have something to say about a subject. So much contemporary graphic design, though, seems to jettison coherent subject matter at the first opportunity, favouring instead the oblique gesture, the disconnected fragment, the abstract sensation and the studied *non sequitur*, and deluding itself that this navel-gazing 'graphic language' is communication enough for the viewer. The notion of a journalist behaving in this way is impossible. Responsible journalism questions and investigates. It pieces together a story and by doing so endeavours to bring greater clarity to a small corner of the world. Journalism, like design, operates under constraints of time, budget, space, ownership and politics, but one thing effective journalists never lose sight of is 'point of view'. Why are they researching, writing and running a story? What are they trying to say and to whom? What do they hope to change?

A Dutch design student at the Royal College of Art created an impressive example of design as visual journalism that shows what might be achieved if this became a regular way of working. In 1999, Harmen Hoogland visited the Fresh Kills Landfill on Staten Island, New York, scheduled for closure by Mayor Giuliani in 2001. Hoogland

took hundreds of photographs of the 2,100-acre citadel of waste, the world's largest dump, visible to the naked eye from space, as well as scenes of trash collection, street cleaning and Fifth Avenue garbage cans. To get to grips with the political background to the closure, he followed up his landfill visit with extensive reading of newspaper reports, website texts and discussion, and official literature from the New York City Department of Sanitation.

Turning this unruly mass of material into a pungent, enlightening and accessible commentary was a considerable challenge. On the way, Hoogland's self-published book, eventually titled *Here* (as in 'Don't Litter. Put It Here'), went through many anguished rethinks. Finally, he hit upon the idea of contrasting edited quotes from official sources with comments by critics and opponents to build up a complex but highly readable mosaic of contradictory views. Each pair of quotes is given a spread (one white page, one black) and these text spreads are intercut with Hoogland's photos to achieve an editorial rhythm that is dense but not daunting, with a genuine, page-turning impact. In one withering sequence the same newsprint image of the smiling, thumbs-up mayor is repeated seven times to sharp ironic effect.

At first sight, the design might appear to be minimal. It makes modest use of Akzidenz Grotesk, a tough but unshowy typeface. There is, however, an immense amount of design thinking in Hoogland's project at the deeper, less immediately obvious level of organisation and structure. The book's narrative and argument are, in the fullest sense, functions of its design. If it were somehow possible to siphon off the 'design', one would be left with the shapeless, unrevealing mass with which Hoogland began. What such a project suggests is that our thinking about the interrelationship of design and editing is still not fluid enough. Just as there is a sense in which writing is a form of design – an editorial structure made out of words, sentences and paragraphs assembled in a particular order – so design is often another form of editing. It's about choice: what to discard, what to include, how all the elements interconnect. The most significant choice of all, because it precedes everything else, is choosing what the design will be about.

Books of blood
and laughter·

Stepping across the threshold of David King's North London house is like
plunging into a history lesson. King has devoted thirty years to amassing what may
be the world's largest private collection of photographs, books and magazines
documenting the history of Russia and the Soviet Union. The surprises begin within
feet of his front door. 'That's amazing! That doesn't exist!' he enthuses, pointing out
a poster thrown from the back of a truck on the night of the October Revolution in 1917.
Hanging next to it on the crowded wall is the poster 'Death to World Imperialism'
(1919) by the revolutionary artist David Moor. It has taken King twenty-five years to
track it down.

 Posters, prints and paintings climb the stairwell. As you head upwards to King's
studio at the top of the house, everything creaks: the floorboards, the staircase, the
banisters. There is so much to examine that progress is slow. King made much of the
furniture and many of the wooden fittings in an angular constructivist style resembling
his designs for books and agitprop posters. From his writing room, where he taps out
no-nonsense prose on an old Remington portable, you can see a giant fake stone head
of Karl Marx lying in the garden – a prop from the 1960s movie *Morgan: A Suitable Case
for Treatment*. And here in a living room full of wirelesses designed by Wells Coates is a
Trotsky mug from 1923 that once belonged to a man King describes as 'the Last British
Stalinist'. Only 700 such mugs were made. 'It just doesn't exist,' he exclaims, with
a burst of manic laughter. A conversation with King about his treasures is always
punctuated by his wild chuckles.

 In recent years, there has been plenty of speculation about the possibilities of
graphic design as a medium of authorship. None of it would hold much interest for
King. He is the genuine article – a designer-author – and has been since 1972, when
Penguin published his *Trotsky: A documentary*. The book was a collaboration with
Francis Wyndham, a colleague from the *Sunday Times Magazine*, Britain's first colour
supplement, where King was art editor from 1965 to 1975. Since his days as a student

at the London College of Printing, he has been driven by an overriding need to lock horns with content that means something to him.

His decision to start the collection that has become his life was prompted, in 1970, by a research visit to Moscow's photographic archives. When he asked to see pictures of Trotsky, he was told: 'Trotsky not important in Revolution. Stalin important!' All traces of the revolutionary leader had been removed.

The terrifying process by which thousands were first murdered by Stalin's butchers and then, if they were public figures, eradicated a second time from the historical record by his retouchers and scissormen has become King's great theme. In his book *The Commissar Vanishes* (1997), he delves into his archive of more than 250,000 images to document, as never before, the falsification of photographs and art in Stalin's Russia.

'I spent an awful long time going through the collection,' he says 'and it was very exciting because I found more and more, and I couldn't believe it – things that I'd stared at for years.' Much of the five years he spent working on *Commissar* was devoted

to finding out the names, occupations and precise fate of those we see expunged person by person from group portraits and documents of official occasions, until only the dictator and perhaps a handful of lucky ones remain.

Once these 'enemies' of the regime had been arrested or had disappeared forever into the Lubyanka, headquarters of the secret police, it was each citizen's responsibility to ensure that any pictures of them in privately-owned books or magazines were defaced or destroyed. One of King's most extraordinary discoveries came in 1984 when he visited the Moscow studio of Alexander Rodchenko, one of the great figures of Russian art, design and photography. When he opened Rodchenko's copy of *Ten Years of Uzbekistan*, designed by the artist in 1934 to celebrate a decade of Soviet rule in the state, he found that Rodchenko himself – on pain of arrest – had obliterated the faces and names of purged Party functionaries with surrealistic veils and blocks of ink. It was 'like opening the door onto the scene of a terrible crime', King writes.[1]

For King, *The Commissar Vanishes* was a triumphant return to form. In the late 1970s, he began a string of publishing projects which united his historical interests and commitment to radical politics – he describes himself as a 'non-aligned leftist . . . a Trotskyist' – with a brutally efficient use of type and image. Catalogues for exhibitions about Rodchenko in 1979 and Mayakovsky in 1982 at the Museum of Modern Art in Oxford underscored their messages with massive rules and a mood of raw, graphic emergency, and King went on to apply a similar approach to his books *Blood and Laughter* (1983), *The Great Purges* (1984) and a photographic biography on Trotsky (1986). 'I always saw things in terms of film,' he explains. 'Close-up, longshot, multi-pictures, giant picture bled off. Crop it harder than it's ever been cropped before, if it works. Contrast it, use primary colours, wood letters, double-printing, triple-printing – fantastic!'

For ten years, after this burst of production, King grew quiet, partly because of changes in the political climate – 'Mainstream publishers didn't want to publish photographic books of leftist subjects; not from a leftist viewpoint, anyway' – and partly because of his reluctance to learn how to design by computer. The main reason, however, was the ascendance of Mikhail Gorbachev and his policy of *glasnost*. Suddenly the photo collection, which had always been a 'back-burner thing' viewed by some of King's acquaintances as a waste of time and money, was in demand. He began taking media calls from all over world, requesting pictures of Lenin, Trotsky and Stalin. Maintaining the collection and handling enquiries became close to a full-time job.

The pictures – slides, transparencies, prints – are filed in sixteen red cabinets in the studio at the top of his house. (King loves red: even his bright red Jeep Cherokee

The Commissar
Vanishes: The
Falsification of
Photographs and Art
in Stalin's Russia,
David King, 1997.
Design: King and
Judy Groves

looks like a constructivist slab on wheels.) There are drawers full of people – Kalinin, Kamenev, Kerensky, Kirov – some of them still awaiting the day a researcher will call. Petrovsky? 'Nobody ever asks for him,' says King. And there are drawers organised by theme: 'industrialisation', 'famine 1932–3', 'literacy and education', 'women', 'health and children', 'show trials'.

King's quest has no end: there are a dozen or so items he has been trying to find for years. He spent a decade looking for a book that turned out not to exist. Sometimes he is lucky and the material finds him. One day, pre-*glasnost*, the postman brought a huge box containing 1,500 photographs sent anonymously from Russia. The last time we met, King was just back from Moscow, gushing about a 1928 album on the history of the Bolsheviks, which he had discovered in an antiquarian bookshop, with no fewer than 39 images scribbled on or scratched out.

Sometimes collectors ask him if he has particular vintage prints. He has thousands, but for him, their value lies not in their uniqueness as objects but in their status as evidence. 'I'm more interested in photo-reportage,' he says. 'I'm not particularly interested in who took the picture, or whether it's an original sepia print. They can be brand-new prints as far as I'm concerned, the sharper and the more detailed the better.'

King's insistence on the content of the image is a reminder that his subject is a human tragedy of almost unimaginable proportions. To laugh at the clumsiness of the retouchers' excisions, at their inept attempts to paint in sleeves and walls and sky, is to forget that every one of these excisions is a death. As he works in his archive, carrying out this self-chosen task, King confronts this awful evidence as a daily reality. How does he feel living so close to such savagery? He ums and ahs, looks out of the window and starts talking about someone outside on the street. Finally, quietly, he says, 'The Stalinists destroyed everything as far as I'm concerned', and you sense he is talking not only about the loss of life, but about a political dream. 'Yes, it's terrible, isn't it?' Then he laughs – a wild, unsettling laugh. 'What are you supposed to say? It's so terrible you can't talk about it.'

It was an unfair question, though, because his answer is already there in his books. He would like to use the collection to create a visual history of Russia. 'There's so much stuff that's never been published and it would be a real eye-opener . . . the true history of what happened.' Few can be better qualified for the task than King.

The critical path

Michael Rock and Susan Sellers are the last designers you would expect to find organising fashion shoots for Levi's among the sprinklers on front lawns in small-town Montana. They seem much too cerebral and bookish. In conversation, they share the habit of firing off words like Gatling guns and have an odd way of sounding simultaneously enthused and detached. Critical writing about graphic design was a small but definite growth area in the early 1990s – especially in the US – and Rock quickly established himself as one of the most searching and readable new voices. Whether the subject was USA Today or the typographic experiments of Neville Brody's Fuse project, annual reports or design competitions, he had a way of slicing through the surface distractions to expose what was really going on.

After studying literature as an undergraduate and graphic design as a postgrad at the Rhode Island School of Design, Rock spent seven years at RISD teaching a class in semiotics. In 1990, he wrote a long letter to Print, the American graphic design magazine, responding to a now notorious public exchange between M&Co founder Tibor Kalman and Joe Duffy, a packaging designer who borrowed heavily from American vernacular design. Rock argued that, despite Kalman's claims to art, in their commercial behaviour and function there was little to choose between the two. Print published the letter as an article and, without quite intending it, Rock's career as a critic had begun.

Rock and Sellers met at RISD, where Sellers was studying graphic design. After graduating she moved to the Netherlands, where she worked for Total Design, though she plays down this early experience: 'I was very unhappy with the state of the profession and had never really worked enough to consider myself a designer.' Back in the US, Sellers registered as a postgraduate student in American Studies at Yale University. Rock, meanwhile, had landed a three-day-a-week position teaching graphic design in Yale's art school under new head of department Sheila Levrant de Bretteville. 'It was a really formative time,' he says, 'because I was spending all my time writing and thinking about design and teaching and doing some small design projects and Susan was spending all

her time writing and thinking about those issues. We had a lot of conversations and that cemented us seeing ourselves as critics and not necessarily as professional designers.' They collaborated on an essay for *Eye* and Sellers went on to publish pieces in the American journals *Visible Language* and *Design Issues*.

They might have continued on this path, combining teaching and writing, but both were concerned by the limited nature of the journal-reading audience. 'We consciously went with the idea of trying to do things that were really mainstream, not commercial, but a very visible kind of work,' says Rock. Hence the decision to move from New Haven to New York and open the studio. For Sellers, a profession she had viewed with ambivalence offered the chance to undertake 'field research' and discover for herself the conditions under which design is produced – and then, perhaps, to shift them. 2×4, their studio on Manhattan's Varrick Street, founded in the mid-1990s with their partner Georgianna Stout, has worked on projects for Knoll and the *New York Times*, designed the Woodstock revisited commemorative book, collaborated with Rem Koolhaas on proposals for the Tate Gallery, London, and the Museum of Modern Art, New York, and sustained, as a result, some rapid company growth.

As writers-turned-designers, Rock and Sellers are engaging with the central dilemma for critically-minded practitioners. It is one thing to pontificate to your peers from the sanctuary of a tenured position about what 'must' be done to ameliorate design, quite another to discover or create or force open spaces for such possibilities in the unforgiving world of fee-paying clients. There has been much bracing talk from design critics about 'critical making' and the 'critically reflective practitioner', but rather fewer instances of such theories successfully realised within the highly competitive domain of professional practice. The problem was made starkly clear, in 1997, at the 'design beyond Design' conference at the Jan van Eyck Akademie in Maastricht, where Sellers and Rock presented a self-initiated cultural project in which a chunk of upper SoHo is re-designated as a 'Museum of the Ordinary'. Despite the organisers' strenuous claims that critical interventions of some kind were also possible in the commercial world, the conference produced no persuasive recent examples.

Rock and Sellers dismiss the Levi's shoot in Montana – an attempt at a 'banal anti-aesthetic' – as a misfire, though one, Sellers believes, that might have future possibilities. More focused realisations of feminist theory – for an audience of two million – have been possible working with Holly Brubach, editor of the *New York Times*' twice-yearly fashion supplement, *Fashions of the Times*. For five issues, 2×4 eschewed professional models for sports teams, caterers, members of the public and fashion designers wearing their own clothes, until the advertisers screamed 'No more!' Rock

'Interfacing' from
Hiding, Mark C.
Taylor, 1997,
Design: 2x4

is careful, though, not to make exaggerated claims for the interrogative power of these strategies. 'It's such a small gesture in a way,' he says, 'but that's where it has to start, somehow, if you're going to take a theoretical idea and use it in a newspaper: how do you do that?'

In the pages of the New York architectural magazine ANY, the design language that embodies 2×4's critical method is much more assertive. With editor Cynthia Davidson's support – 'sometimes we have to remind her of that', Rock notes wryly – design is seen as a legitimate extension of the editorial process. The magazine's often demanding essays are treated by 2×4 as a typographic 'practice space' in which to question the nature and structure of the editorial page, the relationship of page to sequence, text to footnote, word to image. The underlying aim is to create alternative points of entry for the reader. Sometimes, as they readily admit, it 'fails wildly' and the large pages collapse into a jigsaw of irregular text shapes in which the typographic density compounds rather than eases the sensation of daunting arcana. When they pull it off – as in a 1996 issue on 'Whiteness' that squeezed maximum advantage out of the publication's no-colour

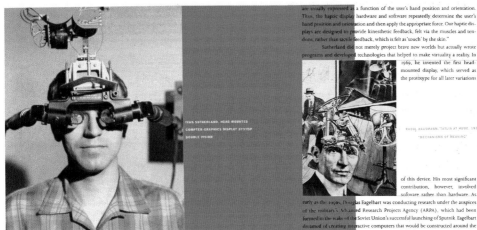

HIDING | 276 277 | INTERFACING

are usually expressed as a function of the user's hand position and orientation. Thus, the haptic display hardware and software repeatedly determine the user's hand position and orientation and then apply the appropriate force. Our haptic displays are designed to provide kinesthetic feedback, felt via the muscles and tendons, rather than tactile feedback, which is felt as 'touch' by the skin.''

Sutherland did not merely project brave new worlds but actually wrote programs and developed technologies that helped to make virtuality a reality. In 1969, he invented the first head-mounted display, which served as the prototype for all later variations

IVAN SUTHERLAND, HEAD-MOUNTED
COMPTER-GRAPHICS DISPLAY SYSTEM
DOUBLE VISION

RAOUL HAUSMANN, TATLIN AT HOME, 1920.
'MECHANISM OF MEANING'

of this device. His most significant contribution, however, involved software rather than hardware. As early as the 1950s, Douglas Eagelbart was conducting research under the auspices of the military's Advanced Research Projects Agency (ARPA), which had been formed in the wake of the Soviet Union's successful launching of Sputnik. Eagelbart dreamed of creating interactive computers that would be constructed around the visual display of data. While the hardware difficulties with the interface were resolved relatively quickly by the invention of the mouse in the 1960s, a solution to the software problem proved considerably more elusive. The challenge was to create software that would make it possible to feed bits of information to control the appearance of pixels on the terminal display screen. Sutherland solved this problem with his revolutionary program Sketchpad, described by Ted Nelson, the inventor of hypertext, as "the most important computer program ever written." "Sketchpad allowed a computer operator to use the computer to create sophisticated visual

In 1965, Sutherland's remarks sounded more like science fiction than scientific theory. But by the early 1990s, research conducted by Frederick Brooks and his colleagues at the University of North Carolina at Chapel Hill had resulted in the development of haptic display systems that fulfill Sutherland's predictions to a remarkable degree. Brooks describes the way in which his system augments visual with kinesthetic display: "Haptic displays give the user the ability to feel objects or force-fields in a virtual environment. The forces exerted on the user's hand or finger

budget – conventional architectural reviews can look bland by comparison.

One of 2×4's most impressive projects, which suggestively reconciles their critical intentions and their desire to work as professional designers, is a spin-off from ANY. Seeing their work in its pages, editorial board member Mark C. Taylor – humanities professor at Williams College and postmodernist philosopher – approached them to collaborate on his book Hiding (1997), a series of essays exploring the surface fixations and 'profound superficiality' of the contemporary world. Here was a rare instance of a writer prepared to invite his graphic designers into the creative process while the book was still being written and given structural shape. 'Our aim was to bring the verbal and visual together in a way that allows the design to perform the argument,' explains Taylor. 'The argument itself is layered: turning the pages is like peeling away layers of skin.'

The result, in design terms, is the most daring and original publication to issue from a university press – in this case, Chicago – since Avital Ronell's notorious The Telephone Book in 1989. Hiding belongs to a more durable genre of typographic experimentation than the action-painter self-advertisements of the Ray Gun school. Using a deliberately inexpressive typography based on Joanna, Bodoni Antiqua, Didot and News Gothic, 2×4 respond to Taylor's arguments by placing the emphasis on the structural relationships of the texts, which are diagrammed on the contents page. One essay has a starting text followed by two interlocking parallel texts, two more parallel texts and a finishing text. The final section, 'Interfacing', is literally born from its predecessor: we watch its page-frame emerge and take on textual and typographic form in the penultimate essay's closing pages. Other parts of the book are pastiches of the glossy magazine, the comic strip, the science book and the pulp novel.

Rock wrote the definitive 1990s essay on 'The designer as author', but backing off from the implications of some of his own arguments, he and Sellers now say that 'We don't believe designers are authors; that term is simultaneously too generous and too limiting. Our role is more akin to performers improvising on Mark's score.' In the case of Hiding, this is doubtless an honest assessment, though the presence of the foreword writer's name on the book's front cover, while 2×4's much more fundamental contribution rates only a conventional design credit inside, suggests that the established hierarchies of authorship cannot be so easily dismissed. Is this new model of the 'designer as performer' significantly different from the old 'designer as service-provider' model which the 'designer as author' theorists attempted to enlarge? The challenge for 2×4 is to find ways of more deeply integrating their practice as writers and designers – Rock's output as an author is much reduced since they set up the studio. It's to be hoped that in the heat of design practice, they don't lose sight of the original critical goal.

When objects dream

Globally Positioned
Table from the
Placebo collection,
2001. Design: Anthony
Dunne and Fiona Raby.
Photography: Rolant
Dafis

Anthony Dunne and Fiona Raby think your television set is boring. The designers are none too impressed by your hi-fi, your DVD player and your mute, inactive tables and chairs. Why do consumer products have to be so predictable in form and function, they ask, as though everybody's taste and view of the world is the same? 'I think we live in incredibly bland times,' says Raby. 'I'm shocked at how people are so narrow in the way they think about how you might use objects or space.' If Dunne and Raby had their way, electronic gadgets would be conceived and presented more like feature films and come in a range of genres to suit every outlook – noir, arthouse, porn, even horror, if that happens to be your thing.

In early 2001, visitors to Selfridges will have noticed a peculiar collection of objects in one of the windows. One of the strangest, a tray full of pink foam pyramids with a handle on the side, looked like a portable draught excluder. Alongside it was a table with a grid of twenty-five compasses set into its surface, a stool fitted with a one-pin electrical plug, and a simple chair featuring two rudimentary footrests. A couple of mysterious rubber nipples projected from its back.

Designed by Dunne and Raby, who teach at the Royal College of Art, they were entries for the first Perrier-Jouët Selfridges Design Prize, an attempt to create design's answer to the Turner or Booker prizes. While the other four nominees – household names among the *Wallpaper**-reading classes – were safe and familiar choices, Dunne and Raby represent a more uncompromising and, arguably, more challenging way of approaching design.

The Selfridges pieces, made out of minimalist MDF and titled *Placebo*, are certainly striking. Dunne and Raby's concern is not, however, with aesthetics, but with a form of 'presence' invisible to the eye. They explore the largely overlooked, yet, to them, infinitely suggestive realm of electromagnetic radiation. A secret world of rays surrounds the televisions, videos, computers, mobiles and microwaves in our homes, like a ghostly aura. Dunne and Raby have a typically poetic way of expressing this. 'Electronic objects are not only "smart",' say the designers, 'they "dream" . . . Thinking of them in terms of dreaminess rather than smartness opens them up to more interesting interpretation.'[1]

Placebo's purpose is to make people aware of these emissions and their possible effects on mental well-being. Needles twitch and spin when mobile phones are placed on the Compass Table and the nodules on the Nipple Chair throb when radiation from a nearby device passes through the sitter's torso. Another piece, the Parasite Light, sucks its power from electromagnetic fields. Each of the objects, first shown at the Victoria & Albert Museum, was available for month-long 'adoption' by members of

the public; applicants filled out forms, explaining how they would use them at home. They told tales of gadgets going haywire, of housemates plagued by static, and of sleep disturbed by silent emanations from satellite dishes fixed to external walls just feet away from resting heads.

Dunne and Raby are in their late thirties. They are open, engagingly enthusiastic and direct. Dunne leans forward on the table when he talks, fixing you with an unwavering gaze; Raby laughs easily. Their clothes are understated, stylishly practical. All they would need to look like a pair of well-scrubbed boffins is a couple of lab coats. If it weren't for the bizarre flights of fancy that have established them as two of Britain's most original design thinkers, one might almost say they were down to earth.

They met in 1986 at the Royal College of Art, where Dunne was doing an MA in industrial design and Raby was studying for her Royal Institute of British Architects' Part 2 in architecture. Within a few weeks, they had moved in together and they have lived and worked as partners ever since. At college, Raby spent more time hanging out with the industrial designers than with her fellow architects and Dunne's theoretical leanings were frowned upon by his final-year professor. 'He just hated what I was doing – thought it was too arty, too pretentious,' says Dunne. Both cheerfully admit they nearly failed.

As they explain it, their real education began in 1988 when they moved to Japan, source at the time of some of the most provocative and compelling design in the world. Dunne landed a job at Sony, where he restyled television sets for a year. 'I guess, like a good industrial designer, I wanted to go into industry and make a difference and make sure that culturally interesting products got into the marketplace,' he says. 'I was completely naïve.'

Dunne had no interest in a career giving cosmetic nips and tucks to products whose function had already been decided by other people. What he wants – what they both want – is freedom to dream up new kinds of product and experience. When Sony asked him to design a Walkman as an in-house experiment, with Raby's help he turned his fascination with Tokyo's street sounds into a proposal for a 'Noiseman' that would allow listeners to interact with the city's audio-landscape by mixing their own soundtracks. 'I think Sony spent a bit of time wondering whether they could turn it into a kid's toy and then they dropped it,' he recalls.

Raby, meanwhile, was working with Tokyo architect Kei'ichi Irie. 'We had such a strong affinity with Japanese things and with their sensibility and modern aesthetic,' she says. 'It's something about the Japanese desire to be futuristic – but not – while living in parallel with a traditional way of thinking.' When Dunne's Noiseman concept

was published in an avant-garde magazine, Japanese architects admired it, confirming his view that there was a much greater openness to speculative thinking in architecture, and that this was the position he wanted to occupy. In 1992, back in London, Dunne and Raby assisted Japanese architect Toyo Ito by creating futuristic 'media terminals' for an installation of shimmering urban imagery at the V&A's *Visions of Japan* exhibition.

Around this time they drew up a business plan, applied for the state's Enterprise Allowance scheme – 'Conservative children!' laughs Raby – set up a studio and wrote endless proposals. 'It was a complete nightmare,' says Dunne. 'We realised we weren't business-oriented in the normal sense, where we could just make lots of money out of design. We believed in it too much! It was hopeless. We'd end up paying to support the projects we were doing.' One outcome was a series of interactive exhibits about health for the Science Museum. They were both teaching several days a week and concluded that their place lay in a research environment somewhere between academia and the marketplace.

In 1992, Dunne started a PhD at the RCA. 'I got fascinated by "What is an electronic product?"' he explains. 'It all boils down to electromagnetic radiation, electricity being shaped and controlled, the physicality of electronics. I spent a lot of time reading about radio and fields and radar and at the same time looking at art and sculpture and especially at artists who invent strange devices or products.' A year later, Raby began work on her MPhil. They became part-time research fellows in the college's ambitious Computer Related Design department, led by Professor Gillian Crampton Smith, and in this conceptual hothouse their concerns took shape in a series of remarkable projects.

The first of these, 'Fields and Thresholds', proposed 'telematic' furniture that would allow new kinds of interaction between people at distant locations. In one scenario, when a person sits on a cold steel bench, it causes a position on a corresponding bench to warm up, opening a sound channel that is initially fuzzy but slowly becomes clearer. Someone at the other location, feeling this 'body heat', can decide to make contact or change their mind and slip away. In another project, the Faraday Chair, the occupant retreats from the 'electronic space' that is our everyday habitat and lies in a foetal position, breathing through a tube, inside a specially coated, transparent cabinet that radio waves cannot penetrate.[2]

It took Dunne and Raby a few years to learn how to collaborate smoothly and, while any partnership needs flexibility, their main strengths reflect the nature of their design disciplines. 'Tony deals with the "objectness" of things, but I deal with the context of the object,' says Raby. 'Tony's like a vacuum cleaner. He absorbs everything he sees – he can't help himself. He's at the raw end of the research.' Dunne agrees: 'I'm more object-

oriented. Fiona likes systems, networks, things spread over distances. I like zooming in and seeing how things are made; whereas, she likes zooming out, almost like editing a project and seeing how all the bits go together to tell a story.'

They believe that while we might appear to benefit as consumers from an extraordinary array of choices, most of these objects – chair, table, Walkman, whatever – comply with pre-established definitions and forms. The spirit Dunne and Raby look for 'doesn't exist in the thing,' says Raby. 'It has to exist in the imagination.' Most electronic devices provide only the most predictable types of pleasure, while encouraging passivity and set ways of relating to the object world and to other people, too. Dunne and Raby believe that everyday life, designed differently, could be a source of wonder, fantasy and new kinds of social encounter.

They coined the term 'design noir' to suggest the psychological complexity that might be possible.[3] 'It referred, of course, to film noir,' says Dunne, 'and this idea of the anti-hero and people moving through a bleak landscape, always alienated, never quite able to connect or fit in and having to deal with dilemmas and existential issues.' As an example of a real electronic product with a noirish dimension, they cite the Counter Spy chain of shops' Truth Phone, which has an integrated voice stress analyser, allowing the user to gauge whether the person on the other end is lying.

'What would happen if we did have real choices, if products forced you to think about things?' asks Dunne. 'Maybe that's one area where products could provide more complex pleasures.' During his doctoral research, working on a project named 'Tuneable Cities', they drove around London with a wideband radio scanner at the ready. In Mayfair, they logged their first evidence that conversations were taking place in a bugged environment. Next they headed out to Chiswick to check for emissions from baby monitors and were astounded to discover the degree to which suburban streets are abuzz with unperceived radio babble.

For a project called 'Thief of Affections', Dunne proposed a device like a mutant walking stick with an earpiece to allow the carrier to listen to weak radio signals emitted by anyone fitted with a pacemaker. The idea of groping someone's vital organ in this way might sound kinky, even unpleasant, but Dunne and Raby have a level-headed matter-of-factness that makes the most unlikely conceptions seem reasonable, almost scientific. Their purpose, they say, is not to present 'utopian dreams or didactic viewpoints'. Rather, it's an alternative way of considering objects that have become so familiar that we no longer perceive their potential for strangeness. They want to show how electronic devices both shape and limit our psychological and social experiences. Their oddball investigations, described in Dunne's book *Hertzian Tales* (1999), led one

ecstatic reviewer – an architect – to declare the text 'set to become an avant-garde classic'. Another writer called it 'a perceptual renovator bar none'.

Unsurprisingly, Dunne and Raby didn't win the Perrier-Jouët Selfridges Design Prize – furniture designers Ron Arad and Jasper Morrison shared the honours – but their presence on Oxford Street suggested their time may be coming. They believe that big corporations consistently underestimate public understanding and taste. You can't buy the *Placebo* furniture; at this stage, each item is an experimental, hand-made one-off. Yet it is clear, reading the completed adoption forms for the glowing Phone Table, the vibrating Nipple Chair and the Electricity Drain stool (just sit on it naked for electrical relief), that people readily grasped their purpose, as well as admiring their looks. 'We liked the ones that move and glow,' wrote one applicant. 'We thought the Parasite Light and the Globally Positioned Table were cool, too. We would like to keep the object in our living room . . . It's our creative space where we have our paintings and music.'

When it comes to the question of mass-producing the pieces, though, Dunne and Raby are cautious. Anyone who visits design student degree shows will see hundreds of spectacularly inventive concept models for futuristic 'electronic' products – dumb simulacra made out of plastic and wood. Dunne's career began with a brace of similar pieces, including a telephone answering machine that looked a bit like a miniature yacht and glowed when it filled up with messages, which was shown on the cover of the industry bible, *Design*. These projects attract attention and job offers, but nothing remotely resembling them ever appears in the shops.

'One of the problems is that designers in companies have no voice,' says Dunne. 'The marketing departments and the technologists really drive development. The marketeers seem to be able to argue convincingly for a space in the real world for a new product and what kind of price it should should be. The technologists deliver new technologies, again at the right sort of price. The designer just seems to be there to create a pleasing, easy-to-use skin for these products.'

Dunne and Raby want no part of this process and now think of themselves as independent researchers, whose primary medium is the 'design proposal'. Yet clearly, if the aim is to bring about visionary changes to industry's view of design, someone has to venture inside and take on the task. 'The thing we don't want to be is ivory tower occupants,' agrees Dunne. 'The *Placebo* project is about trying to find a way of getting beyond that. Most designers would say, "Well, the only way is to put your things into production yourself." But that then raises all the problems of consumption and super-expensive designer objects. If we could find a way of putting them out that was

affordable, we would do that. We see it more like publishing – publishing your ideas in the form of objects.'

With a previous collection of 'psychological furniture' intended for the home and garden, *Weeds, Aliens & Other Stories* – a project created with Michael Anastassiades – they made only limited headway. A London furniture entrepreneur turned them down, but a German design producer, Anthologie Quartett, liked one of the pieces, Rustling Branch, and wanted to buy twenty of them. It consists of a wooden shelf with a recess underneath for a leafy branch – every so often, a concealed motor gives it a small, surreptitious shake. The designers were reluctant to get bogged down in technical issues, though, and decided not to pursue it. They did, however, sell a Rustling Branch to Doris Lockhart Saatchi.

'As important to me as the power of the idea that produced it is the fact that, like its companion objects, it is well-made and beautiful,' she writes in a booklet about the project. 'The first time I laid eyes on the piece, the branch shivered as I started to turn away and I wasn't sure what I'd seen. I turned back and – oh joy – the branch shivered again.'[4]

And there, in essence, in that little moment, is a glimpse of a form of design we don't, for the most part, yet have. It might sound inconsequential – a shivering branch? It might sound like nothing at all – what is this 'joy'? But why, ask Dunne and Raby, can't everyday life be filled with many such tiny epiphanies and moments of pleasure, and why shouldn't electronics, as a medium with inherently 'magical' properties for many of us, also deliver those moments? Our designers have the talent to do it. What we lack are companies with the vision to invest just a little in this form of speculative research. What if a manufacturer were to create twenty editions of *Placebo* and put them into people's homes to try them out and see how it went? There may well be potential buyers for this kind of product, but conventional market research, on its own, will never discover them.

'No one should have to live with a Compass Table, if they don't want to,' says Raby. 'We're not saying the world should reflect our values, but we are saying: look at the values that are being reflected – aren't they banal? It's really interesting when people start to think, "What would I do with an object like this?" They get excited and imagine a totally different narrative than we would predict.'

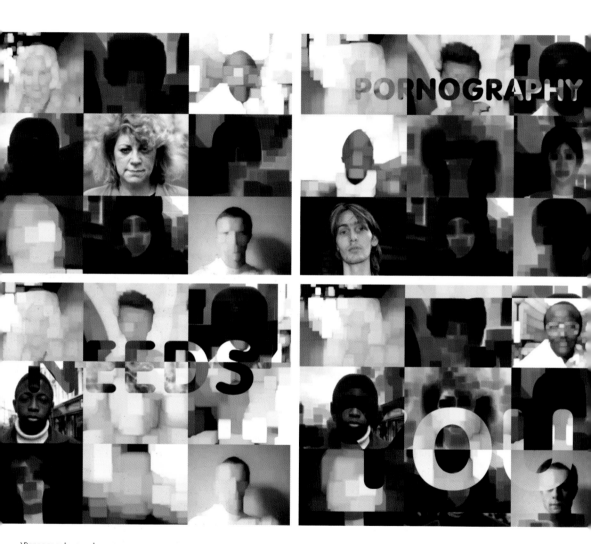

'Pornography needs
you', Stills from
Original Copies,
Peter Miles, Damon
Murray, Stephen
Sorrell of Fuel, 2000

Power to translate

In the 1990s, the idea that graphic design could be used by the designer as a vehicle
for personal authorship was the subject of prolonged and sometimes heated debate –
largely among design educators and critics. Even now, the proposition would be
mystifying to many people in the professional mainstream, and it would be completely
perplexing to most clients, who might wonder what such a notion had to do with the
commercial service they thought they were buying. The London graphic design team
Fuel – along with their colleagues Tomato – are leading lights in the British wing of this
international tendency. It says something about designers' continuing reluctance to
come to terms with any form of theory that, at least in their early work, Fuel certainly
didn't regard themselves as exponents of 'graphic authorship' – a term they had not
heard until the late 1990s, when they reacted to it in conversation with derisive laughter.
'We aren't about articulating what we do,' they insist, 'and never have been.'

An encounter with Fuel is always a slightly uncomfortable experience. It's not that
the crop-haired trio – Peter Miles, Damon Murray and Stephen Sorrell – aren't willing
to talk, but the collective conversational style certainly cannot be described as easy-
going chat. It doesn't take long to sense which of one's interviewing gambits will fall
on stony ground. Inquiries about their creative chemistry are met with a dismissive
'Is that interesting?' Venture a mild criticism of one of their projects and you will be
informed you have raised 'a very minor point'. And the team's influences? Another
tightly shut door. 'It makes it easier for the viewer to come to a conclusion and that's
lazy,' says Miles.

In 1998, they changed the studio's name to Miles Murray Sorrell (Fuel), but 'Fuel'
is such a sharp and memorable image that it has probably stuck. They called their
1996 book *Pure Fuel* and the 2000 follow-up is titled *Fuel Three Thousand*. They have been
together since the early 1990s, when they were students at the Royal College of Art. It
was there that they started their own magazine, *Fuel*, each issue given a hard-hitting title,
consisting, like their name, of just four letters – Girl, Hype, USSR, Cash, Dead, Grey. Fuel

was uncompromising in its subject matter, but what made it so striking was the extreme, almost brutal reticence of the design at a time when most paid-up graphic experimentalists were using the computer to build up complex and often barely legible patchwork quilts of type and image. When this craze passed in London, and taste swung back towards simplicity, Fuel looked all the more prescient, although, as they are quick to point out, they have no interest in graphic trends. 'Those things have come and gone,' says Murray, 'and will probably come and go again, but we will still be working along the same lines because this is how we work. For us, it's not a fashion thing.'

When it came to their image, though, Fuel were acutely self-conscious. They had themselves photographed in weird dresses made of pinstripe by a tailor in London's East End and, in *Pure Fuel*, an illustration depicts them in business suits, snarling at the viewer, like a gang of delinquent stockbrokers rampaging through the City. They say they are uninterested in creating a personal mystique – it's their work that counts – but they have cultivated a difficult, even unapproachable air. They won't see students ('For both sides, it's a waste of time') and they only agree to see photographers if they know Fuel's work. In their first eight years as a studio, they briefly employed only one assistant. Unlike other designers with a similar level of celebrity, they rarely participate in conferences or lectures.

Fuel's aim, from the outset, was to combine commercial commissions with projects of their own. They have forged regular relationships with youth-culture clients such as Levi's, Caterpillar and MTV. In 1999, for fashion photographer Juergen Teller, they designed *Go-Sees*, a no doubt unintentionally troubling collection of pictures of vulnerable, young, would-be models posed outside his London studio. Fuel accept that the opportunities for personal expression with these clients are limited, but say that they genuinely relish the opportunity to apply their professional craft. 'We're passionate about graphic design,' explains Miles. 'The thing that really drives us is graphic design and it's disappointing to see how it's wasted. We think graphic design has the biggest potential of all the arts. That's how we view it. It has a versatility. You can mould it to say anything you want to say, in any voice, at any level.'

Pure Fuel was a graphic exploration, in ten chapters, of such topics as function, leisure, chaos, society, truth and space. Fuel's method, as with their magazine, was to commission photographers and illustrators to create work on given themes, which was then placed in ambiguous juxtaposition with texts by newspaper journalist Richard Preston. As a calling card, the book was another powerful statement that Fuel is no ordinary design team – but not everyone was convinced that it had something significant to say. An American critic concluded that 'Placed alongside the posters of

the Guerrilla Girls [art world activists], for instance, or a Barbara Kruger work, Fuel shows itself as naïve in intellect – not in design.'[1]

Fuel acknowledge that such sceptical responses have obliged them to rethink. What hasn't changed is their commitment to initiating their own projects. They spent a year working on a series of short experimental films, *Original Copies*, which were shown at international film festivals. One piece, a kind of anti-commercial for AIDS – 'if acquiring it were not so deadly we would probably call it brilliant' – uses a sequence of blurred images from hardcore pornography, melting into each other with seductive and threatening viscosity. In another, they return to a visual idea in *Pure Fuel*, and point their video camera at the faces of teenagers playing video games in a London arcade to discover an extraordinary array of involuntary tics and expressions – scowling, lip-biting, tongue-flicking – that raise questions about the addictive allure of digital technologies. When asked about the film, though, they will only say that its subject is 'concentration'. But there are many other ways such a theme could be expressed – why this one? 'I don't think there's any point in us trying to pin it down after the fact,' says Murray. Similar issues of motivation and purpose arise with another of Fuel's anthropological forays into techno-culture. The overwhelming impression, intended or not, of the first issue of *Wow Wow*, their Internet review of 'sites unseen', launched in May 2000, was the now familar one of the medium as a rolling freak show for contortionists, rubber enthusiasts, outlandishly long hairstyles and men who like to immerse their whole bodies in quicksand.

In the complexity of its content, and in its relative lack of sensationalism, *Fuel Three Thousand* is their most intellectually ambitious project to date.[2] 'There was more ambiguity in *Pure*,' says Sorrell. 'With this book, we wanted to answer a few of the questions that had been raised, to structure it a bit more. The ideas are bigger, rather than the short, sharp statements of *Pure*.' Although they are not writers themselves, the verbal components and linguistic circuitry of their projects have always been crucial to Fuel. They display an advertising copywriter's instinct for slogans that grab the viewer's attention and detonate in the mind: 'Prevent contact with eyes' . . . 'Strike away from body' . . . 'Pornography needs you'. This fascination with advertising's highly condensed mode of reference and address is shared by their collaborator on the book, Shannan Peckham, a fellow at Oxford University with an interest in cultural politics, who wrote the text spoken by supermodel Kate Moss in their film *Can I own Myself?*

Fuel Three Thousand's three-part structure – anatomy, endings and translation – grew 'organically' from discussions between Peckham and Fuel. 'These were terms that emerged as building blocks around which other ideas accrued,' says Peckham.

'They became quite obvious markers. Translation is in some sense the master metaphor, the organising framework.' For both Peckham and Fuel, the project is a good deal more self-reflexive than its photographic images of plants, street scenes, children and families, or Fuel's vague claim that it is an 'anatomy of contemporary obsessions', might at first suggest. 'I was aware of some of the issues surrounding their work,' says Peckham, 'and that was the point of departure. What we were interested in doing was for me to theorise their practice and for that theorising then to be worked into the practice, so that there would an interesting relationship between the two. That's where the concept of translation begins.' The book addresses one of the most fundamental questions that can be asked of a practice based on the calculated fusion of word and image: in what ways does meaning change when a verbal idea is translated into visual form, or vice versa? And this may, or may not, be intended as a broader cultural critique in a document that smuggles unacknowledged quotations from Marx and Engels' *Communist Manifesto* ('All that is solid melts into air . . . ') into its pages; none of the collaborators is saying.[3] The book ends with the slogan 'Freedom is power to translate', embroidered on a cloth badge (to be worn as a motto?), but the implication seems to be that freedom is just as much the power to transgress, to mistranslate and to get your interpretation productively 'wrong' in the process. A six-page section showing mismanufactured screws culminates in the phrase: 'A word mismanufactured into poetry with a slip of the tongue.'

The book has significantly more text than Fuel's previous projects and the balance of elements has been carefully achieved. At the last minute, seeing the colour proofs, they decided that the ending was too heavy and cut an entire section, asking Peckham to generate alternative paragraphs on 'blind sight' in a matter of days, which he did. Throughout the book, words combine with images in ways that occasionally recall artists' books, though typography is rarely handled by fine artists with this level of rhetorical assurance. Sometimes there is just a sentence or two under, or superimposed on, a picture; at other times Peckham's precise mini-essays and aphoristic observations are allowed to fill the page. Continuous changes of type size reflect degrees of emphasis and nuances of meaning. Stylistic and structural unity is maintained by a single, standard Macintosh typeface, Palatino, with Compacta employed sparingly for moments of typographic display. In some of the strongest pages, text is absorbed into the image – 'translated' – by being carved into a surface, embossed on three-dimensional book covers, or unfurled on a roll of specially made tape.

Fuel Three Thousand was produced by a London publisher known for its design list and this raises the question of whom exactly it is for. Peckham, as a non-designer,

imagines no fixed readership. 'I see it,' he says, 'in terms of people who are interested in finding out, quite basically, about the world they live in. It's not academic. It's not purely creative. It's not purely a work of art and, in that sense, it mirrors some of the ambiguities of graphic design.'

Fuel are emphatic, though, that their work be understood as a development of graphic design's possibilities and not as a weak form of art. 'Historically, there aren't that many examples of this kind of direction and way of working,' says Miles. 'The examples that there are don't stand up to any criticism outside graphic design. As soon as you take them outside that narrow limitation, it tends to fall flat.' By their own admission, they are still learning. They seem keen to leave the excesses of youthful self-myth-making behind. One senses that they have reached the point of accepting that the critical attention work like this will attract means they will need to reflect more critically on their own practice – to think more like artists, at least in this respect – if they are going to develop the rigour required to continue on this path. In their self-initiated films and publishing projects, they are starting to produce new types of communication that can withstand closer scrutiny outside the inward-looking enclave of design.

Future imperfect

While some designers view the kind of design that seems to threaten the unravelling of all design with understandable trepidation, others are drawn to the idea, like kamikaze pilots to a battleship. In the punk period, people used to talk excitedly about a phenomenon sometimes called 'anti-design' or 'anti-style'. For the initiated, the rejection of craft rules, aesthetic proportion and stifling good taste was proof positive of the work's authenticity. It wasn't a ruse or an image, it was the thing itself, a genuine expression of what its makers felt.

A few years later, Cranbrook Academy of Art designers such as Edward Fella and Jeffery Keedy used the term 'anti-mastery' to describe their aims. This was the intellectual version of anti-design, hip to mind-bending French critical theory, and lobbed, as a calculated act of provocation, at the received wisdoms and comfortable complacencies of the design profession. Eventually, the idea filtered down to every Joe Schmo and his PowerMac that there is no such thing as 'good design', just your own opinion, and therefore anything goes.

This wasn't great news for the designer who sincerely believes that 'real' design has something special to offer both client and audience. Nevertheless, the idea of a form of design healthily free of the impurity of added professional slickness soon found a place in the design pro's cabinet of styles and concepts. A book about Tibor Kalman neatly captures the paradox in its subtitle – 'Design and Undesign'. Just as the famous exclamation, 'Thank God, I am still an atheist!' attests to an enduring belief in the Almighty, so 'undesign' as a design strategy depends on the continuing existence of design to make it plain to us exactly what it isn't.

The great attraction of punk was that it didn't give a damn what the design profession thought about anything (it barely understood that there was a profession). One problem with the sundry rejections, repudiations and academic re-evaluations that have followed is that they so obviously do care. This type of work is simply too knowing to escape from the massive gravitational pull of Planet Design. Fella is a case in point.

His typographic inventions are among the most self-aware, deliberate and truly inspired rule-breaking of recent years – sheer unfettered creativity – and in the late 1980s they were so far from registering on the profession's radar that his work did indeed seem to be a profound, semi-secret affront to the very nature of typographic design. When professionals stumbled across it by chance, they didn't know whether to be baffled, outraged, or both.

Looking at the section on Fella in *Radical Graphics/Graphic Radicals*, a recent American design book, it is striking how familiar his work now seems. The more we see of Fella's flights of extreme and unpredictable virtuosity, the more we know exactly what to expect. Anti-mastery turns out to be an alternative form of mastery, and now that the initial shock has worn off, it has been painlessly absorbed by a graphic mainstream that apparently regards 'radical graphics' as a genre in its own right.

But there is another area of 'undesign' that hasn't attracted the same labels,

Emperor Tomato Ketchup, Stereolab, 1996

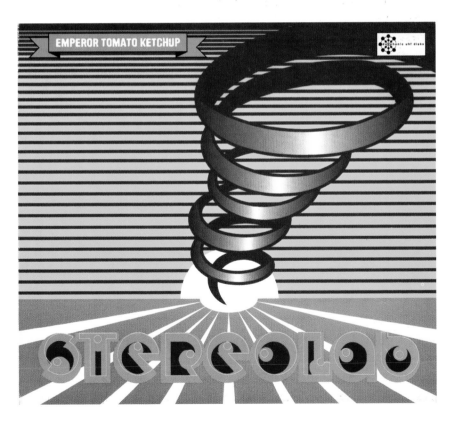

theories or attention, because it is much more ordinary, much less flamboyant and, as a result, much closer to the heart of our everyday experience of design. What I have in mind could perhaps be termed 'flawed mastery', though 'imperfect design' would be more direct. Observing my own spontaneous behaviour as a viewer and consumer of things that happen to be designed (as opposed to being a detached design-watcher, a 'critic') I find that imperfection is a key source of pleasure in design, a quality that often draws me to a thing.

I don't mean to suggest by this some camp or ironic 'so bad it's good' way of seeing. Nor do I mean design that is so lacking in saving graces that not even the most dedicated ironist could tease any humour from it. It is something much subtler than that: a line of type slightly smaller than it ought to be; a contrast tried for, but not quite achieved; an area of unwarranted overemphasis; a feeling that some aspect of the design hasn't been as well articulated or resolved as it might have been; an air of probably unintentional strangeness in the choice of type, image, or the way they are brought together. Any, or all, of these things can result in a design that has about it the almost indefinable quality of animation that the British designer Paul Elliman, who teaches at Yale, describes as the 'breath of life'.

This is most definitely not the kind of design that wins all the prizes. Whatever their style, award-winners almost invariably radiate the sense that everything has been perfectly judged and is in precisely the right place. However, like the proverbial model with the flawless looks who finds it hard to get a date, because only the most supremely attractive have the nerve to ask her out, absolute perfection is not always the most engaging quality in a design. Designers with a commitment to traditional notions of craft tend to assume that achieving a state of visual perfection must necessarily mean that a design will communicate more effectively. But there is rarely any solid evidence that this is the case and approaching communication from this angle can often lead a designer to miss the point.

I saw this happen with a favourite British band which produces a strange hybrid music that somehow fuses rock, dance rhythms, bright easy listening and hypnotic, minimalist chants and drones. The group, Stereolab, has released a series of CDs with bold but slightly peculiar covers. The parts don't quite fit together, in an aesthetic sense, yet the effect is strong. In one of the best, a coiled element spirals up from a sun-like semi-circle on a graphic horizon, against a background of horizontal lines. For no particular reason, the title is placed in a ribbon-like device at the top and the band's name is rendered in an odd, custom-built font whose centrifugal turning movements recall glimpses of washing in a tumble dryer.

There is a design credit of sorts – it reads 'Sleeve at Trouble with assistance from Frank and Bettina' – but it isn't clear who created this or most of the other early covers. For its next release, the band turned to a design company with a recognisable name and reputation and the results were immediately apparent in a CD cover that boasted a series of archly minimalist Op-Art variations on a circle. The record label's daffy molecular logo was rebranded into a cluster of exquisitely balanced blobs and a sinuous 'space-age' typeface was pressed into use. Suddenly an operation that had seemed innocently weird now looked like a calculated exercise in pseudo-corporate image-building. No question it was 'better designed', but it was also arid and lifeless.

For designers, self-consciousness is an occupational hazard. A designer is by definition someone with hyper-sensitive feelers for what is fashionable in both society and design, and this can be deeply inhibiting. Some of the most engaging instances of flawed mastery and suggestively oblique image-making come from people who seem relatively immune to these concerns. What led the cover designer of a book of Jean Baudrillard's photographs to match a widely letter-spaced, modernistic, 1930s-looking typeface with one of the theorist's snaps? For design purists it is an obvious *faux pas*, yet it makes a much more unsettling and memorable cover image than the standard little dab of Helvetica hiding in a corner that would no doubt have won instant reflex approval from fashion-conscious proponents of the neo-modernist revival that never seems to run its course.

Designers who allow space for the peculiar, the wayward, the imperfect – and, sometimes, the just plain 'wrong' – set in motion a process and create the conditions for the viewer to have truly unexpected encounters with design that are one of its keenest, most human pleasures and a large part of its point.

Notes

INTRODUCTION

1. Richard Tomkins, *Financial Times*, 16 December 2000
2. *Can You Live Without Designer Labels?*, Channel 4, 19 June 2001
3. Nick Compton, 'The revolution will not be franchised', i-D, no. 205, January 2001, p. 85
4. Interviewed by Sean Dodson, 'Confused? You won't be', *Media Guardian*, 12 March 2001, p. 7
5. 'Arts industry worth £100bn', *Guardian*, 14 March 2001, p. 7
6. *Time*, 26 June 2000
7. Paul Dickinson and Neil Svensen, *Beautiful Corporations: Corporate Style in Action*, Edinburgh and London: Pearson Education, 2000, p. 15
8. Ibid., p. 28
9. Quoted in Geoffrey Wansell, 'The new adlads', *The Business: Financial Times*, 20 May 2000, p. 36
10. Quoted in David Redhead, 'Experience required', *Space: Guardian*, 20 July 2000, p. 34
11. Richard Murray, 'The domination game', *Design Week*, 21 July 2000, p. 12
12. Richard Seymour, 'Welfare statements', *Blueprint*, no. 183, May 2001, p. 44. See also: Richard Seymour, 'Let's design as if humans mattered', *Domus*, no. 838, June 2001, pp. 26–7, and Richenda Wilson, 'A superhuman task', *Creative Review*, vol. 21 no. 6, June 2001, pp. 65–8
13. Vilém Flusser, *The Shape of Things: A Philosophy of Design*, London: Reaktion Books, 1999, p. 17

THE BOREDOM OF PLENTY

1. Quoted in Russell Miller, *Magnum: Fifty Years at the Front Line of History*, London: Pimlico, 1999, p. 297
2. Interviewed by Caroline Egan, 'My cultural life', *Guardian*, 10 December 1999
3. Colin Jacobson, 'Friend or foe?', *Creative Review*, November 2000, p. 47

4. Gerry Badger, 'Fleshpots of Catalonia – Martin Parr's Benidorm' in *About the World: Martin Parr – Benidorm*, Hannover: Sprengel Museum, 1999
5. Adam Phillips, 'On being bored' in *On Kissing, Tickling and Being Bored*, London: Faber and Faber, 1993, p. 74

INSIDE THE BLUE WHALE

1. Paul Barker, 'Malls are wonderful', *Independent on Sunday*, 28 October 1998, p. 9
2. Ibid., p. 12
3. Marcus Field, 'Tragedy in the chalk pit', *Blueprint*, no. 161, May 1999, p. 45
4. Ibid.
5. Fiona Rattray, 'Bluewater or ditch-water?', *Blueprint*, no. 161, May 1999, p. 47
6. Research quoted in *Vision to Reality*, London: Lend Lease, 1999, p. 60
7. Kuhne was given the title 'concept designer'. He had never designed a shopping mall before. His practice, Eric Kuhne & Associates, is known for parks and civic spaces. The project architect, supporting and developing the design process, was Benoy
8. Field, p. 45
9. *Vision to Reality*, p. 73
10. Andrew Adonis and Stephen Pollard, *A Class Act: The Myth of Britain's Classless Society*, London: Penguin, 1998, p. 4
11. Ibid., p. 10
12. Ibid.
13. Bryan Appleyard, 'The age of plenty', *Prospect*, no. 41, May 1999, p. 46
14. Ibid.
15. Dan Roberts, 'Shoppers prefer out-of-town sites', *Daily Telegraph*, 19 November 1998 (source: Electronic Telegraph). Research by the British Council of Shopping Centres found that four of the top five shopping destinations were away from traditional shopping areas. Preferred sites were the Metro Centre, Gateshead; Lakeside, Essex; Meadowhall, Sheffield; Merry Hill, West Midlands

PROZAC FOR THE EAR

1. Aldous Huxley, *Brave New World*, London: Flamingo, 1994 (first published 1932), p. 180
2. Joseph Lanza, *Elevator Music: A Surreal History of Muzak, Easy-Listening, and other Moodsong*, New York: Picador, 1995, p. 233
3. Jon Savage, 'Leave my history alone: pop in ads' in *Time Travel: Pop, Media and Sexuality 1976–96*, London, Chatto & Windus, 1996, p. 232

ALTERNATIVE BY DESIGN?

1. Lewis Blackwell, *The End of Print: The Graphic Design of David Carson*, London: Laurence King, 1995, unpaginated
2. Quoted in Steven Levy, 'Ad nauseam: how MTV sells out rock & roll', *Rolling Stone*, 8 December 1983, p.33
3. Ibid., p. 34
4. Quoted in Blackwell, unpaginated
5. Levy, p. 78
6. Andrew Goodwin, 'Fatal distractions: MTV meets postmodern theory' in Simon Frith, Andrew Goodwin and Lawrence Grossberg (eds.), *Sound & Vision: The Music Video Reader*, London and New York: Routledge, 1993, p. 46
7. Ibid., p. 63
8. Larry McCaffery (ed.), *After Yesterday's Crash: The Avant-Pop Anthology*, New York: Penguin, 1995, pp. xvii–xix

BRANDED JOURNALISM

1. Milton Glaser, 'Censorious advertising', *The Nation*, 22 September 1997, p. 7
2. Quoted in Robin Pogrebin, 'Magazine publishers circling wagons against advertisers', *New York Times*, 29 September 1997
3. Quoted in Blake Fleetwood, 'News at a price', *The Editor: Guardian*, 17 September 1999, p. 12

HERE IS ME!

1. Tom Wolfe, 'The me decade and the third great awakening' in *Mauve Gloves & Madmen,*

Clutter & Vine, New York: Bantam Books, 1977, pp. 111–47
2. Lewis Blackwell in Lewis Blackwell, P. Scott Makela and Laurie Haycock Makela, *Whereishere*, London: Laurence King Publishing, 1999
3. Max Bruinsma, 'The aesthetics of transience', *Eye*, no. 25 vol. 7, summer 1997, p. 44
4. Jorge Frascara, 'Graphic design: fine art or social science?' in Victor Margolin and Richard Buchanan (eds.), *The Idea of Design: A Design Issues Reader*, Cambridge, Mass. and London: MIT Press, 1995, pp. 44–55

DON'T THINK, SHOOT
1. 'Don't worry about any rules' in *What the hell is Lomo?*, promotional booklet, Vienna: Lomographic Society International, undated
2. Salvador Dalí, 'Photographic data' in *Oui: The Paranoid-Critical Revolution. Writings 1927–1933*, Boston: Exact Change, 1998, p. 71

INEFFABLE COOL
1. Quoted in Naomi Klein, *No Logo*, New York: Picador and London: Flamingo, 2000, p. 69
2. Norman Mailer, 'The white negro: superficial reflections on the hipster' in *Advertisements for Myself*, Cambridge, Mass. and London: Harvard University Press, 1992 (first published 1959), p. 339
3. Thomas Frank, *The Conquest of Cool: Business Culture, Counterculture, and the Rise of Hip Consumerism*, Chicago and London: University of Chicago Press, 1997, p. 20
4. Ibid., p. 229
5. Quoted in Steven Heller, 'Tibor Kalman, designer and editor', *Print*, LII:I, January/February 1998, p. 217
6. Kalle Lasn, *Culture Jam: The Uncooling of America*, New York: Eagle Brook, 1999, p. xvi

SHOPPING ON PLANET IRONY
1. Renzo Rosso in *Diesel Advertising. The*

Beginning. 1991–1998, Molvena: Diesel, 1998, unpaginated
2. Bruce Grierson, 'Shock's next wave', *Adbusters*, no. 20, winter 1998, p. 25

DIGITAL SUPERGIRLS
1. Murray Healy and Tony Cobb, 'Apocalypse Norb', *Pop*, no. 1, autumn/winter 2000/2001, p. 153
2. Robin Derrick in Mark Sanders, Phil Poynter and Robin Derrick, *The Impossible Image*, London: Phaidon, 2000, p. 3

GRAPHIC SEX
1. François Chalet, *Chalet*, Berlin: Die Gestalten Verlag, 2000, pp. 8–9
2. Quoted in Isabel Tang, *Pornography: The Secret History of Civilization*, London: Channel 4 Books, 1999, p. 162
3. Quoted in Natacha Merritt, *Digital Diaries*, Cologne: Taschen, 2000, p. 218
4. See Tang

DEATH IN THE IMAGE WORLD
1. Quoted in Simon Brett, 'Silent history: the photographic archive of Dr Stanley Burns', *Speak*, no. 15, summer 1999, p. 55
2. Bruno Bettelheim, *The Uses of Enchantment: The Meaning and Importance of Fairy Tales*, London: Penguin, 1991, p. 214
3. David Kerekes, 'Editorial: why we shouldn't eat human flesh', *Headpress*, no. 1, 1991, p. 1
4. Jonathan Glover, *Humanity: A Moral History of the Twentieth Century*, London: Pimlico, 2001, p. 406
5. Georges Bataille, *The Tears of Eros*, San Francisco: City Lights Books, 1989. For a detailed account of the pictures, see John Taylor, *Body Horror: Photojournalism, Catastrophe and War*, Manchester: Manchester University Press, 1998, pp. 30–4
6. H. R. Giger, *HR Giger ARh+*, Cologne: Taschen, 1996, p. 36
7. Norman Rosenthal *et al.*, *Apocalypse: Beauty and Horror in Contemporary Art*, London:

Royal Academy of Arts, 2000, pp. 212–25
8. Stanley Cohen, *States of Denial: Knowing about Atrocities and Suffering*, London: Polity Press, 2001, p. 287

TOO MUCH STUFF
1. Jean-Paul Sartre, *Nausea*, London: Penguin, 1963 (first published 1938), p. 190
2. James B. Twitchell, *Adcult USA: The Triumph of Advertising in American Culture*, New York: Columbia University Press, 1996, p. 11
3. Ibid.
4. Deyan Sudjic, *Cult Objects: The Complete Guide to Having it All*, London: Paladin, 1985, p. 8
5. Victor Papanek, *Design for the Real World: Human Ecology and Social Change*, London: Thames and Hudson, 1985 (first published 1971), p. ix
6. Nigel Whiteley, *Design For Society*, London: Reaktion Books, 1993, p. 114

DESIGN IS ADVERTISING
1. Belinda Archer, 'Which species are you?', *Media Guardian*, 24 November 1997, p. 5
2. Stuart Ewen, 'Living by design', *Art in America*, vol. 78 no. 6, June 1990, p. 75
3. James B. Twitchell, *Adcult USA: The Triumph of Advertising in American Culture*, New York: Columbia University Press, 1996
4. Steven Heller, 'Advertising: mother of graphic design', *Eye*, no. 17 vol. 5, summer 1995, p. 32
5. Quoted in Lynda Relph-Knight, 'Election head to head', *Design Week*, 16 January 1998, p. 7
6. See Hugh Aldersey-Williams *et al.*, *Cranbrook Design: The New Discourse*, New York: Rizzoli, 1990
7. Thomas Frank, 'Why Johnny can't dissent' in Thomas Frank and Matt Weiland (eds.), *Commodify Your Dissent*, New York and London: W. W. Norton, 1997, p. 41
8. Umberto Eco, 'Towards a semiological guerrilla warfare' in *Travels in Hyperreality*, London: Picador, 1987, pp. 135–44.
9. Quoted in David Campany and Gavin

Jack, 'AVI', *Transcript*, vol. 3 no. 1, undated, p. 84

10. Russell Bestley, 'Design, intervention, and the Situationist approach', *Zed* no. 3, Design + Morality, 1996, p. 50

11. A revised version of Gui Bonsiepe's paper was published as 'Some virtues of design' in *design beyond Design*, Maastricht: Jan van Eyck Akademie, 1998, pp. 105–10.

12. Neal Ascherson, 'We live under the most arrogant of all world orders, but it will not last', *Independent on Sunday*, 25 January 1998

13. Quoted in Mark Dery, *Culture Jamming: Hacking, Slashing, and Sniping in the Empire of Signs*, Westfield, NJ: Open Magazine Pamphlet Series, 1993, p. 6

14. Hakim Bey, *TAZ: The Temporary Autonomous Zone, Ontological Anarchy, Poetic Terrorism*, Brooklyn, NY: Autonomedia, 1985, 1991, p. 99

15. Kalle Lasn, 'The meme wars', *Adbusters* no. 23, autumn 1998, p. 7

16. Bey, p. 100

17. Critical Art Ensemble, *Electronic Civil Disobedience and Other Unpopular Ideas*, Brooklyn: Autonomedia, 1996, p. 11

18. Ibid., p. 24

19. Hakim Bey, *Immediatism*, Edinburgh and San Francisco: AK Press, 1994, p. 10

FIRST THINGS FIRST

1. Ken Garland, *A Word in Your Eye: Opinions, Observations and Conjectures on Design, from 1960 to the Present*, Reading: University of Reading, 1996, p. 94

2. Anthony Wedgwood Benn, 'First things first', *Guardian*, 24 January 1964

3. Jock Kinneir, 'Graphics for information', *SIA Journal*, no. 134, April 1964, p. 8

4. Ken Garland, 'First things first: a manifesto' in *A Word in Your Eye*, p. 30

5. Katherine McCoy, 'Countering the tradition of the apolitical designer' in *Essays on Design 1: AGI's Designers of Influence*, London: Booth-Clibborn Editions, 1997, p. 90

6. Ibid., p. 87

7. Johanna Drucker, 'Talking theory/teaching practice' in Steven Heller (ed.), *The Education of a Graphic Designer*, New York: Allworth Press, 1998, p. 85

FIRST THINGS NEXT

1. Gary Williams, 'First Things First – what were you thinking?' (letter), *Emigre*, no. 52, fall 1999, p. 5

2. Nick Shinn, 'Hypemongers' (letter), *Eye* no. 34 vol. 9, winter 1999, p. 6

3. Rudy VanderLans, 'Reply', *Emigre*, no. 52, fall 1999, p.5

4. Tim Rich, 'Ideas before manifestos', *Design Week*, 5 November 1999, p. 17

5. Michael Bierut, 'A manifesto with ten footnotes', *I.D.*, March/April 2000, p. 76

6. Alex Cameron, 'Painting by morals', *Living Marxism*, no. 125, November 1999

7. Nico Macdonald and Kevin McCullagh (Design Agenda), 'Designing is not a political act' (letter), *Emigre*, no. 52, fall 1999, p. 4

8. Tod Ramzi Karam, 'First Things First manifesto', *Adbusters*, no. 28, winter 2000, p. 6

9. Jelly Helm, 'Saving advertising', *Emigre*, no. 53, winter 2000, p. 6

10. Statement by Armand Mevis for an exhibition about *First Things First 2000* curated by Barbara Usherwood, University of Portsmouth, UK, September 2000

11. Monika Parrinder, 'Just say no . . . quietly', *Eye*, no. 35 vol. 9, spring 2000, p. 8

12. Andrew Howard, 'Design beyond commodification', *Eye*, no. 38 vol. 10, winter 2000, p. 11

THIRTEEN PROVOCATIONS

1. Karrie Jacobs and Tibor Kalman, 'The End' in Susan Yelavich (ed.), *The Edge of the Millennium*, New York: Whitney Library of Design, 1993, p. 41

2. Tibor Kalman and Karrie Jacobs, 'We're here to be bad', *Print*, January/February 1990, p. 122

3. See Edward Steichen, *The Family of Man*,

New York: Museum of Modern Art, 1986 (first published 1955)

4. Hakim Bey, *TAZ: The Temporary Autonomous Zone, Ontological Anarchy, Poetic Terrorism*, Brooklyn, NY: Autonomedia, 1985, 1991

5. Hans-Peter Feldmann, *Voyeur*, Cologne: Verlag der Buchandlung Walther König, 1997

SURFACE WRECKAGE

1. Jonathan Miller, *Nowhere in Particular*, London: Mitchell Beazley, 1999, unpaginated

2. Quoted in Christopher Phillips, 'When poetry devours the walls', *Art in America*, vol. 78 no. 2, February 1990, p. 140

3. Herbert Spencer, *Traces of Man*, London: Lund Humphries, 1967

4. Robert Brownjohn, 'Street level', *Typographica*, new series no. 4, December 1961. p. 29

5. Hans-Rudolf Lutz, 'Graphic design as a live art', *Baseline*, no. 14, 1991, pp. 4–7

6. Brownjohn, p. 30

7. Quoted in Warren Berger, 'What makes David Carson tick?', *Affiche*, no. 14, 1995, p. 49

8. Jean Baudrillard, 'For illusion isn't the opposite of reality . . .' in *Photographies 1985–1998*, Ostfildern-Ruit: Hatje Cantz, 1999, p. 131

PREPARING FOR THE MEME WARS

1. Designers Republic, 'Visual symbolism. Vol 94', *Emigre*, no. 29, winter 1994

2. Oliver Burkeman, 'A hairy naked man in a rubber ring. Interested?', *G2: Guardian*, 9 July 2001, pp. 2–3

3. William Burroughs in James Grauerholz and Ira Silverberg (eds.), *Word Virus: The William Burroughs Reader*, London: Flamingo, 1999, p. 304

4. William Burroughs, *Nova Express*, New York: Grove Press, 1977 (first published 1964), p. 48

5. Seth Godin, 'Unleash your ideavirus', *Fast Company*, no. 37, August 2000

6. Quoted in Richard Dawkins, 'Viruses of the mind' in Bo Dahlbom (ed.), *Dennett and his Critics: Demystifying Mind*, Oxford and Cambridge, Mass.: Blackwell, 1993, p. 13

7. Dawkins, p. 21

8. Richard Brodie, *Virus of the Mind: The New Science of the Meme*, Seattle: Integral Press, 1996

9. Paul Marsden, 'Mental epidemics', *New Scientist*, 6 May 2000

10. Quoted in Jon Pratty, 'This little meme went to market . . .', *Connected* (Electronic Telegraph Network), 13 April 2000

BOOKS OF BLOOD AND LAUGHTER

1. David King, *The Commissar Vanishes: The Falsification of Photographs and Art in Stalin's Russia*, Edinburgh: Canongate Books, 1997, p. 10

WHEN OBJECTS DREAM

1. Anthony Dunne and Fiona Raby, 'Hertzian tales and other proposals' in Melanie Keen (ed.), *Frequencies: Investigations into Culture, History and Technology*, London: Institute of International Visual Arts, 1998, p. 55

2. See Anthony Dunne, *Hertzian Tales: Electronic Products, Aesthetic Experience and Critical Design*, London: Royal College of Art, 1999, pp. 104–5

3. See Anthony Dunne, 'Design noir', *Blueprint*, no. 155, November 1998, pp. 24–5

4. Doris Lockhart Saatchi, 'One of the other stories . . .' in *Weeds, Aliens & Other Stories*, London: Royal College of Art/Salvo, 2000

POWER TO TRANSLATE

1. Kenneth Fitzgerald, 'Fuel full pull poll pool cool cook book', *Emigre*, no. 44, fall 1997, p. 24

2. Peter Miles, Damon Murray, Stephen Sorrell and Shannan Peckham, *Fuel Three Thousand*, London: Laurence King Publishing, 2000

3. Ibid., p. 117

Bibliography

Adonis, Andrew and Pollard, Stephen, *A Class Act: The Myth of Britain's Classless Society*, London: Penguin, 1998

Baudrillard, Jean, *Photographies 1985–1998*, Ostfildern-Ruit: Hatje Cantz, 1999

Bey, Hakim, *TAZ: The Temporary Autonomous Zone, Ontological Anarchy, Poetic Terrorism*, Brooklyn, NY: Autonomedia, 1985, 1991

———, *Immediatism*, Edinburgh and San Francisco: AK Press, 1994

Blackwell, Lewis, Makela, P. Scott and Haycock Makela, Laurie, *Whereishere*, London: Laurence King Publishing, 1998

Borsook, Paulina, *Cyberselfish: A Critical Romp through the Terribly Libertarian Culture of High Tech*, London: Little, Brown, 2000

Bourdieu, Pierre, *Acts of Resistance: Against the New Myths of our Time*, Cambridge: Polity Press, 1998

Branwyn, Gareth, *Jamming the Media: A Citizen's Guide*, San Francisco: Chronicle Books, 1997

Brodie, Richard, *Virus of the Mind: The Science of the Meme*, Seattle: Integral Press, 1996

Carson, David and Meggs, Philip. B., *Fotografiks*, London: Laurence King Publishing, 1999

Cohen, Stanley, *States of Denial: Knowing about Atrocities and Suffering*, Cambridge: Polity Press, 2001

Critical Art Ensemble, *The Electronic Disturbance*, Brooklyn, NY: Autonomedia, 1994

———, *Electronic Civil Disobedience and other Unpopular Ideas*, Brooklyn, NY: Autonomedia, 1996

Davidson, Martin, *The Consumerist Manifesto: Advertising in Postmodern Times*, London and New York: Routledge, 1992

Dawkins, Richard, *The Selfish Gene*, Oxford and New York: Oxford University Press, 1976, 1989 (revised edition)

Debord, Guy, *The Society of the Spectacle*, New York: Zone Books, 1994 (first published 1967)

Derber, Charles, *Corporation Nation: How Corporations Are Taking Over Our Lives and What We Can Do about It*, New York: St Martin's Griffin, 1998

Dery, Mark, *Culture Jamming: Hacking, Slashing, and Sniping in the Empire of Signs*, Westfield, NJ: Open Magazine Pamphlet Series, 1993

Dickinson, Paul and Svensen, Neil, *Beautiful Corporations: Corporate Style in Action*, Edinburgh and London: Pearson Education, 2000

Diesel Advertising. The Beginning. 1991–1998, Molvena: Diesel, 1998

Duis, Leonie ten and Haase, Annelies, *The World must Change: Graphic Design and Idealism*, Amsterdam: De Balie, 1999

Dunne, Anthony, *Hertzian Tales: Electronic Products, Aesthetic Experience and Critical Design*, London: Royal College of Art, 1999

Eco, Umberto, *Travels in Hyperreality*, London: Picador, 1987

Ewen, Stuart, *Captains of Consciousness: Advertising and the Social Roots of the Consumer Culture*, New York: McGraw-Hill, 1976

———, *All Consuming Images: The Politics of Style in Contemporary Culture*, New York: Basic Books, 1988

Feldmann, Hans-Peter, *Voyeur*, Cologne: Verlag der Buchhandlung Walther König, 1997

Flusser, Vilém, *The Shape of Things: A Philosophy of Design*, London: Reaktion Books, 1999

Frank, Thomas and Weiland, Matt (eds.), *Commodify Your Dissent: Salvos from 'The Baffler'*, New York and London: W. W. Norton, 1997

Frank, Thomas, *The Conquest of Cool: Business Culture, Counterculture, and the Rise of Hip Consumerism*, Chicago and London: University of Chicago Press, 1997

———, *One Market Under God: Extreme Capitalism, Market Populism and the End of Economic Democracy*, London: Secker & Warburg, 2001

Frith, Simon, Goodwin, Andrew and Grossberg, Lawrence, *Sound & Vision: The Music Video Reader*, London and New York: Routledge, 1993

Garland, Ken, *A Word in Your Eye: Opinions, Observations and Conjectures on Design, from 1960 to the Present*, Reading: University of Reading, 1996

Gladwell, Malcolm, *The Tipping Point: How Little Things can Make a Big Difference*, London: Little, Brown, 2000

Glover, Jonathan, *Humanity: A Moral History of the Twentieth Century*, London: Pimlico, 2001

Grauerholz, James and Silverberg, Ira (eds.), *Word Virus: The William Burroughs Reader*, London: Flamingo, 1999

Heller, Steven (ed.), *The Education of a Graphic Designer*, New York: Allworth Press, 1998

Hertz, Noreena, *The Silent Takeover: Global Capitalism and the Death of Democracy*, London: William Heinemann, 2001

Hirst, Damien, *I Want to Spend the Rest of My Life Everywhere, with Everyone, One to One, Always, Forever, Now*, London: Booth-Clibborn Editions, 1997

Hutton, Will and Giddens, Anthony (eds.), *On the Edge: Living with Global Capitalism*, London: Vintage, 2001

Huxley, Aldous, *Brave New World*, London: Flamingo, 1994 (first published 1932)

King, David, *The Commissar Vanishes: The Falsification of Photographs and Art in Stalin's Russia*, Edinburgh: Canongate Books, 1997

Klein, Naomi, *No Logo*, New York: Picador and London: Flamingo, 2000

Lanza, Joseph, *Elevator Music: A Surreal History of Muzak, Easy-Listening and other Moodsong*, New York: Picador, 1995

Lasch, Christopher, *The Culture of Narcissism*, London: Abacus, 1980

Lasn, Kalle, *Culture Jam: The Uncooling of America*, New York: Eagle Brook, 1999

Lynch, Aaron, *Thought Contagion: How Belief Spreads through Society*, New York: Basic Books, 1996

Mailer, Norman, *Advertisements for Myself*, Cambridge, Mass. and London: Harvard University Press, 1992 (first published 1959)

Margolin, Victor and Buchanan, Richard
(eds.), *The Idea of Design: A Design Issues
Reader*, Cambridge, Mass., and London:
MIT Press, 1995

McCaffery, Larry (ed.), *After Yesterday's Crash:
The Avant-Pop Anthology*, New York:
Penguin, 1995

McKay, George, *Senseless Acts of Beauty:
Cultures of Resistance since the Sixties*, London
and New York: Verso, 1996

——— (ed.), *DiY Culture: Party & Protest
in Nineties Britain*, London and New York:
Verso, 1998

McQuiston, Liz, *Graphic Agitation*, London:
Phaidon, 1993

Merritt, Natacha, *Digital Diaries*, Cologne:
Taschen, 2000

Miles, Peter, Murray, Damon, Sorrell,
Stephen and Peckham, Shannan, *Fuel
Three Thousand*, London: Laurence King
Publishing, 2000

Miller, John, *Egotopia: Narcissism and the New
American Landscape*, Tuscaloosa: University
of Alabama Press, 1997

Miller, Jonathan, *Nowhere in Particular*,
London: Mitchell Beazley, 1999

Miller, Russell, *Magnum: Fifty Years at the Front
Line of History*, London: Pimlico, 1999

Monbiot, George, *Captive State: The Corporate
Takeover of Britain*, London: Macmillan,
2000

O'Toole, Laurence, *Pornocopia: Porn, Sex,
Technology and Desire*, London: Serpent's
Tail, 1998, 1999 (revised edition)

Papanek, Victor, *Design for the Real World:
Human Ecology and Social Change*, London:
Thames and Hudson, 1971, 1985
(revised edition)

Parr, Martin, *The Cost of Living*, Manchester:
Cornerhouse Publications, 1989

———, *Small World: A Global Photographic
Project 1987–1994*, Stockport: Dewi Lewis
Publishing, 1995

———, *Common Sense*, Stockport: Dewi
Lewis Publishing, 1999

Phillips, Adam, *On Kissing, Tickling and Being
Bored: Psychoanalytic Essays on the Unexamined*

Life, London: Faber and Faber, 1993

Polhemus, Ted, *Diesel: World Wide Wear*,
London: Thames and Hudson, 1998

Pountain, Dick and Robins, David,
Cool Rules: Anatomy of an Attitude, London:
Reaktion Books, 2000

Reid, Jamie and Savage, Jon, *Up They Rise:
The Incomplete Works of Jamie Reid*, London:
Faber and Faber, 1987

Ruggiero, Greg and Sahulka, Stuart,
*Project Censored: The Progressive Guide to
Alternative Media and Activism*, New York:
Seven Stories Press, 1999

Rushkoff, Douglas, *Media Virus! Hidden
Agendas in Popular Culture*, New York:
Ballantyne Books, 1994, 1996 (revised
edition)

Sanders, Mark, Poynter, Phil and Derrick,
Robin, *The Impossible Image: Fashion
Photography in the Digital Age*, London:
Phaidon, 2000

Sartre, Jean-Paul, *Nausea*, London: Penguin,
1963 (first published 1938)

Savage, Jon, *Time Travel: Pop, Media and
Sexuality 1976–96*, London: Chatto &
Windus, 1996

Stallabrass, Julian, *Gargantua: Manufactured
Mass Culture*, London and New York: Verso,
1996

Steichen, Edward, *The Family of Man*,
New York: Museum of Modern Art, 1986
(first published 1955)

Sudjic, Deyan, *Cult Objects: The Complete Guide
to Having it All*, London: Paladin, 1985

Tang, Isabel, *Pornography: The Secret History
of Civilization*, London: Channel 4 Books,
1999

Taylor, John, *Body Horror: Photojournalism,
Catastrophe and War*, Manchester and New
York: Manchester University Press, 1998

Taylor, Mark C., *Hiding*, Chicago and
London: University of Chicago Press,
1997

Toorn, Jan van (ed.), *design beyond Design:
Critical Reflection and the Practice of Visual
Communication*, Maastricht: Jan van Eyck
Akademie Editions, 1998

Twitchell, James, B., *Adcult USA: The Triumph
of Advertising in American Culture*, New York:
Columbia University Press, 1996

Whiteley, Nigel, *Design For Society*, London:
Reaktion Books, 1993

Wolfe, Tom, *Mauve Gloves & Madmen, Clutter
& Vine*, New York: Bantam Books, 1977

Yelavich, Susan (ed.), *The Edge of the
Millennium*, New York: Whitney Library
of Design, 1993

Index

Acknowledgements

PICTURE CREDITS

Cover illustration: Kam Tang
p. 6 courtesy of Shepard Fairey
p. 14–5 Illustration by Kam Tang
p. 16 Photo: © Martin Parr/Magnum. *Small
World* published by Dewi Lewis Publishing
p. 21 Photo: © Martin Parr/Magnum. *Common
Sense* published by Dewi Lewis Publishing
p. 24 Photo: © Bluewater
p. 36 courtesy of *View on Colour*
p. 50 courtesy of Saatchi & Saatchi
p. 56 Photo of *A&F Quarterly*: © Annie
Schlechter
p. 63 Photo: © Boris Bocheinski/Rex Features
p. 64 courtesy of Stefan Sagmeister
p. 79 courtesy of TBWA GGT and NatWest
p. 81 courtesy of Diesel
p. 84–5 courtesy of Diesel
p. 91 courtesy of Yacht Associates
p. 95 courtesy of Andrew Richardson
p. 109 courtesy of Saatchi Gallery, London
p. 112 top left: © Churches Advertising
Network, 1999
top right: courtesy of *Sleazenation*
bottom left: courtesy of NME
bottom right: courtesy of the *Guardian*
p. 118–9 Illustration by Kam Tang
p. 129 courtesy BLF, photo: © Nicole
Rosenthal
p. 154 courtesy of Benetton
p. 159 courtesy of Mitchell Beazley Publishers
p. 162 Photo: © Darko Vojinovic/AP
p. 165 courtesy of Virgin Records
p. 170 courtesy of PETA
p. 173 courtesy of Jonathan Barnbrook
p. 174 courtesy of Barnardo's and BBH
p. 181 courtesy of Shepard Fairey
p. 177 courtesy of Jonathan Barnbrook
p. 186 courtesy of Harmen Hoogland
p. 190 courtesy of David King. *The Commissar
Vanishes* published in the UK by Canongate
Books
p. 195 courtesy of University of Chicago Press
p. 197 Photo: © Rolant Dafies
p. 204 courtesy of (Miles Murray Sorrell)
FUEL
p. 211 courtesy of Duophonic Records

'Death in the image world' and the
introduction are previously unpublished.
Earlier versions of the other pieces –
sometimes with different titles – have
appeared in the following publications: 'The
boredom of plenty' (*2wice*, 2001); 'Inside the
blue whale' (*Harvard Design Magazine*, summer
2000); 'Prozac for the ear' (*2wice*, 1998); 'The
medium of emergent desire' (*I.D.*, March/April
1996); 'In every dream home' (*2wice*, 1997);
'Alternative by design?' (*Ray Gun: Out of Control*,
Booth-Clibborn Editions, 1997); 'Branded
journalism' (*Metropolis*, October 2000);
'Sentenced to buy' (*Eye*, spring 2000); 'Here
is me!' (*Graphis*, March/April 1999); 'Don't
think, shoot' (*Print*, November/December
2000); 'An artist's rights' (*Frieze*,
September/October 1997); 'Ineffable cool'
(*Print*, May/June 2000); 'Blank look' (*The
Business: Financial Times*, 9 October 1999);
'Shopping on planet irony' (*Domus*, December
2000); 'Digital supergirls' (*Eye*, winter 2000);
'Graphic sex' (*Print*, July/August 2000); 'Erotic
documents' (*Eye*, autumn 1999); 'Che is risen'
(*Eye*, summer 1999, and summer 2001);
'Under the knife' (*Graphis*, May/June 2000);
'Too much stuff' (*Blueprint*, October 1997);
'Design is advertising' (*Eye*, autumn 1998,
and winter 1998); 'First things first' (*Adbusters*,
autumn 1999); 'First things next' (*Adbusters*,
July/August 2001); 'Thirteen provocations'
(*Tibor Kalman: Perverse Optimist*, Booth-Clibborn
Editions, 1998); 'Surface wreckage' (*Eye*,
winter 1999); 'This is a record cover' (*Frieze*,
May 1998); 'Fighting ads with ads' (*The
Business: Financial Times*, 13 November 1999); 'A
child's fate?' (*Eye*, autumn 2000); 'Preparing
for the meme wars' (*Graphis*, November/
December 1999, and *Print*, March/April 2001);
'The designer as reporter' (*Graphis*,
January/February 2000); 'Books of blood and
laughter' (*Print*, November/December 1998);
'The critical path' (*Blueprint*, June 1998);
'When objects dream' (*The Business: Financial
Times*, 19 May 2001); 'Power to translate'
(*Domus* and *Idea*, September 2000); 'Future
imperfect' (*Graphis*, March/April 2000).

My deep thanks to these publications and
to their editors and publishers for all their
encouragement and support: J. Abbott Miller,
editor/designer, and Patsy Tarr, editor-in-
chief of *2wice*; Nancy Levinson and William S.
Saunders, editors of *Harvard Design Magazine*;
Chee Pearlman, former editor of *I.D.*; Martin
C. Pedersen, executive editor, and Susan S.
Szenasy, editor-in-chief of *Metropolis*; B.
Martin Pedersen, creative director of *Graphis*;
Joyce Rutter Kaye, managing editor of *Print*;
Max Bruinsma, former editor, and Nick Bell,
creative director of *Eye*; Kalle Lasn, editor-in-
chief, James MacKinnon, senior editor, and
Chris Dixon, former art director of *Adbusters*;
Matthew Slotover, publisher of *Frieze*;
Marcus Field, former editor of *Blueprint*;
Julia Cuthbertson, editor of *The Business*, the
Financial Times' weekend magazine; Deyan
Sudjic, editor of *Domus*; and Manabu Koseki,
editor-in-chief of *Idea*.

For allowing me the luxury of regular
columns in which to develop some of these
themes, I particularly wish to thank Martin C.
Pedersen, former editor of *Graphis*; John L.
Walters, editor-in-chief of *Eye*; and Martin
Fox, redoubtable, long-serving editor of *Print*.

Thanks also to Marvin Scott Jarrett,
founder of *Ray Gun*; to Maira Kalman, Peter
Hall and Michael Bierut; and to Booth-
Clibborn Editions for commissioning the
essays on *Ray Gun* and Tibor Kalman.

Many thanks to all the individuals and
organisations, listed here, who gave
permission to use their pictures, and
especially to Shepard Fairey for blessing the
memetic Giant's appearance in this guise.

I am hugely grateful to Nick Barley and
Stephen Coates, directors of August Media,
and Robert Steiger at Birkhäuser, for their
generous commitment to the project. Thanks,
too, to Alex Stetter, the book's project editor;
to Anne Odling-Smee, its designer; and to
Kam Tang for a wonderful cover.
Rick Poynor